HUNTINGTON LIBRARY PUBLICATIONS

Early British Drawings in the Huntington Collection

➤➤ 1600-1750 ◄◄

BY ROBERT R. WARK

THE HUNTINGTON LIBRARY · SAN MARINO, CALIFORNIA
1969

This volume has been published with the assistance of a grant from the Ford Foundation.

TABLE OF CONTENTS

EARLY BRITISH DRAWINGS

The IMPORTANT BRITISH PAINTINGS in the Huntington Art Gallery are reasonably familiar both to students and to the general public. Much less well known, even to scholars in the field, is the large collection of drawings, forming one of the most impressive assemblages of British draftsmanship to be found outside London. There are now about three thousand drawings in the gallery, ranging in date from the early seventeenth to the late nineteenth century, and nearly all phases of British draftsmanship for that period are represented. The present book deals with a numerically small but artistically and historically important portion of the collection, the works dating between 1600 and 1750.

The items included in this volume have entered the Huntington gallery from different sources and at various times, although most of them have been acquired during the past decade. Mr. Huntington himself was not greatly attracted by drawings. He purchased practically none aside from notable groups by Blake, Rowlandson, Cosway, and the Cruikshanks. It was not until the late 1950's, thirty years after Mr. Huntington's death, that a serious program was launched to acquire a well-rounded collection of British drawings as a supplement to the great series of British paintings in the gallery. But Mr. Huntington was fascinated by and collected grangerized books. These compendia of miscellaneous illustrations often contain drawings, and some of the most interesting included in the present volume come from such sources.

The popularization of the practice of extra-illustrating books is usually associated with an otherwise rather obscure eighteenth-century clergyman, James Granger. In 1769 Granger brought out a *Biographical History of England* set up with blank leaves interspersed between the pages of text so that engraved portraits of the notables discussed could be inserted as these became available to the owner. The book enjoyed great vogue; the price of portrait engravings jumped phenomenally; and the whole notion of extra-illustrations spread rapidly. The idea could be applied to a great

3

many different types of books. Nor, of course, was it necessary to have an edition specially designed for the purpose. Any volume could be taken out of its binding; prints and drawings could be mounted and inserted between the leaves, and the whole bound back together again. The book would usually be expanded to several volumes by this process. One suspects there was considerable rivalry among the gentlemen who indulged in this practice to see who could produce the bulkiest extra-illustrated set.

Among the earliest and most assiduous of the extra-illustrators was a certain Richard Bull (1721?-1805). In addition to a very ambitious Granger, expanded to thirty-five volumes, Bull also extra-illustrated a copy of Burnet's *History of His Own Time* and Hamilton's *Mémoires du Comte de Grammont*. All three of these sets are now in the Huntington Library, and all three contain British drawings of considerable interest. Very little is known about Bull's life, but he was apparently accumulating material at least as early as the 1770's. The important group of drawings by Robert White which Bull incorporated in his Granger he acquired at James West's sale in 1773.

Other extra-illustrated books yielded items of almost equal interest. A group of drawings of artists by George Vertue came from a set of the 1826 edition of Walpole's *Anecdotes of Painting*. We do not know who made up this series, but one supposes the sketches were originally with the Vertue papers and hence may have passed through the hands of Walpole himself. The fascinating group of New Testament illustrations by Thornhill is in the largest of the extra-illustrated sets in the Huntington Library, the so-called "Kitto" Bible in sixty volumes, compiled in the nineteenth century by a J. Gibbs. While every reasonable effort has been made to locate and record the drawings in extra-illustrated books, the possibility certainly exists that more remain to be discovered within the Huntington Library's extensive resources in this field.

But if grangerized books have yielded a few of the most interesting early English drawings, the major portion of the Huntington collection came through two *en bloc* purchases in 1959 and 1963. In 1959 the Trustees had the good fortune to acquire almost the entire Gilbert Davis collection. The gallery thus obtained at once a fine representative group of nearly two thousand British drawings and watercolors ranging in date from the seventeenth to the late nineteenth century. Mr. Davis had formed the collection with great care, mostly during the previous fifteen years, and had made it

into one of the most distinguished in private hands. Furthermore, the meticulous records he kept concerning the histories of the sketches considerably enhances the material for the student. The great strength of the collection is in the British watercolor school of the late eighteenth and early nineteenth century, with comparatively few items falling within the compass of the present book. Those that do are for the most part the works of precursors of the landscapists, men like Taverner and Alexander Cozens, who sit on the forward edge of the chronological limits for this volume.

In 1963 the Huntington Trustees had another great opportunity to enlarge the gallery's holdings in British drawings. The institution was granted the privilege of choosing about four hundred from the collection of the late Sir Bruce Ingram before it was dispersed at auction. Naturally the emphasis in this selection was placed on artists and periods not fully represented already in the Huntington gallery. Special attention was given to the seventeenth- and early eighteenth-century material, in which Sir Bruce's collection was comparatively rich. In particular, there were fine groups by men like Hollar, Place, Thornhill, and the draftsmen in plumbago. Indeed the major portion of the drawings cataloged in this volume were at one time in Sir Bruce's possession.

The Ingram collection (like that of Gilbert Davis) was reasonably well known in England, where many items had been included in public exhibitions. Sir Bruce's collection was exhibited in part at the Arts Council in 1946-1947, and at Colnaghi's in 1936, '37, '38, and '52. Selections from the Gilbert Davis collection appeared at the Arts Council in 1949, '50, and '55. And both men were regular lenders to general exhibitions involving British drawings. The two collectors were friendly rivals in their hobby, and actually at one point Gilbert Davis prepared a card index of Sir Bruce's drawings. It is particularly appropriate, accordingly, that major portions of both collections should now be together at the Huntington Library. Each man took keen personal pleasure in gathering his material and ferreted it out from a wide variety of sources. But a guiding spirit for both seems to have been the late D. C. T. Baskett of Colnaghi's, a great connoisseur-dealer in the field of British drawings, whose knowledge and energy was behind the formation of many important collections in that field.

The Huntington gallery has, of course, acquired many drawings in addition to those included in the Ingram and Davis collections and the grangerized books. But most of these others are for the period after 1750.

5

English seventeenth- and early eighteenth-century sketches do not in fact appear frequently on the market. This is partly because of their rarity, but also partly because they do not command the widespread interest of the later material among collectors. Although the Huntington collection of drawings is still actively growing, it seems unlikely that substantial additions can now be made to this early area.

If a volume were to appear with the same general chronological limits as this one but devoted to some phase of Continental art, the chances are strong that the words "baroque" and "rococo" would be in the title. The terms have an alien sound and not a great deal of relevance when applied to British drawings. But there is for British as for Continental art of the seventeenth and early eighteenth centuries a degree of coherence and direction which is broken, rather sharply as such breaks go, about 1750. The drawings reflect this state of affairs, at least with sufficient clarity to make those included in this book a meaningful unit.

Simply on the planes of technique and subject matter, the nature of British draftsmanship shifts markedly with the late eighteenth century, at which time watercolor takes over as the dominant medium and landscape as the dominant theme. There is a corresponding change in emphasis from the drawing as a preparatory study for a painting or print to the drawing or watercolor as a complete, self-contained work of art. And these considerations do not include the basic ideological change in the mid-century toward ideas about art that pave the way for the romantic period.

Nevertheless, anyone turning through the plates in this volume will probably be more impressed by the diversity in style, technique, and artistic intention than by any overall unity in the material presented. This variety is partly the result of the different origins of the draftsmen included, whose works often reflect artistic training and ideas from widely separated areas of the Continent. But much of the variety also stems from the fact that the term "drawing" has many different meanings, and the items here included reflect these various ideas.

What most of us probably have in mind when we speak of a drawing is a free, spontaneous, first inspiration concerning some artistic idea which is later developed into a painting or sculpture. We admire the deft control with which the draftsman sets down his thoughts. And we are fascinated and delighted by the insight provided into how an artist grasps and devel-

ops an artistic problem. We think of drawings as a record of the creative process, and as such they are among the most precious artistic documents we have.

But the term "drawing" is also regularly applied to any work of art executed in pen, pencil, or wash. Here the distinguishing feature is the medium, not the artistic intention. Many pictures which are entitled to be called drawings because of their media may be complete, self-contained works of art, with nothing tentative or preparatory about them.

We also apply the word "drawing" in a more general sense to the artist's executive control over his material (whether this be brush, pen, or pencil), his ability to construct his forms with sureness, economy, and elegance. Understood in this way, drawing is a factor present to a degree in all two-dimensional works of art that involve some sort of manual dexterity.

As far as this book is concerned, the most important group of drawings in the first use of the term are those by Sir James Thornhill. He clearly enjoyed sketching as a means of experimenting with ideas, and he frequently filled whole sheets with all the permutations and combinations he could think of for a particular subject. Furthermore, the summary character of his washes for suggesting figures provides qualities of spontaneity, immediacy, and improvisation that are particularly attractive to mid-twentieth-century eyes. There are other drawings in this book which, like those of Thornhill, are first notations for more ambitious works of art. The sketches by Kneller, Vanderbank, and Wyck, for instance, all can be understood and enjoyed in essentially this way. But the majority of the works here illustrated do not fit comfortably into this category. They are drawings simply by virtue of the media in which they are executed, and their appeal consequently is of a different kind.

Sometimes this appeal is in terms of elegance of craftsmanship, the delicacy and precision with which the tools are used. This is surely what is most attractive about the miniature portraits in pencil (or "plumbago" as it is often called) and pen, drawings like those of Loggan, White, Forster, and Faber. There is, of course, nothing tentative about these engaging little works of art; they are finished portraits that simply happen to exist in a drawing medium rather than in paint. The tradition was one brought to England from the Continent, but one that found English soil particularly congenial. It continued well on into the eighteenth century in the hands of men like James Ferguson and George Vertue, although they are likely to

construct their figures more in terms of monochrome washes than pencil or pen. Frequently, especially with White and Vertue, the drawings served as the source for engravings, and many of them were doubtless undertaken with that end specifically in mind. But the artistic idea nearly always reaches full development in the drawing itself, of which the print is little more than a reproductive record.

Many other drawings in this book were also undertaken primarily with engraving in mind and consequently have been worked out in considerable detail by the artist. This would seem to be the case with all the Barlow items included, as well as those by Hollar and the other topographers. The early eighteenth-century drawings by Kent, Gravelot, and Hayman likewise were for book illustrations. In all these instances the drawings frequently have an appeal that does not carry over into the prints. The source of this attraction is the line used by the artists to delineate their forms, a line which tends to lose much of its flexibility and personality when transformed into engraving. This appeal, which is essentially akin to that of fine calligraphy, is a feature that runs through the whole history of English draftsmanship from Hiberno-Saxon illuminations in the eighth century down to the present day, and which reached something of an apogee at the turn of the eighteenth to the nineteenth centuries in the work of such different artists as Blake and Rowlandson.

The major exception to this tendency of British draftsmen to work in terms of line and contour is the great group of landscape watercolorists. The first intimations of this achievement in landscape appear just at the end of the period covered by this book in the work of men like Taverner, Skelton, and Alexander Cozens, all of whom belong in spirit (as they almost do in date) to the second half of the century. As this school of landscape develops in England, what it produces takes on more and more the character of paintings in watercolor, and the connection with drawing, in the various ways we understand the term, becomes distinctly tenuous. Of the three men included in the present book it is really only Cozens who produces drawings; the other two are already making paintings that happen to be executed in watercolor or gouache. Like all paintings, these partake of the qualities of drawings in so far as we respond to the artist's control over his medium, the dexterity and elegance with which he constructs his forms. But it is really only in this sense that they are entitled to be called drawings.

ops an artistic problem. We think of drawings as a record of the creative process, and as such they are among the most precious artistic documents we have.

But the term "drawing" is also regularly applied to any work of art executed in pen, pencil, or wash. Here the distinguishing feature is the medium, not the artistic intention. Many pictures which are entitled to be called drawings because of their media may be complete, self-contained works of art, with nothing tentative or preparatory about them.

We also apply the word "drawing" in a more general sense to the artist's executive control over his material (whether this be brush, pen, or pencil), his ability to construct his forms with sureness, economy, and elegance. Understood in this way, drawing is a factor present to a degree in all two-dimensional works of art that involve some sort of manual dexterity.

As far as this book is concerned, the most important group of drawings in the first use of the term are those by Sir James Thornhill. He clearly enjoyed sketching as a means of experimenting with ideas, and he frequently filled whole sheets with all the permutations and combinations he could think of for a particular subject. Furthermore, the summary character of his washes for suggesting figures provides qualities of spontaneity, immediacy, and improvisation that are particularly attractive to mid-twentieth-century eyes. There are other drawings in this book which, like those of Thornhill, are first notations for more ambitious works of art. The sketches by Kneller, Vanderbank, and Wyck, for instance, all can be understood and enjoyed in essentially this way. But the majority of the works here illustrated do not fit comfortably into this category. They are drawings simply by virtue of the media in which they are executed, and their appeal consequently is of a different kind.

Sometimes this appeal is in terms of elegance of craftsmanship, the delicacy and precision with which the tools are used. This is surely what is most attractive about the miniature portraits in pencil (or "plumbago" as it is often called) and pen, drawings like those of Loggan, White, Forster, and Faber. There is, of course, nothing tentative about these engaging little works of art; they are finished portraits that simply happen to exist in a drawing medium rather than in paint. The tradition was one brought to England from the Continent, but one that found English soil particularly congenial. It continued well on into the eighteenth century in the hands of men like James Ferguson and George Vertue, although they are likely to

construct their figures more in terms of monochrome washes than pencil or pen. Frequently, especially with White and Vertue, the drawings served as the source for engravings, and many of them were doubtless undertaken with that end specifically in mind. But the artistic idea nearly always reaches full development in the drawing itself, of which the print is little more than a reproductive record.

Many other drawings in this book were also undertaken primarily with engraving in mind and consequently have been worked out in considerable detail by the artist. This would seem to be the case with all the Barlow items included, as well as those by Hollar and the other topographers. The early eighteenth-century drawings by Kent, Gravelot, and Hayman likewise were for book illustrations. In all these instances the drawings frequently have an appeal that does not carry over into the prints. The source of this attraction is the line used by the artists to delineate their forms, a line which tends to lose much of its flexibility and personality when transformed into engraving. This appeal, which is essentially akin to that of fine calligraphy, is a feature that runs through the whole history of English draftsmanship from Hiberno-Saxon illuminations in the eighth century down to the present day, and which reached something of an apogee at the turn of the eighteenth to the nineteenth centuries in the work of such different artists as Blake and Rowlandson.

The major exception to this tendency of British draftsmen to work in terms of line and contour is the great group of landscape watercolorists. The first intimations of this achievement in landscape appear just at the end of the period covered by this book in the work of men like Taverner, Skelton, and Alexander Cozens, all of whom belong in spirit (as they almost do in date) to the second half of the century. As this school of landscape develops in England, what it produces takes on more and more the character of paintings in watercolor, and the connection with drawing, in the various ways we understand the term, becomes distinctly tenuous. Of the three men included in the present book it is really only Cozens who produces drawings; the other two are already making paintings that happen to be executed in watercolor or gouache. Like all paintings, these partake of the qualities of drawings in so far as we respond to the artist's control over his medium, the dexterity and elegance with which he constructs his forms. But it is really only in this sense that they are entitled to be called drawings.

8

Many of the works in this volume are documents of considerable interest aside from any aesthetic value they may have. A large proportion are records of the appearance of either people or places, and this is the principal source of their appeal. The English, like their neighbors the Dutch, had a tendency to prefer portraits of themselves, their homes, and their possessions to the more imaginative forms of art, and this inclination is apparent in drawings as well as paintings. Many of the portrait studies have been preserved because they represent people of distinction. Even when the sketches are not actually life studies, they sometimes are the only record of a portrait that has disappeared. There is, for instance, reason to believe that the Vertue drawing of Milton is the best copy extant of a highly important but apparently lost study by Faithorne. Likewise Vertue's wash study of Thomas Van Wyck seems to be our only record of what must have been an impressive portrait by Frans Hals. Some of the topographical drawings, such as Hollar's views of Tangier, or the anonymous view of Plymouth, have considerable interest as records of the appearances of places that have subsequently changed a great deal. Indeed there can be little doubt that nearly all the portrait and topographical drawings here included were made basically for the purpose of record rather than in response to any aesthetic impulse.

One basic source of appeal shared by all the drawings in this volume is the quality of intimacy and direct personal contact between the artist and the spectator. Regardless of the varying reasons for which the sketches were created, none was intended for general public display. Even the most meticulously finished plumbago portraits were surely for purely private contemplation. Drawings have an attraction akin to that of chamber music and good conversation, in which the more grandiloquent effects of the exhibition hall, the concert stage, or the rostrum are dispensed with and the exchange of ideas is altogether on a more personal level. Of course a large part of this appeal is lost when the original document itself is not at hand for study. But generally drawings suffer less in reproduction than many of the grander art forms, and a good deal of the fascination of these objects still comes through, together with a comfortable sense of proximity to the men who produced them.

The greatest assemblage of British drawings of the seventeenth century is at the British Museum. The collection there so far surpasses all others in the quality, quantity, and comprehensive character of its holdings that it is

9

in a class entirely by itself. It is a difficult and probably not particularly important task to attempt to rate other repositories of this material in order of merit. But among these secondary collections (which are not numerous), that in the Huntington gallery certainly holds an honorable place. It has been hitherto virtually unknown, largely because of its physical remoteness from the other centers in England.

The sixteenth- and seventeenth-century drawings in the British Museum have been recently and meticulously published in exemplary fashion. A volume on the early eighteenth century is due in the near future. The ready accessibility of these very thorough catalogs makes unnecessary and redundant much general descriptive information and biographical data about artists which might otherwise be expected in the present volume. The emphasis here has been on the presentation of the individual drawings, with illustrations of each item.

Acknowledgments

A CATALOG such as this one is always a work of cooperative scholarship. Although there has been no previous publication devoted to the Huntington collection of drawings for the period 1600-1750, several of the items here included have appeared in exhibitions in England where they have been the subjects of study. Even those drawings that are now published for the first time have passed through the hands of scholars, connoisseurs, and art dealers who have all contributed in one way or another to our understanding of them. I am happy to acknowledge, if only in general terms, my debt to these earlier students.

During the course of my own research on these drawings I have received much generous assistance from many colleagues. It is a pleasure to recall the friendly and helpful spirit with which inquiries were invariably treated. In those instances where information obtained has materially affected what is said about a drawing I have attempted to acknowledge that fact in the particular entry concerned.

I owe a very special debt of gratitude to Edward Croft-Murray and Paul Hulton of the British Museum, both of whom read the text of the catalog in typescript. They made numerous helpful suggestions and assisted in the elimination of many errors. But they must not, of course, be held responsible for those mistakes in fact or judgment that may remain.

Several illustrations in the text portion of the catalog are of items not in the Huntington collection. Grateful acknowledgment is made to the owners for permission to reproduce the following: Fig. 4, The National Portrait Gallery, London; Figs. 6 and 8, The Pierpont Morgan Library; Fig. 9, Trustees of the Chatsworth Settlement; Fig. 10, The Earl of Derby; Fig. 11, The Tate Gallery.

Ann Ely and Nancy Moll of the Huntington Library staff have been of the greatest help in the irksome task of preparing the catalog for the printer. The publication of the book was made possible through the generosity of the Trustees of the Huntington Library and the support of the Ford Foundation.

R. R. W.
San Marino, California
May 1968

CATALOG

BARLOW, Francis (1626?-1704)

Not much is known about the outward circumstances of Barlow's life. The date and place of his birth are uncertain, but he spent most of his career in London. During his own day he enjoyed a reputation as a painter (primarily of animal and sporting subjects) as well as an etcher.

Barlow's drawings are among the most esteemed and attractive by English seventeenth-century draftsmen. Nearly all his drawings appear to be preliminary studies for prints. Some of these he engraved himself; many others were etched by men such as Hollar, Faithorne, and Place. As a draftsman Barlow uses the pen-and-wash technique, which is a standard English form during the seventeenth and eighteenth centuries. What gives his drawings their particular attraction is his flexible and stylized pen-work, a feature that does not normally carry over into the prints. He likes to delineate his forms with clear, decisive outlines. Occasionally, especially in his early work, he uses cross-hatching for modeling, but more often simply a monochrome gray or brown wash. The touches of watercolor on E appear to be distinctly unusual.

A. *Emblematic Portrait of Oliver Cromwell*

Pen and black ink with gray wash; verso treated with red pencil for tracing; many of the outlines scored by tracing; 22½″ x 16¾″
ENGR: in reverse with several variations and added captions as "The Embleme of Englands Distractions" (1658). The print is attributed to William Faithorne (Fig. 1).
LIT: Louis Fagan, *A Descriptive Catalogue of the Engraved Works of William Faithorne* (London, 1888), p. 31
PROV: The drawing was found in a multiple-volume collection of portrait prints and drawings of British notables formed in the late eighteenth century by Richard Bull. The compilation is known as Bull's Granger.

On the page to which the drawing is attached there is an inscription in Bull's hand: "This is the Original Drawing from which Faithorne engraved

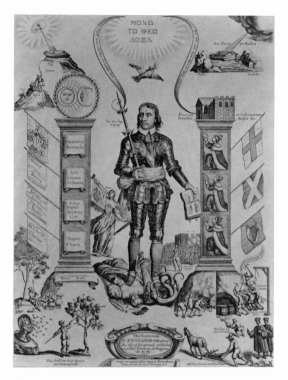

Fig. 1. WILLIAM FAITHORNE, *The Embleme of Englands Distractions* (engraving)

the Print, and which is so scarce that an impression thereof, sold for £9.3.0 at Mr. West's Auction." The auction referred to is probably one of several sales in 1773 of the property of James West, President of the Royal Society.
ACQ: 1951 (in Bull's Granger, gift of Estelle Doheny)

There are several differences between the drawing and the print (aside from the reversal and added captions): the head of Cromwell in the print is an older, more particularized portrait than in the drawing, but both appear to derive ultimately from the miniature by Samuel Cooper; the winged figure (Fame) behind Cromwell has been radically reworked, reduced in scale, and placed on one side in the print; in the print the church has no skulls impaled on spires; also in the print a castellated wing has been added to the church; two small foxes, their tails tied together and aflame, are added in the print beneath the two clerics with a lantern; the kneeling figures of England, Scotland, and Ireland are male in the drawing, female in the print.

15

Many captions and inscriptions have been added on the print:

[in the cartouche at the bottom] The Embleme / of Englands Distractions / As also of her attained, and further / expected Freedome, & Happines / Per H. M. / 1658

[on the scroll beneath the cartouche] Anglia ne meritas, sistas immota Triumphans / Pacis Oliva tibi vere Olivarus erit [England, as long as you deserve to, may you stand unmoved and triumphant. Oliver will truly be the olive of peace to you]

[in the gloria at the top, in Greek] Glory to God Alone

[below the ark at rest] Ararat

[below Abraham and Isaac] Moria

[on the top scroll on the pillar surmounted by the Sun and Moon] Constantia Fortitudo [constancy fortitude]

[the adjoining flag has the family arms of Oliver Cromwell]

[on the second scroll] Lex Corona Columna [the law is a crown and a pillar]

[on the adjoining flag] Honos pro Bonis [honor for good men]

[on the third scroll] Salus Populi Suprema Lex [the safety of the people is the supreme law]

[on the adjoining flag] Salva sit Insula Legibus Munita [the island fortified by laws is safe]

[on bottom scroll] Magna Charta

[on adjoining flag] Ex Charta Charitas [charity from charter]

[on hill below pillar] Mons Sion

[beside shepherd] Oliva Pacis [olive of peace]

[below man gathering grapes] They shall beat their Speares into Pruneing-hooks

[below man ploughing] And their Swords into Plow-shears

[on scrolls encircling the gloria] Bee still, and know that I am God
I will never faile thee, nor forsake thee

[beside Cromwell's sword] Pro Deo lege et grege [before God, law, and flock]

[beside figure with trumpet] Fame [the trumpet banner bears the arms of Cromwell as Lord Protector]

[below prostrate female figure] Babilon

[on the serpents] Faction / Error

[on cup held by prostrate female figure] Papa / Poculum aureum / plenum Abomnatio . e [Pope / the golden cup when full is abomination]

[beside building capping second pillar] Floreant Protector et Parliamentum Angliae etc [May the Protector and Parliament of England flourish]

[on book held by Cromwell] Tollo Perlego Protego [I lift up, I read through, I protect]

[below soldiers behind Cromwell] Vis unita fortior [united force is stronger]

[below the kneeling figures on the pillar] Anglia / Scotia / Hibernia

[issuing from mouth of figure with fox's head] Dolent non machinantes Dolum [they grieve when they are not plotting]

[beside gallows] Latrant Latrones [the robbers bark]

[below men with pickaxes] Proditorum finis funis [death is the end of traitors]

[beside man with bellows] Uror dum alij non uruntur [I burn while others are not burnt]

[above ark between rocks] Per flatus per fluctus [through tempest through flood]

[near ark between rocks] Scylla / Caribdis / Remora

The gist of the iconography and symbolism in this complicated drawing is clear enough, although many details remain obscure. Cromwell is presented as the champion who has brought Britain through trials and tribulations to peace and prosperity. He has safely piloted the ship of state through troubled waters and remora, between Scylla and Charybdis. The state now rests, like the ark after the flood, on Mt. Ararat, while the Dove returns with the olive branch of peace in its beak. Presumably Cromwell's faith in the Divine Will (like that of Abraham sacrificing Isaac) has contributed to the successful outcome. He has used his military prowess to maintain the unity of England, Scotland, and Ireland, to stamp out faction and error, and to preserve the church from the inroads of Roman Catholicism (symbolized by the Whore of Babylon). But now these various crises are past: the spears have become pruning hooks; the swords have become ploughs; the bees are making their hive in the helmet. Oliver has brought the olive branch of peace to the land.

The meaning of some of the symbols remains uncertain. The group working with pickaxes below the pillar supporting church and state may refer

to surreptitious activities against the government such as the Gunpowder Plot, traitorous acts which end at the gallows. The two clerics carrying a lantern may also refer to clandestine operations on the part of the Roman Catholic Church. The foxes with tails tied together and ablaze in the wheatfield (a reference to the exploits of Samson against the Philistines) may also have something to do with the suppression of heresy and subversion. The sun and the moon resting on top of the pillar of the law may refer to the universal and enduring quality of Cromwell's achievement.

It is unlikely that Barlow himself was responsible for the program of the print, but no written source has been found. The publisher, H. M., might be Humphrey Moseley (who printed some of Milton's writings).

Among Barlow's works the drawing is remarkable for its physical size, elaboration, and iconographic complexity. Nevertheless the draftsmanship, especially of the small subsidiary elements, is entirely characteristic of Barlow. There can be no reasonable doubt that he is responsible for the drawing, although his name has not hitherto been associated with the design. The engraving itself (which is unsigned) has always been attributed to Faithorne. Barlow and Faithorne are known to have collaborated in producing many plates.

I am indebted to John Steadman for assistance with this entry.

B. *An Elephant and a Camel*

Pen and brown ink with gray wash; 5¾″ x 8″ (the sheet has been torn and repaired along the left margin and the lower right corner)
ENGR: apparently the preliminary drawing for the third plate of a series etched in reverse by W. Hollar, "Variae quadrupedum species per Fr. Barlow." The print is inscribed: F. Barl inv. W Hollar fecit 1663. See Gustav Parthey, *Wenzel Hollar. Beschreibendes Verzeichniss Seiner Kupferstiche* (Berlin, 1853), p. 449. Several other drawings connected with this series are in the British Museum (*Catalogue of British Drawings*, I [1960], 100-102).
ACQ: before 1927 (in a portfolio of drawings all attributed to Thomas Rowlandson)

A pencil drawing, doubtfully attributed to Barlow, the reverse of the Huntington drawing and with several other variations, was in a Sotheby sale October 18, 1961, Lot 8 (illustrated).

C. *The Pedlar and His Ass*

Pen and brown ink with gray wash; blackened on verso (for tracing); 10 3/16″ x 7½″
INSCR: [verso] 6
ENGR: The drawing was etched by Richard Gaywood (in reverse) to illustrate Fable XXXIX in John Ogilby's *Aesopic's or a Second Collection of Fables Paraphras'd in Verse* (London, 1668), facing p. 101.
PROV: H. S. Reitlinger (Lugt 2274a); Gilbert Davis (Lugt 757a)
ACQ: 1959 (Acc. No. 59.55.62)

Barlow was much involved with illustrations to Aesop during the mid-1660's. He provided one hundred and twelve illustrations to a translation by Thomas Philipott that appeared in 1666, adding thirty-one extra plates illustrating Aesop's life to the second edition in 1687. Most of the drawings for this publication are in the British Museum. The Huntington drawing belongs to an independent group designed for Volume II of the second edition of John Ogilby's Aesop, published in 1668.

For a discussion of Barlow's illustrations to Aesop see Philip Hofer, "Francis Barlow's Aesop," *Harvard Library Bulletin*, II (1948), 279-295.

D. *Two Heralds*

Pen and brown ink with gray wash, with alterations indicated in red and black pencil; 4 9/16″ x 2¾″ (on mount 6½″ x 4⅞″)
INSCR: [in pencil above man to left] paper in his hand; [above man to right] A Book in his hand; [signed on mount] Barlow. d.; [inscribed in pencil on mount] part of ye coronation K. James 2d
PROV: Sir Bruce Ingram (Lugt 1405a)
ACQ: 1963 (Acc. No. 63.52.15)

The drawing appears to be a study for two figures in a publication depicting the Coronation of James II, 1685. Probably the drawing represents the Rougecroix Pursuivant and the Rougedragon Pursuivant, although the correspondence is not precise (Fig. 2). The figures in the print move in the same direction as in the drawing (whereas one might expect them to be in reverse), but the paper and book mentioned in the inscription on the drawing have been added on the print. The copy of the publication in the Huntington Library has been cut up and mounted in an extra-illustrated copy of Burnet's *History of His Own Time*, IV, 628 ff., and there is no indication of who was responsible

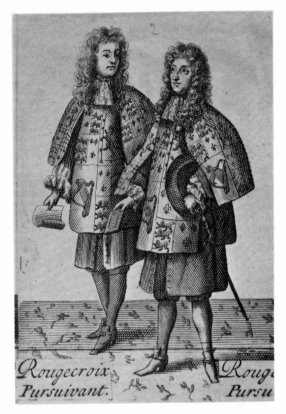

Fig. 2. ROUGECROIX PURSUIVANT AND ROUGEDRAGON PURSUIVANT *(detail from a print depicting the Coronation of James II)*

E. *Design for a Title Page or Decorative Panel*
Pen and gray wash with touches of watercolor; 8 7/16″ x 6¼″
INSCR: F. Barlow del. No. 6
EXH: *The Works of British-born Artists of the Seventeenth Century* (Burlington Fine Arts Club, London, 1938), No. 45; *Stuart Drawings* (Bristol, 1952), No. 8
LIT: Edward Croft-Murray, *Decorative Painting in England*, I (London, 1962), 216
PROV: Richard Bull?; Sir Bruce Ingram (Lugt 1405a)
ACQ: 1963 (Acc. No. 63.52.16)

The arms on the lintel are those of William III. The palace in the background has a vague general relationship to some of Wren's palace designs, particularly for Hampton Court. There is an old crease down the center axis of the drawing suggesting that the symmetrical parts of the design were created by folding the paper and making a rubbing.

There was a drawing in the Richard Bull sale (Sotheby, May 23, 1881, Lot 9) described as "Francis Barlow—View of a Palace with English Royal Arms above, pen washed, in indian ink and neutral tint, signed."

BARLOW, Francis (1626?-1704), after

Group of Birds
Pen and black ink with gray wash; 7⅛″ x 10″ (uneven)
EXH: *Stuart Drawings* (Bristol, 1952), No. 2
ILLUS: John Woodward, *Tudor and Stuart Drawings* (London, n.d.), Pl. 28
PROV: Sir Robert Witt (Lugt 2228b); Sir Bruce Ingram (Lugt 1405a)
ACQ: 1963 (Acc. No. 63.52.14)

The drawing is closely related to an etching by Jan Griffier (Fig. 3). The preliminary drawing by Barlow for the etching (the reverse of the print) is in the British Museum (see *British Drawings*, I [1960], Pl. 60). The Huntington drawing reads in the same direction as the print, but with numerous changes: several birds, a monkey, and most of the background are omitted; the grouping of the remaining birds has been consolidated. There is, however, little reason to doubt that the drawing follows rather than precedes the print. The drawing is in a technique close to Barlow's, but not his.

for the plate of the procession. Other plates are signed by W. Sherwin or S. Moore.

The full title of the publication is:

The / Coronation / of the Most High, Most Mighty, and Most / Excellent Monarch, / James II. / By the Grace of God, King of / England, Scotland, France and Ireland, / Defender of the Faith, etc. / And of His Royal Consort / Queen Mary: / Solemnized in the Collegiate Church of St. Peter in / the City of Westminster, on Thursday the 23 of April, being / the Festival of St. George, in the Year of Our Lord 1685. / With an Exact Account of the several Preparations in Order thereunto, Their / Majesties most splendid Processions, and Their Royal and / Magnificent Feast in Westminster-Hall.

There does not appear to be any copy of this publication listed in Donald Wing, *Short-Title Catalogue of Books Printed in England ... between 1641 and 1700* (New York, 1945).

18

The pen lines in particular are thinner and less flexible than is normal in Barlow's work.

BEALE, Charles II (1660-1726?)

Charles was the son of the portraitist Mary Beale, whom he is known to have assisted by painting the draperies and backgrounds in some of her pictures. As a painter Charles doesn't seem to have any clear-cut personality of his own, but his drawings are a different matter. There are two sketchbooks in the British Museum and the Morgan Library filled with distinctive drawings in red chalk. On the strength of a footnote in the 1786 edition of Walpole's *Anecdotes of Painting in England*, the B. M. sketchbook was for many years attributed jointly to Mary and Charles. The Morgan sketchbook is inscribed "Charles Beale / 1st Book, 1679." The drawings in both books are completely consistent stylistically, and they are now all generally accepted as the work of Charles alone.

The drawings, almost all of heads or figures, appear to be either life studies or copies after works by other artists. They are executed in red chalk, frequently heightened with black lead. Beale employs a distinctive form of cross-hatching to model the figures, giving them a strong although not entirely consistent three-dimensional quality.

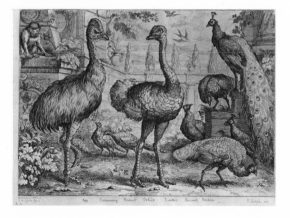

Fig. 3. JAN GRIFFIER, *Group of Birds* (etching after Francis Barlow)

In the Victoria and Albert Museum is a third sketchbook now given to Charles (although previously attributed to Mary). It contains some drawings very similar in style to those in the British Museum and the Morgan Library but also others in differing techniques that somewhat enlarge our idea of Charles's artistic personality, assuming that they are all in fact by him.

A. *Portrait of a Man Reading*

Red chalk strengthened with black lead; 9¾" x 7½"; watermark (lower portion only) apparently Heawood 1781
PROV: Richard Bull?; Dr. John Percy (Lugt 1504), as Mary Beale; O'Bryne (Christie's, April 3, 1962, Lot 48)
ACQ: 1962 (Acc. No. 62.3)

The attribution of this drawing to Charles Beale II is based on the close stylistic similarity to the large group of drawings now given to this artist in the British Museum. The watermark belongs to the same group and period as those on the British Museum and Morgan Library sketchbooks by Beale. The drawing appears to be a study from life rather than after the work of another artist.

There was a drawing in the Richard Bull sale (Sotheby, May 23, 1881, Lot 10) described as "Mary Beale—Man in hat and wig, reading from an open book, which lies open before him on a table, highly finished in red chalk."

B. *Anthony Ashley Cooper, 1st Earl of Shaftesbury*

Red chalk strengthened with black lead; 10¾" x 7⅞"
INSCR: [in a later hand] Anthony Earl of Shaftesbury
PROV: Sir Bruce Ingram (Lugt 1405a)
ACQ: 1963 (Acc. No. 63.52.17)

The drawing is connected (in reverse) with Robert White's engraved portrait of Shaftesbury dated 1680. It is possible that White may have worked from the Beale drawing, but more probable that Beale was copying White's preliminary design.

Another version of this drawing (more finished and smaller in scale) is in the British Museum (*British Drawings*, I [1960], 184-185).

BEALE, Charles II (1660-1726?), attributed to
C. *Head of a Man* (perhaps the Duke of Monmouth)
Black chalk, heightened with white, on blue-gray paper; 9⅝" x 7 15/16"
VERSO: slight sketch of a three-quarter-length male portrait
PROV: Sir Bruce Ingram (Lugt 1405a)
ACQ: 1963 (Acc. No. 63.52.131)

The portrait, traditionally identified as the Duke of Monmouth, resembles him closely but is not immediately connected with any of the established portraits.

The style, medium, and paper of the drawing are like several in a scrapbook in the Victoria and Albert Museum now attributed to Charles Beale II. The drawings in this book are more varied in character than those in the sketchbooks given to Charles Beale in the British Museum and in the Morgan Library. The Huntington drawing and those it resembles are softer and less tight in handling than the drawings normally attributed to Charles Beale II.

BECKETT, Isaac (1653-1719), attributed to
Portrait of a Man (said to be Louis, 2nd Earl of Feversham)
India ink and brush on vellum; 3⅜" x 2¾" (oval)
EXH: *International Exhibition of Miniatures* (Brussels, 1912), No. 351; Victoria and Albert Museum, 1914-18; *The Works of British-born Artists of the Seventeenth Century* (Burlington Fine Arts Club, London, 1938), No. 55
LIT: *Catalogue of the Miniatures and Portraits in Plumbago or Pencil belonging to Francis & Minnie Wellesley* (London, [1926?]), p. 11; J. J. Foster, *A Dictionary of Painters of Miniatures* (London, 1926), p. 16; Basil S. Long, *British Miniaturists* (London, 1929), p. 24
PROV: Francis Wellesley; G. P. Dudley Wallis; Sir Bruce Ingram (Lugt 1405a)
ACQ: 1963 (Acc. No. 63.52.18)

The ascription of this attractive miniature to Isaac Beckett appears to have been accepted without question, but aside from tradition there does not in fact seem to be any support for the attribution. Beckett, who is known primarily as a printmaker, did make a mezzotint of Feversham after John Riley. But the Huntington drawing bears no relation to the print; nor is the facial resemblance sufficiently strong to offer much support for the identification of the sitter in the drawing as the Earl of Feversham. On the other hand, if there is no evidence to support the traditional attribution to Beckett, there is equally no evidence to deny it, as this appears to be the only known drawing that is attributed to him.

BOITARD, Louis Philippe (active 1740-1750)
Man Asleep at a Table
Pen and watercolor; 6⅞" x 5⅛"
PROV: Ponsonby Shaw, Dublin, 1818; Jonathan Eyre, Stoke Newington; Leonard Duke
ACQ: 1967 (Acc. No. 67.37)

Not much is known about Boitard. He was born in France. Redgrave (*A Dictionary of Artists of the English School*) says he was active in England during the reigns of George I and George II primarily as a book illustrator; but he also calls Boitard a humorist, "occasionally with his pencil burlesquing the eccentricities of his time." In this guise Boitard is an interesting precursor of the numerous English comic draftsmen at the end of the eighteenth century. The technique of the Huntington drawing is precisely that of Rowlandson, Isaac Cruikshank, and other caricaturists active from 1780 on.

I am indebted to Mr. Leonard Duke for information about the provenance of the drawing. It was in an album of sixty-five Boitard drawings at one time in Mr. Duke's possession (see Iolo Williams, *Early English Watercolours* [1952], p. 20).

BUCK, Samuel and Nathaniel; Samuel (1696-1779), assisted by his younger brother Nathaniel (no dates) from 1727 to 1753.

The Bucks are known as topographical draftsmen and engravers. Their major work was a series of over five hundred views of British ruined abbeys and castles as well as cities and towns. They began publishing the views in 1720 and continued working on them for more than thirty years. Their known drawings all appear to be preparatory to the prints. The drawings are, of course, primarily topographical in in-

tention and make no claim to distinction in draftsmanship. They continue the tradition established in seventeenth-century England by men like Hollar and Place, but without the spirited penwork of the earlier men, and without Hollar's enlivening use of watercolor.

A. *The Southeast View of Fowey Castle*
Pen and wash; 6⅞" x 14 7/16"
INSCR: The South-east view of Fowey-Castle, in the County of Cornwall. [and] N. Buck
ENGR: S. & N. Buck 1734 (with the addition of another ship in the center middle-ground) in *Perspective Views of the Remains of the Most Remarkable Castles and Religious Houses in England & Wales* (Vol. III, Pl. 10, of the edition issued by R. Sayer in 1774)
PROV: Edward Croft-Murray; Sir Bruce Ingram (Lugt 1405a)
ACQ: 1963 (Acc. No. 63.52.29)

B. *The East View of St. Maws Castle*
Pen and wash; 7¼" x 14½"
INSCR: [at top] The East View of St. Maws Castle [and below] N. Buck [and] Cornwall
[The features of the drawing are numbered and itemized below as follows:]
1. Pendennis Castle 2. Falmouth 3. Penreen 4. Worth Esqr. Seat. 5. Flushing 6. Trefusis Esqr. Seat
ENGR: S. & N. Buck 1734 (with more showing of Pendennis Castle to the left) in *Perspective Views of the Remains of the Most Remarkable Castles and Religious Houses in England & Wales* (Vol. III, Pl. 8, of the edition issued by R. Sayer in 1774)
PROV: Sir Bruce Ingram (Lugt 1405a)
ACQ: 1963 (Acc. No. 63.52.30)

BULFINCH, John (active ca. 1680-1720)
Bulfinch appears to have been a dealer in pictures, prints, and drawings. His own drawings, in pen and wash, are mostly rather crude copies of portraits of notables. He must have been among the first to make this type of drawing to meet the developing demand for such material to "extra-illustrate" books. Several of his drawings are in the grangerized "Sutherland *Clarendon*" in the Ashmolean Museum. The three

in the Huntington collection are also in a famous extra-illustrated set, Richard Bull's Granger, made up in the late eighteenth century.

A. *Thomas Blood* (notable adventurer and soldier of fortune)
Ink wash; 9⅜" x 6⅜"
SIGNED: Bulfinch del.
PROV: Richard Bull; Estelle Doheny
ACQ: 1951 (in Bull's Granger, gift of Estelle Doheny, XVII, 122)
The drawing appears to be derived from another drawing of Blood which at one time belonged to Pepys and is now with his collection of prints at Magdalene College, Cambridge.

B. *Sir John Lawson* (admiral)
Ink wash; 11" x 9"
SIGNED: Bulfinch del.
PROV: Richard Bull; Estelle Doheny
ACQ: 1951 (in Bull's Granger, gift of Estelle Doheny, XIV, 89)
Derived from Lely's portrait of Sir John Lawson in the Royal Collection.

C. *Gilbert Sheldon, Archbishop of Canterbury*
Ink wash; 10½" x 8"
SIGNED: Bulfinch del.
PROV: Richard Bull; Estelle Doheny
ACQ: 1951 (in Bull's Granger, gift of Estelle Doheny, XIII, 47)
The drawing does not seem to derive directly from the known portraits of Sheldon by Lely and Cooper.

BYNG, Edward (died 1753)
Lord Torrington
Pen and black ink with gray wash, touched with white, on blue paper; 11½" x 8⅛"
INSCR: [twice, in a later hand] Byng Lord Torrington
PROV: Sir Bruce Ingram (Lugt 1405a)
ACQ: 1963 (Acc. No. 63.52.117)
Byng was one of Kneller's assistants. His drawings, of which there are a large number in the British Museum, appear to be mostly records of Kneller compositions. There are some grounds for con-

fusion about the Huntington drawing, as the surname of the 1st Viscount Torrington was also Byng. The drawing is, however, completely consistent in style with the established work of Edward Byng in the B. M. Like most of Byng's drawings, this one probably is connected with a Kneller portrait, but not the portrait of Lord Torrington in the National Maritime Museum. The drawing is more closely related to the Kneller portrait of Lord Torrington that served as the source for Houbraken's print of 1747 included in Thomas Birch, *The Lives of Illustrious Persons* (London, 1747-1752); but the print does not include the hand, nor is the correspondence otherwise precise. A studio version of this Kneller portrait (likewise without the hands) is at Kensington Palace.

CARWITHAM, Thomas (active ca. 1713)

Carwitham is a very shadowy figure. He is known by a group of drawings, all closely related in style, most of them illustrations to Ovid's *Metamorphoses*. One of these, formerly belonging to William Gilpin, described Carwitham as a pupil of Thornhill, a suggestion amply supported stylistically by the drawings themselves. The only date connected with Carwitham is on a sheet of studies of a river god in the Victoria and Albert Museum which is signed and dated 1713.

A. *An Illustration to Virgil's* Aeneid, *Bk. I* (Aeneas and Achates meet Venus disguised as a huntress, lines 305-334)
Pen and brown ink with brown wash; 5⅝" x 7⅛"
INSCR: vir. Æno. lib. 1.
PROV: Sir Bruce Ingram (Lugt 1405a)
ACQ: 1963 (Acc. No. 63.52.40)

B. *An Illustration to Ovid's* Metamorphoses, *Bk. III* (possibly lines 316-320)
Pen and brown ink with brown wash; 4¾" x 7⅜"
INSCR: Met lib. 3.
PROV: Sir Bruce Ingram (Lugt 1405a)
ACQ: 1963 (Acc. No. 63.52.39)

C. *An Illustration to Ovid's* Metamorphoses, *Bk. V* (Athena addressing the Muses, lines 250-255)

Pen and brown ink with brown wash; 4 15/16" x 7"
INSCR: Met. lib. 5.
PROV: Sir Bruce Ingram (Lugt 1405a)
ACQ: 1963 (Acc. No. 63.52.38)

COZENS, Alexander (ca. 1717-1786)

Alexander Cozens, after a long period of neglect, is now recognized as one of the most important and influential figures in early English landscape drawing. He was born about 1717 of English parents in Russia, where his father was a shipbuilder. Alexander was back in England at least by the early 1740's, although he returned to the Continent for visits more than once and was in Rome in 1746. Most of his career was spent as a drawing master, particularly at Christ's Hospital and Eton.

With one or two incidental exceptions, Cozens' artistic output is limited to landscape drawings. His subjects (especially in his mature work) are nearly always imaginary, and his use of color is sharply restricted. Most of his drawings are executed in gray wash, frequently reinforced by pen. The paper is often light brown in tone, a color achieved by tinting and/or varnish.

Cozens' landscapes appeal to the imagination through the evocative forms; but they also appeal in a more abstract sense through the visually stimulating play of light and shadow. Thus Cozens combined an interest in the imaginary mood landscape (which had its finest English manifestation in the drawings of Gainsborough) with the type of interest in chiaroscuro and irregular shapes that fascinated the "picturesque" school of late eighteenth-century English draftsmen.

Cozens, as well as drawing and teaching, wrote about art. His most famous publication is *A New Method of Assisting the Invention in Drawing Original Compositions of Landscape*. In this book he advocated a type of "blot" technique, free elaboration of shapes with pen or brush, as a means for stimulating the visual imagination.

A. *River Landscape with Buildings*
Pen and india-ink wash, heightened with white, on blue paper; 9½" x 14⅜"
Signed and dated (on mount) 1746
LIT: possibly, A. P. Oppé, *Alexander and John Robert Cozens* (London, 1952), p. 80
PROV: Gilbert Davis (Lugt 757a)
ACQ: 1959 (Acc. No. 59.55.369)

This is a comparatively early drawing, one of a group executed while Cozens was in Rome. A similar drawing with related buildings is in the British Museum (1867.10.12.8), but that study is on white paper. Another drawing of what appears to be the same building is illustrated in A. P. Oppé, "A Roman Sketch-book by Alexander Cozens" in *Walpole Society*, XVI (1928), Pl. XVII.

B. *View in a Wood*
Pen and brown wash on tinted paper; 4½" x 6" (including original mount)
Signed and dated (on mount) 1764
EXH: *Drawings by Old Masters* (Royal Academy, London, 1953), No. 434
LIT: A. P. Oppé, *Alexander and John Robert Cozens* (London, 1952), Pl. 9, p. 91; Francis W. Hawcroft, "A Water-colour Drawing by Alexander Cozens," *Burlington Magazine*, CII (1960), 486, n. 6.
PROV: T. R. C. Blofeld (?); Randall Davies; Gilbert Davis (Lugt 757a)
ACQ: 1959 (Acc. No. 59.55.372)

C. *Landscape with Ruins*
Pen and brown wash on varnished paper; 5⅞" x 7¾"
INSCR: 4 [upper left corner]
PROV: Mountbatten; Palmerston; Gilbert Davis (Lugt 757a)
ACQ: 1959 (Acc. No. 59.55.370)

D. *Landscape with Ruined Castle*
Pen and brown wash on varnished paper; 4" x 6⅛"
PROV: Mountbatten; Palmerston; Gilbert Davis (Lugt 757a)
ACQ: 1959 (Acc. No. 59.55.367)

E. *A Rocky Landscape*
Gray wash on tinted paper; 8½" x 11⅞"
INSCR: 6 [upper left]
EXH: Worcester, 1938; Victoria and Albert Mu-

seum, 1943; *Alexander Cozens* (The Tate Gallery, 1946), No. 47
PROV: Home Drummond-Murray; Sir Robert Witt (Lugt 2228b)
ACQ: 1961 (Acc. No. 61.20)

F. *Lake Scene*
Pen and brown wash on varnished paper; 6" x 7⅜"
LIT: Paul Oppé, *Alexander and John Robert Cozens* (London, 1952), pp. 91-92
PROV: Mountbatten; Palmerston; Gilbert Davis (Lugt 757a)
ACQ: 1959 (Acc. No. 59.55.366)

G. *Landscape with Ruined Temple*
Pen and brown wash on varnished paper; 6½" x 8"
INSCR: 42 [upper right corner]; c [upper left corner]
PROV: Mountbatten; Palmerston; Gilbert Davis (Lugt 757a)
ACQ: 1959 (Acc. No. 59.55.370)

H. *Tree with Seated Figure*
India-ink wash; 6¼" x 7¾" (9" x 10⅜" including mount)
Signed on mount
PROV: Gilbert Davis (Lugt 757a)
ACQ: 1959 (Acc. No. 59.55.371)

I. *Sunlit Bush*
Brown wash on mauve paper; 8¼" x 6⅞"
PROV: Gilbert Davis (Lugt 757a)
ACQ: 1959 (Acc. No. 59.55.365)

DAHL, Michael (1659?-1743), attributed to
Head of a Boy
Black chalk heightened with white on blue-gray paper; 13⅞" x 10⅛"
PROV: Sir Bruce Ingram (Lugt 1405a)
ACQ: 1963 (Acc. No. 63.52.115)

Dahl, an artist of Swedish birth, became Kneller's principal competitor as a portraitist during the late seventeenth and early eighteenth centuries.

This drawing was at one time attributed to Kneller, but it lacks his brisk, decisive handling and is closer in spirit to Dahl. It also has a general resemblance to some of Dahl's portraits: see, for instance, Wilhelm Nisser, *Michael Dahl* (Uppsala, 1927), Pl. VIII. But Dahl's personality as a draftsman is not yet clearly defined.

EDWARDS, George (1694-1773), attributed to

A. *Nut-hatch*
Watercolor; 10¾″ x 9″
INSCR: Nut-hatch at Thorndon Park 1740; [verso] Nut-hatch killed in Thorndon Park
PROV: Sir Bruce Ingram (Lugt 1405a)
ACQ: 1963 (Acc. No. 63.52.69)

George Edwards was a naturalist, particularly remembered for his books on birds.

Neither this nor the following drawing (which is clearly by the same hand) can be attributed to Edwards without reservation. The drawings do not appear directly associated with any of Edwards' engraved designs. Furthermore, they are not entirely characteristic of him in technique. These drawings are in watercolor, whereas Edwards normally worked in a more opaque body color. But in other respects the drawings resemble Edwards' style, and they date from a time (1740) when he was in the midst of gathering material for his various publications on birds.

B. *Smaller Cockatoo*
Watercolor; 10¾″ x 9″
INSCR: Smaller Cockato; [verso] The white parrot calld The Yellow Crested Cockato at Sr Charles Wagers / Smaller Cockato
PROV: Sir Bruce Ingram (Lugt 1405a)
ACQ: 1963 (Acc. No. 63.52.68)

ENGLISH SCHOOL (ca. 1680)

George Villiers, 2nd Duke of Buckingham
Black pencil and chalk heightened with white; 11⅞″ x 9″
PROV: Sir Bruce Ingram (Lugt 1405a)
ACQ: 1963 (Acc. No. 63.52.147)

There is no documentary evidence for either the attribution or identification of this drawing, but the relationship with established portraits of Buckingham is sufficiently close to justify retaining this connection. The drawing was at one time attributed to Edward Luttrell, but the technique is unusual for him, as he normally worked in pastels.

ENGLISH SCHOOL (ca. 1680)

A Young Man
Pastel; 10″ x 8⅛″
EXH: *Old Master Drawings from the Collection of Sir Bruce Ingram* (Colnaghi, London, Jan.-Feb. 1952), No. 52, illus.
PROV: Sir Bruce Ingram (Lugt 1405a)
ACQ: 1963 (Acc. No. 63.52.71)

This handsome and unusually accomplished portrait cannot be directly associated with any one of the late seventeenth-century English pastelists, but this is partly because the artistic personalities of these men are not yet clearly defined. Two possible candidates might be Henry Tilson (1659-1695) or Edmund Ashfield (fl. 1669-1690). In the Introduction to the 1952 Colnaghi catalog Paul Oppé suggested that T. Thrumpton (working ca. 1670) might be responsible for the drawing, but the technique is not very close to the signed pastels by Thrumpton in the Ashmolean and British Museums.

ENGLISH SCHOOL (late seventeenth century)

Plymouth Sound (Cattewater to extreme right, Drake's Island to extreme left, Mount Batten middle distance to right)
Pen and wash; 5¼″ x 11⅛″; paper bears watermark with arms of William III
INSCR: 11 [upper right corner]
PROV: Sir Joshua Reynolds (Lugt 2364); Sir Bruce Ingram (Lugt 1405a)
ACQ: 1963 (Acc. No. 63.52.178)

This drawing was at one time attributed to Francis Place, but although it is contemporary with him, it does not have all the characteristics of his style. Dr. F. Springell has suggested (in a letter to the Huntington Art Gallery) that the drawing is by the same hand responsible for two drawings in the Devonshire collection (under No. 67), a drawing in the Hollareum at Prague (No. 35), and a drawing belonging to the Staatliche Graphische Sammlung, Munich (No. 1106).

Another closely related drawing, also from the Ingram collection and also attributed to Place, was sold at Sotheby's Dec. 9, 1964, Lot 313.

ENGLISH SCHOOL (ca. 1700)

Sir John Moore, Lord Mayor of London
Pen and brown ink with gray wash; 10″ x 7¼″
INSCR: Sir John Moor, Lord Mayor of London.
1681; [numbered] 528
PROV: Richard Bull
ACQ: 1926 (in Richard Bull's extra-illustrated copy
of Burnet's *History of His Own Time*, III, facing
528)

The drawing is not closely related to known por-
traits of Moore in pose, but there seems no reason
to doubt the accuracy of the old inscription. There
are two full-length statues of Moore, one by Grin-
ling Gibbons (now at Horsham, Sussex) and one
by Sir William Wilson (at the Appleby School,
Leicester). Neither statue resembles the Hunting-
ton drawing closely, but the drawing might be an
idea connected with one or the other. The draw-
ing is not close enough stylistically to the work of
Gibbons to justify an attribution to him on that
basis. Drawings by Sir William Wilson appear to
be unknown.

ENGLISH SCHOOL (second quarter of the eighteenth century)

Alexander Pope
Black chalk heightened with white; touches of pen
and wash on the head; 8½″ x 6½″
INSCR: [in a later hand] Alex Pope Port.
PROV: Dr. Max A. Goldstein; Bruce Bradford
ACQ: 1967 (Acc. No. 67.7)

This interesting drawing is sufficiently closely re-
lated to known portraits of Pope to justify retain-
ing the old identification. The cramped position
of head on hand is one (judging from other por-
traits) which he liked to assume, and the position
and pose of the torso suggest a deformity similar
to Pope's. The face has not been worked out in
any detail, but the general proportions are those
of Pope's head as it has been recorded in numerous
drawings by Richardson (see William Kurtz Wim-
satt, *The Portraits of Alexander Pope* [New
Haven, 1965], Ch. viii). Among the finished por-
traits of Pope the closest affiliations of the Hunt-
ington drawing are with the full length by Charles
Jervas (Fig. 4) and the three-quarter length by
Richardson (Wimsatt 3.2 and 9.2). The draw-
ing is close enough to the Jervas, except for the
position of the legs, that it might be a preliminary

idea for that portrait. Unfortunately there are
no known drawings by Jervas for comparison.
Normally Richardson's drawings are more finicky
in technique than the Huntington study, but he
could be broader on occasion, and it is not impos-
sible that the study may be by him.

FABER, John I (ca. 1650-1721)

Little is known about Faber's life. He is said to
have been born in The Hague. Certainly he was
settled in England by 1698, and he may have
visited that country earlier.

Most of his known work is in the form of
miniature portrait drawings. The two in the

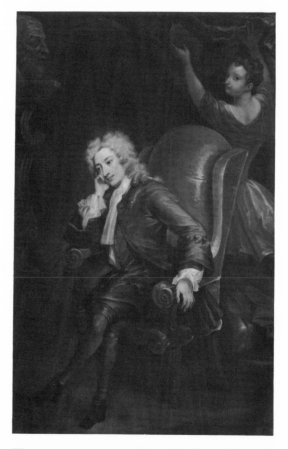

Fig. 4. CHARLES JERVAS, *Alexander Pope* (National
Portrait Gallery, London)

Huntington collection are both executed in pen and ink, a technique well established in the Low Countries. Later in his career Faber also adopted the pencil (or plumbago) technique which was more popular in England (see Loggan, White, and Forster).

A. *Queen Anne*
Pen and black ink, highly finished, on vellum, 4¾″ x 4″ (oval)
INSCR: Anna. D. G. Angl. Scot. Fran. & Hiber. Regina. A. 1705 J. Faber penna fecit 1705
PROV: Sir Bruce Ingram (Lugt 1405a)
ACQ: 1963 (Acc. No. 63.52.72)

This drawing appears to be adapted from a portrait of Queen Anne by Sir Godfrey Kneller. Another drawing by Faber of Queen Anne is in the British Museum, but it has a different arrangement for the hair and accessories.

B. *John, Duke of Marlborough*
Pen and black ink, highly finished, on vellum; 5¼″ x 4¼″ (oval)
INSCR: His Excell: John Duke of Marlborough, Marquis of Blandford etc. Captain Genl. of all Her Majties Forces and Knight of the Garter J. Faber Ao 1705 June 12
PROV: Sir Bruce Ingram (Lugt 1405a)
ACQ: 1963 (Acc. No. 63.52.73)

The drawing must derive ultimately from a portrait of Marlborough by Kneller. However, it does not appear to be directly copied from any known portrait. The closest Marlborough print located is one by P. Schenck, Amsterdam, 1705. But it is not clear whether this appeared before Faber's drawing. Another closely related drawing of Marlborough by Faber is in the Sutherland Collection at the Ashmolean Museum. The last digit of the date on the Ashmolean drawing is not clear; it appears to be "3," but could be "5."

FAITHORNE, William (1616?-1691), attributed to

Self-portrait
Pencil and india-ink wash; 10¼″ x 6⅝″ (edges have been reinforced and slightly extended) on paper with unrecorded watermark but of a mid- or late seventeenth-century type

ENGR: by John H. Robinson in the 1862 edition of Horace Walpole's *Anecdotes of Painting in England*, III, facing 909
LIT: Louis Fagan, *A Descriptive Catalogue of the Engraved Works of William Faithorne* (London, 1888), p. 90, as follows: "10¼ in. x 6⅝ in. The original drawing, by himself, from which the engraving by H. Robinson was made for 'Walpole's Catalogue of Engravers.' Bust, turned to the left, but looking towards the spectator. Indian ink. In Mr Alfred Morrison's collection."
PROV: Alfred Morrison; Sir Bruce Ingram (Lugt 1405a)
ACQ: 1963 (Acc. No. 63.52.74)

Faithorne is known primarily as an engraver and enjoys a justly high reputation in that field. He had his initial training in England but spent some time in France in the late 1640's, when he may have worked with both Philippe de Champaigne and Robert Nanteuil.

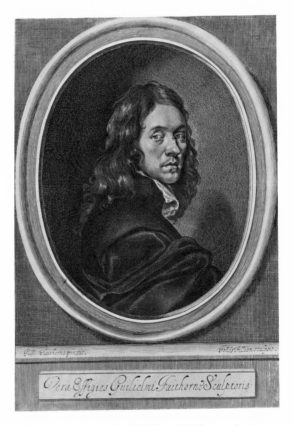

Fig. 5. JOHN FILLIAN, *William Faithorne* (engraving after a self-portrait)

Faithorne's drawings are usually portraits, either in pastels or in a combination of pencil and india-ink wash. The Huntington drawing is related (in reverse) to the Fillian engraving of Faithorne which was based on an early self-portrait (Fig. 5). But the drawing is not close enough to the print to have served as the source. There are many minor differences, and the overall impression of the face is younger in the drawing. The technique is tighter than in most Faithorne drawings. Possibly the drawing is a contemporary copy after a lost original. In the absence of any such original, the quality, age, and iconographic connections of the Huntington drawing justify an attribution to Faithorne himself.

FERGUSON, James (1710-1776)

Ferguson was of Scottish birth and very humble origins. He achieved a reputation as an astronomer and also as a miniaturist. His drawings, which seem all to be in india ink, have frequently been attributed to Bernard Lens III. Lens, however, does not appear to have drawn this type of monochrome miniature portrait. Ferguson seems not to have been active as a draftsman after the 1750's.

A. *Portrait of Mrs. Hooth*
India-ink wash on vellum; 3⅛" x 2⅜" (oval)
PROV: Richard Bull; Estelle Doheny
ACQ: 1951 (in Bull's Granger, gift of Estelle Doheny, XXXIV, 31v)

The identification of the sitter as Mrs. Hooth rests on a pencil inscription on the page on which the drawing is mounted in Bull's Granger. The inscription is presumably by Richard Bull and should be respected. Nothing is known about Mrs. Hooth. The artist is not identified by Bull; the drawing, however, is consistent in style with those attributed to James Ferguson in the Victoria and Albert Museum and in the British Museum.

B. *Portrait of a Woman*
India-ink wash on vellum; 3 3/16" x 2½" (oval)
PROV: G. C. Williamson; Sir Bruce Ingram (Lugt 1405a)
ACQ: 1963 (Acc. No. 63.52.132)

FORSTER, Thomas (born ca. 1677, working till after 1712)

Virtually nothing is known of Forster's life. He is one of the latest, as he is also one of the most accomplished, of the artists who drew miniature portraits in pencil (plumbago) on vellum (see also Loggan and White). His drawings have great elegance, delicacy, and decorative appeal.

A. *Portrait of a Man* (said to be Joseph Addison)
Black lead on vellum; somewhat rubbed, and apparently varnished; 3½" x 2 13/16" (oval)
INSCR: T. Forster delin 1698
EXH: Victoria and Albert Museum, 1914-1918
LIT: *Catalogue of the Miniatures and Portraits in Plumbago or Pencil belonging to Francis & Minnie Wellesley* (London, [1926?]), p. 49
PROV: Hodgkins; Wellesley; Sir Bruce Ingram (Lugt 1405a)
ACQ: 1963 (Acc. No. 63.52.78)

The tentative identification of the sitter as Addison, suggested in the Wellesley catalog, does not have much visual evidence to support it. The nose and mouth resemble those of Addison (especially in the Richardson portrait at Althorp), but the cheeks and jaw are much heavier, and the forehead somewhat lower.

B. *Portrait of a Man*
Black lead on vellum; 4½" x 3½" (oval)
INSCR: T. Forster delin. 1703
ILLUS: J. J. Foster, *Samuel Cooper and the English Miniature Painters of the XVII Century* (London, 1914-16), p. 88 (there identified as John, Duke of Marlborough, and given as in Lord Tweedmouth's collection); J. J. Foster, *Miniature Painters* (London, 1903), Vol. II, Pl. cxxii, No. 218
PROV: Lord Tweedmouth; Sir Bruce Ingram (Lugt 1405a)
ACQ: 1963 (Acc. No. 63.52.83)

J. J. Foster's identification of the sitter as the Duke of Marlborough does not seem to have any clear documentary or other support.

C. *Portrait of a Lady*
Black lead on vellum; 4½″ x 3½″ (oval)
INSCR: T. Forster delin 1703
PROV: Sir Bruce Ingram (Lugt 1405a)
ACQ: 1963 (Acc. No. 63.52.82)

D. *Portrait of a Young Woman*
Black lead on vellum; 4⅜″ x 3⅜″ (oval)
INSCR: T F 1668 [? or 1708]
PROV: Sir Bruce Ingram (Lugt 1405a)
ACQ: 1963 (Acc. No. 63.52.80)

The inscription appears to have been tampered with, and the date 1668 (on the basis of dress and hair style) is patently false. The drawing, however, is entirely characteristic of Forster and probably comes from the first decade of the eighteenth century.

E. *Portrait of a Young Lady*
Black lead on vellum; 4½″ x 3½″ (oval)
INSCR: T. Forster delin 1706
PROV: Sir Bruce Ingram (Lugt 1405a)
ACQ: 1963 (Acc. No. 63.52.79)

F. *Portrait of a Woman*
Black lead on vellum; 4¼″ x 3¼″ (oval)
INSCR: T Forster delin. 1707
EXH: *The Works of British-born Artists of the Seventeenth Century* (Burlington Fine Arts Club, London, 1938), No. 70
PROV: G. C. Williamson; Sir Bruce Ingram (Lugt 1405a)
ACQ: 1963 (Acc. No. 63.52.81)

GRAVELOT, Hubert François (1699-1773)

Two Women Standing in a Boudoir
Pen and gray wash; 2⅞″ x 4″
ENGR: in reverse, by G. Bickham as "On Guardians Power" in *Songs in the Opera Flora* (1737)
PROV: Gilbert Davis (Lugt 757a)
ACQ: 1959 (Acc. No. 59.55.614)

Gravelot, a mid-eighteenth-century French illustrator, is often included with English artists because he spent a considerable portion of his career in England (from about 1732 to 1745 and again in the early 1750's). Gainsborough studied with him in the 1740's. Gravelot should be regarded as one of the principal channels through which some of the elegance of the French rococo entered English art, particularly book illustration.

The Huntington drawing is for a series of head-pieces to *Songs in the Opera Flora*, one of the more ambitious of Gravelot's illustrated books from his English period. Other drawings connected with the project are in the Metropolitan Museum, the British Museum, and the collection of H. A. Hammelmann. I am indebted to Mr. Hammelmann for identifying the book for which the Huntington drawing was engraved.

GREENHILL, John (ca. 1640-1676)

Countess of Gainsborough
Colored chalks; 9⅞″ x 7½″
EXH: *Art Treasures* (Manchester, 1857)
LIT: Lionel Cust, "John Greenhill," in *Dictionary of National Biography*; Ellis K. Waterhouse, "John Greenhill," in *Old Master Drawings*, XI, No. 44, p. 70; *British Portraits* (Royal Academy, London, 1956), under No. 562
PROV: John Tollemache; Sir Bruce Ingram (Lugt 1405a)
ACQ: 1963 (Acc. No. 63.52.90)

Greenhill studied and worked with Lely during the early 1660's. About 1667 he set up as a portrait painter on his own. He achieved quick recognition and numbered many important people among his sitters. His drawings are rare and are usually in pastels, very much in the manner of Lely. The Huntington drawing is apparently one of two mentioned by Cust as at Peckforton (the other now in the Victoria and Albert Museum) which Waterhouse was unable to trace.

There is a smudged area in the lower left corner of the drawing which may have contained Greenhill's monogram, with which he frequently signed his portraits. What appears to be the date (1669) is still faintly discernible in this corner. An old label on the backboard stated: "Countess of Gainsborough / Greenhill fecit in Drury Lane / 1669." Actually Edward Noel, 1st Earl of Gainsborough, was not elevated to that title until Dec. 1, 1682. He had married Lady Elizabeth Wriothesly, May 1, 1661.

28

HAWKSMOOR, Nicholas (1661-1736)

Project for the West Wall of the Hall at Blenheim

Pen and gray wash over pencil; 13½" x 16⅞"

LIT: Kerry Downes, "Two Hawksmoor Drawings," *Burlington Magazine*, CIII (1961), 279-280, fig. 107

PROV: Alan G. Thomas (who acquired it at Sotheby's Nov. 30, 1960, Lot 14)

ACQ: 1961 (Acc. No. 61.9)

Hawksmoor is one of the major English architects, particularly connected with the brief but brilliant flowering of "English Baroque" at the turn of the seventeenth to the eighteenth century. He is closely involved with Sir John Vanbrugh, with whom he evidently cooperated on many projects. The Huntington drawing for Blenheim, which is primarily Vanbrugh's creation, is an instance of this cooperation.

Downes dates the drawing to the winter of 1706-07 and relates it to a group of drawings for the south and west walls of the Hall. "The major difference between most of the drawings . . . and the building is that in the final design the southernmost bay is separated from the rest of the hall by a proscenium arch and is not carried up to the clerestory."

HAYMAN, Francis (1708-1776)

The State of Great Britain with Regard to Her Debt (an allegorical illustration)

Pen and gray wash; scored; verso blackened for transfer; 8¼" x 6¾"

ENGR: in reverse, by C. Grignion in Jonas Hanway, *An Historical Account of the British Trade over the Caspian Sea*, II (London, 1753), facing 308. The "Explanation of the Copper Plates in this Work" describes the design as "Emblematical description of the state of Great Britain with regard to her debt."

PROV: Sir Bruce Ingram (Lugt 1405a)

ACQ: 1963 (Acc. No. 63.52.97)

Hayman was a versatile artist, active and influential in many ways. He is still best known today as a painter of "conversation piece" group portraits and as the probable teacher of Gainsborough in this genre. He was also active as a painter of large-scale narrative and historical pictures, and as a book illustrator. His drawings, especially for illustrations, are normally in pen and monochrome wash, similar to (but distinctly coarser than) those of Gravelot.

The engraving based on the Huntington drawing accompanies a chapter in Hanway's book subtitled: "Comparison of the debt of the United Provinces with that of Great Britain. The situation of British subjects in regard to their debt. The reduction of national interest. Moral reflections on the motives to economy."

I am indebted to Mr. H. A. Hammelmann for identifying the book for which the Huntington drawing was engraved.

HOGARTH, William (1697-1764), attributed to

Gin Lane

Black pencil over sanguine; 16¼" x 12 9/16"

INSCR: [lower left corner] 1751 / WH; [on coffin suspended as a sign] WH; [on gin pot] Royal Gin; [above door to right] Gripeall Pawnbrok . . . ; [verso] To Lady M Montagu

ENGR: in reverse, with minor variations, presumably by Hogarth himself, in 1751

LIT: *A Catalogue of Woodcuts and Engravings in the Huth Library* (London, 1910), p. 89 and facing plate; *Hogarth's Graphic Works*, compiled with a commentary by Ronald Paulson (New Haven, 1965), I, 209

PROV: Alfred Henry Huth

ACQ: 1910 (Acc. No. 64.15)

Hogarth, one of the most brilliant and original of all British painters, makes a much less impressive showing as a draftsman. His drawings are rare, but not necessarily of high quality. Many of those that are known are working studies for engravings and are frequently rather tight in handling.

The Huntington drawing is frankly a puzzle for which no clear solution has yet been found. In technique it is unlike most of Hogarth's autograph work. Nevertheless, it seems probable that he at least had a hand in the execution of the drawing. There is another drawing of the same subject in the Morgan Library (Fig. 6). Both the Morgan and Huntington studies are the reverse of the print (Fig. 7); they differ in many details from the print and from each other; there seems no reason to doubt that both drawings must precede the print.

In most of the variations between the drawings the Huntington example is closer to the print. Several figures that are entirely absent from the Morgan sketch appear in both the Huntington drawing and the print. But there are also several pentimenti in the Huntington study that have no counterpart in either the Morgan drawing or the print: the right leg of the seated female figure was first placed at a different angle; the dog beside the man in the lower left was first drawn in and then replaced by a keg; the posts at the head of the stair were surmounted by balls, the one to the left being later removed.

There are too many basic variations between the two drawings for one to be considered a tracing of the other. And there are too many basic variations between the Huntington drawing and the print for the former to be dismissed as an engraver's study. In any event the print may have been engraved by Hogarth himself (Paulson,

Fig. 7. WILLIAM HOGARTH, *Gin Lane* (engraving)

p. 206), as no other name appears on the plate. But there is a hard, mechanical quality about many of the lines in the Huntington drawing that is unlike Hogarth's own draftsmanship. The most satisfactory explanation is that the drawing, having obviously been extensively abraded and smudged at some point, has been rather heavily reinforced by some later hand.

The inscription on the verso, "To Lady M Montagu," remains a puzzle. It does not seem possible that it could refer to Lady Mary Wortley Montagu, who was not living in England when the print and, presumably, the drawing were executed. Another possible candidate is Mary, later Duchess of Montagu, who seems to have been known as Lady Montagu.

Fig. 6. WILLIAM HOGARTH, *Gin Lane* (The Pierpont Morgan Library)

30

HOLLAR, Wenceslaus (1607-1677)

Hollar was born in Prague. He traveled and worked in many parts of Europe before coming to England in 1636 in the service of the Earl of Arundel. Thereafter, except for a few years during the Commonwealth, he worked either in England or for English patrons, principally as an engraver.

Most of Hollar's drawings are topographical views, and most of them are pen and ink with watercolor washes. He is much the most distinguished topographical draftsman working in seventeenth-century England and is the dominant influence on English topographical drawing until the middle of the eighteenth century.

A. *View of Rye*
Pen over pencil; 2⅜" x 5⅜"
INSCR: Rye; [verso] Rye, WH
EXH: *Masters of Maritime Art* (Colnaghi, London, 1937), No. 6
ENGR: by Hollar, inset in his map of Kent (Gustav Parthey, *Wenzel Hollar* [Berlin, 1853], p. 144, No. 665c)
LIT: *Illustrated London News*, CXC (March 20, 1937), 484-485; Horst Vey, *Die Zeichnungen Anton Van Dycks* (1962), I, 349-350
PROV: Sir Bruce Ingram (Lugt 1405a)
ACQ: 1963 (Acc. No. 63.52.106)

This drawing is apparently Hollar's preliminary study for the engraving of Rye on his map of Kent. The engraving is lettered: "Sr. Anthony Van Dyck Delineavit." The Huntington drawing appears to be Hollar's own adaptation from the larger, slightly more extended view of Rye by Van Dyck dated 1633, now in the Pierpont Morgan Library (Fig. 8).

B. *View of the Coast of Tangier, with Fortifications*
Pen and watercolor; 6⅞" x 22 1/16" (on two sheets joined together)
INSCR: At Tangier
EXH: *Drawings and Etchings by Wenceslaus Hollar* (Czechoslovak Institute, London, 1942), No. 30; *Wenceslaus Hollar* (City of Manchester Art Gallery, 1963), No. D 94
LIT: F. Sprinzels, *Hollar Handzeichnungen* (Vienna-Prague, 1938), No. 377a, fig. 303

PROV: Patrick Allan Fraser of Hospitalfield, Arbroath; Sir Bruce Ingram (Lugt 1405a)
ACQ: 1963 (Acc. No. 63.55.4)

"Tangier was the dowry of Charles II's Queen, Catherine of Braganza, but it was left by the Portuguese to the English navy to try to take firm possession of it. In order to achieve this, Lord Henry Howard, younger grandson of Hollar's patron Arundel, was sent on a mission to Tangier. His orders were to come to some agreement with the Moorish King El Rashed II Tafileta, but he did not even succeed in making personal contact with him. Hollar accompanied Lord Howard as 'His Majesty's scenographer, or designer of prospects' and stayed with the expedition for one and a half years until his return to England in December, 1669. A series of twelve prints by Hollar after drawings made in Tangier were published in 1673 to which Parthey adds three more undated ones. The number of surviving Tangier drawings is much larger. Fourteen are in the British Museum, and one in the Ashmolean" (*Wenceslaus Hollar* [Manchester], p. 34). There were in addition sixteen more drawings in the collection of Sir Bruce Ingram, of which eight are now in the Huntington Art Gallery.

C. *Part of Tangier along the Strand*
Pen and watercolor; 7 3/16 x 22 3/16" (on five pieces of paper glued together)
INSCR: Part of Tangier, along the Strand Opposite to Spaine / Yorke Castle / C. Malabata / the Bay
EXH: *Wenceslaus Hollar* (City of Manchester Art

Fig. 8. SIR ANTHONY VAN DYCK, *View of Rye* (The Pierpont Morgan Library)

Gallery, 1963), No. D 95 (mislabeled as "The Port of Tangier")
LIT: F. Sprinzels, *Hollar Handzeichnungen* (Vienna-Prague, 1938), No. 378a, fig. 307
PROV: Sir Bruce Ingram (Lugt 1405a)
ACQ: 1963 (Acc. No. 63.55.5)
See under B.

D. *The Mouth of the Straits of Gibraltar, toward the Levant*
Pen and watercolor; 3⅞" x 25¼" (on three sheets of paper glued together)
INSCR: The Mouth of the Straights of Gibraltar / toward the Levant, from Tangier Road. [The following places are also identified on the drawing, reading from left to right] Teriffa / Coast of Spaine / C. of Gibraltar / C. Alcassar / C. Malabata / Apes hill / Coast of Barbary / Part of the Bay of Tangier
EXH: *Masters of Maritime Art* (Colnaghi, London, 1936), No. 80a, illus.; *Old Master Drawings from the Collection of Sir Bruce Ingram* (Colnaghi, London, 1952), No. 6
LIT: F. Sprinzels, *Hollar Handzeichnungen* (Vienna-Prague, 1938), No. 383a, fig. 310
PROV: Sir Bruce Ingram (Lugt 1405a)
ACQ: 1963 (Acc. No. 63.55.1)
See under B.

E. *The Mouth of the Straits of Gibraltar, toward the West*
Pen and watercolor; 4" x 25" (on three sheets of paper glued together)
INSCR: The Mouth of the Straights of Gibraltar, toward the West from Tangier Road. [The following places are also identified on the drawing, reading from left to right] Tangier / Yorke Castle / Governors house / The Upper Castle / Peterborou Tower / Charles fort / Tiveots hill / Henrietta fort / Whitby / Cape Spartell / Part of Spaine
EXH: *Masters of Maritime Art* (Colnaghi, London, 1936), No. 80b, illus.; *Seventeenth Century Art in Europe* (Royal Academy, London, 1938), No. 534; *Old Master Drawings from the Collection of Sir Bruce Ingram* (Colnaghi, London, 1952), No. 5; *Wenceslaus Hollar* (City of Manchester Art Gallery, 1963), No. D 98
LIT: F. Sprinzels, *Hollar Handzeichnungen* (Vienna-Prague, 1938), No. 383b, fig. 311

PROV: Sir Bruce Ingram (Lugt 1405a)
ACQ: 1963 (Acc. No. 63.55.2)
See under B.

F. *Prospect of Yorke Castle*
Pen and watercolor; 6 11/16" x 22" (on two sheets of paper glued together)
INSCR: Prospect of Yorke Castle at Tangier, opposite to Spaine / from the Strand, Close under it, it being the North Side. [The following features of the drawing are also inscribed] the 3 Gunns in the Parade / part of the Upper Castle / the great Bastion / Way from Whitby, at Low Water
EXH: *Drawings from the Bruce Ingram Collection* (The Arts Council, London, 1946-47), No. 45; *Old Master Drawings from the Collection of Sir Bruce Ingram* (Colnaghi, London, 1952), No. 3
LIT: F. Sprinzels, *Hollar Handzeichnungen* (Vienna-Prague, 1938), No. 377b
PROV: Sir Bruce Ingram (Lugt 1405a)
ACQ: 1963 (Acc. No. 63.52.107)
See under B.

G. *Tangier: the Beach*
Pen over pencil (not fully worked out); 7⅞" x 24 7/16" (drawn within a ruled margin, on two pieces of paper glued together)
INSCR: At Tangier [partly trimmed off]
EXH: *Wenceslaus Hollar* (City of Manchester Art Gallery, 1963), No. D 103, Pl. VII
LIT: F. C. Springell, "Unpublished Drawings of Tangier by Wenceslaus Hollar," *Burlington Magazine*, CVI (1964), 69-74, fig. 25
PROV: Sir Bruce Ingram (Lugt 1405a)
ACQ: 1963 (Acc. No. 63.55.6)
See under B.

H. *View of Tangier*
Pen over pencil (not fully worked out on left); 7 15/16" x 23⅞" (drawn within a ruled margin, on two pieces of paper glued together)
INSCR: At Tangier
EXH: *Old Master Drawings from the Collection of Sir Bruce Ingram* (Colnaghi, London, 1952), No. 2, illus.; *Wenceslaus Hollar* (City of Manchester Art Gallery, 1963), No. D 102
LIT: F. C. Springell, "Unpublished Drawings of Tangier by Wenceslaus Hollar," *Burlington Magazine*, CVI (1964), 69-74, fig. 24
PROV: Sir Bruce Ingram (Lugt 1405a)

ACQ: 1963 (Acc. No. 63.55.7)
See under B.

I. *Tangier Fortifications* (partly duplicates the view in No. B, continuing to right)
Pen and watercolor; 6 11/16″ x 23¾″ (on two sheets of paper glued together)
INSCR: At Tangier
EXH: *Wenceslaus Hollar* (City of Manchester Art Gallery, 1963), No. D 97
LIT: F. Sprinzels, *Hollar Handzeichnungen* (Vienna-Prague, 1938), No. 381a, fig. 305
PROV: Sir Bruce Ingram (Lugt 1405a)
ACQ: 1963 (Acc. No. 63.55.3)
See under B.

KENT, William (1684-1748)

An Illustration to Spenser's Faerie Queene
Pen and wash; 7 3/16″ x 11 1/16″ (the drawing within ruled borders 6½″ x 9¼″)
SIGNED AND INSCR: Wm Kent Invt / 6 Book 9th Canto / ye sixth Book old Melibee ask ye Shepheard assist fair Pastorella home to Drive her fleecy flock / Sr Calidore / Corridon / Pastorella & attendance Old Melibee inviting Calidore to his Cottage / 32
ENGR: in reverse, Edmund Spenser, *The Faerie Queene* (London, 1751), III, between 334 and 335. Aside from the reversal, the print follows the drawing closely and is of approximately the same size.
PROV: Sir Bruce Ingram (Lugt 1405a)
ACQ: 1963 (Acc. No. 63.52.114)

Kent was an artist of many parts: architect, designer, landscape gardener, decorative painter, and illustrator. He was closely associated with Lord Burlington and wielded great influence through that arbiter of taste. Kent is now remembered primarily as an architect. His drawings, mostly in pen and monochrome wash, belong to the late baroque tradition of which Thornhill is the primary English exponent. Twenty-five additional drawings by Kent for the *Faerie Queene* are in the Victoria and Albert Museum.

KNAPTON, George (1698-1778)

George, Prince of Wales (later George III), his brother Edward, Duke of York, with Lord Harcourt and Mr. Scott

Black chalk heightened with white on buff paper; 16″ x 19¾″
ACQ: 1966 (Acc. No. 66.24)

A handwritten early label, previously on the back of the old mount, gives the following information: "Sketch for a Picture by Knapton. The Persons represented are George Prince of Wales—afterwards King George the Third—& his Brother Edward Duke of York Simon Earl Harcourt / Their Governor Mr. Scott- / Sub Governor. The Drawing is particularly valuable as the Figures were drawn from Life—but the Picture was never Executed."

The information given by the label fits well enough with historical circumstances, and there seems little doubt that it is substantially correct. The date of the drawing is probably late 1751 or early 1752. Harcourt was appointed governor of the prince in April 1751 after the death of his father, Frederick, Prince of Wales. Scott was actually the prince's subpreceptor: the subgovernor was a man called Andrew Stone. Before the end of 1752 a feud broke out between Harcourt and the two tutors; and this may explain why no painting was ever developed from the drawing.

Knapton's most ambitious work, a group portrait of the widowed Princess of Wales and her family, was painted in 1751. The two boys are included in the large painting.

Drawings by Knapton are apparently rare, and there are no examples available that would make a useful comparison. The technique of the drawing suggests that the artist was accustomed to working in pastel, and this was a favorite medium with Knapton.

KNELLER, Sir Godfrey, Bart (1646- or 1649-1723)

Portrait of a General (traditionally said to be the Duke of Schomberg)
Red chalk, heightened with black and white, on buff paper; 11½″ x 9¾″
PROV: Sir Bruce Ingram (Lugt 1405a)
ACQ: 1963 (Acc. No. 63.52.116)

Kneller is the most important painter active in England between the death of Lely and the emergence of Hogarth. He was born in Lübeck and received his early training with Rembrandt's follower, Ferdinand Bol, in Amsterdam. Kneller came

Fig. 9. GEORGE LAMBERT, *Chiswick House* (Devonshire Collection, Chatsworth)

to London first in 1675 and definitely settled in England in the mid-1680's.

Kneller's drawings are still not entirely separated from those of his contemporaries working in a similar style. At its best his draftsmanship is brisk, crisp, and decisive, with a firm grasp of three-dimensional form.

The Huntington drawing does not appear to be connected with a known portrait of the Duke of Schomberg. The face is not sufficiently particularized to settle the identification one way or the other.

LAMBERT, George (1700-1765), attributed to

Lambert is one of the most important figures in early English landscape painting, but his position and personality as a draftsman are not clear. He is known to have collaborated with other artists (including Hogarth) in his paintings, and (according to evidence transcribed by Iolo Williams, *Early English Watercolours* [1952], p. 23) this collaboration extended even to drawings—all of which greatly complicates the problem of attribution.

A. *View of Chiswick House*

Pen and gray wash over preliminary pencil; 12¾" x 21 1/16"
PROV: Sir Bruce Ingram (Lugt 1405a)
ACQ: 1963 (Acc. No. 63.52.120)

This would appear to be the preliminary drawing for a well-known painting of Chiswick House by Lambert, with figures possibly by Hogarth (Fig. 9). The figures are absent from the drawing. The painting (which is signed and dated 1742) was lent by the Duke of Devonshire to the *British Country Life Exhibition* of 1937, No. 51. Aside from the figures, there are a few minor differences between the drawing and painting of the building. In the drawing the chimneys are shown surmounted by pots, which are absent in the painting. The urns in front of the hedge in the painting are not present in the drawing.

Under the circumstances it is logical to assume that the Huntington drawing is by Lambert. It should be pointed out, however, that drawings in very much the same style (but of different subjects) exist in the British Museum (1893-5-16-395) by Luke Sullivan, and in the Victoria and Albert Museum (D 259.90) by J. Rocque (see under B). Lambert's known collaboration with other artists only complicates the problem further.

34

B. *View of the Bowling Green at Claremount, Surrey*

Pen and wash; 9⅜" x 15½" (on two sheets of paper glued together)

INSCR: A view of the Bowling Green

PROV: Gilbert Davis (Lugt 757a)

ACQ: 1959 (Acc. No. 59.55.1308)

This drawing is clearly by the same hand as C. Both have been identified by Mr. John Harris (in a letter to the Huntington Library) as representations of the gardens at Claremount in Surrey. These were designed by Vanbrugh and later embellished by Kent. The Vanbrugh Belvedere is in the center distance.

Stylistically this and the following drawing are related to the View of Chiswick attributed to Lambert. All three may be by the same hand. It is probable, however, that the figures and animals in this and the following drawing are by another artist. Lambert is known to have used other artists to execute the figures in his paintings.

A French engraver, J. Rocque, produced some plans and views of Claremount in the late 1730's. It is entirely possible that the two Huntington drawings may be connected with Rocque's project, and that he may have had some hand in their execution. A closely related drawing of the same view, but much more highly finished and generally more competent, is in the Victoria and Albert Museum (D259.90), there given to Rocque. In the V. and A. drawing there is not the same inconsistency between figures and landscape that one finds in the two Huntington drawings.

C. *View in the Park at Claremount, Surrey*

Pen and wash; 9⅜" x 15½"

PROV: Gilbert Davis (Lugt 757a)

ACQ: 1959 (Acc. No. 59.55.1347)

See under B.

A related painting was in a Sotheby sale, Nov. 23, 1966, Lot 48, listed as English School ca. 1740.

LAROON, Marcellus, the Younger (1679-1772)

Laroon is known primarily as a figure draftsman of small-scale portrait groups. His drawings are more numerous than his paintings, the latter retaining very much the character of drawings. His line is highly personal, rather fussy and nervous, but decorative.

A. *A Musical Party*

Pencil; 10⅝" x 8¼"

INSCR: The finished Drawing for Mr. Bendall Martyn 1733 / Secretary to the Excise

EXH: *Marcellus Laroon* (Blairman and Sons, London, 1951), not in catalog

LIT: Robert Raines, *Marcellus Laroon* (London, 1966), No. 51, Pl. 18

PROV: Clifford Duits; Sir Bruce Ingram (Lugt 1405a)

ACQ: 1963 (Acc. No. 63.52.127)

The inscription is ambiguous. It may mean that this is the finished drawing, or that a more finished drawing based on this one was made for Mr. Martyn. The latter interpretation seems more probable, as a more finished drawing of the same subject does exist in the Fitzwilliam Museum, Cambridge (see Raines, No. 50). Bendall Martyn, as well as being Secretary of the Excise, was a talented musician (see Raines, p. 54).

B. *A Family Group*

Pencil; 8¾" x 12½"

INSCR: Father & five Sons. Eldest artist [?] .2d in ye army, two at Sea / Capt. Laroon

EXH: *Marcellus Laroon* (Whitechapel Art Gallery, London, Spring 1906), No. 12

LIT: Robert Raines, *Marcellus Laroon* (London, 1966), No. 84, Pl. 14

PROV: Sir Edward Marsh; Gilbert Davis (Lugt 757a)

ACQ: 1959 (Acc. No. 59.55.801)

The group has some stylistic affinities with two drawings by Laroon both signed and dated 1732/3 (see *Connoisseur*, LXXIV, 9). The drawing was at one time thought to represent members of the Laroon family. But the date is too late for the elder Laroon (who, in any event, had only three sons). Marcellus did not marry.

C. *The Morning Ride*

Pen and wash; 14⅝" x 11"

Signed and dated 1770

EXH: *British Water Colours and Drawings from the Gilbert Davis Collection* (The Arts Council, London, 1949), No. 1, Pl. I

LIT: Robert Raines, *Marcellus Laroon* (London, 1966), No. 66, Pl. 70
PROV: Viscount Knutsford; Gilbert Davis (Lugt 757a)
ACQ: 1959 (Acc. No. 59.55.802)

LELY, Sir Peter (1618-1680)

Lely is the major painter active in England during the reign of Charles II. He was born in Westphalia, studied in Haarlem, and probably came to England in 1641. Lely's drawings are of several types. Probably the best known are bust-length portraits in colored crayons. Although these are much freer and lighter in handling than most late-seventeenth-century English pastels, Lely seems to have regarded them as self-contained, finished portraits. He also made drawings of hands and drapery that are presumably preparatory studies for portraits in oils, and he occasionally drew copies of existing portraits.

A. *Portrait of a Lady*
Pencil and colored chalks on brown paper; 10⅝" x 7⅞", mounted on paper 16½" x 13½" with drawn enframement
INSCR: [on mount] Sir Peter Lely
EXH: *Old Master Drawings from the Collection of Sir Bruce Ingram* (Colnaghi, London, 1952), No. 45, illus.
PROV: Mrs. E. A. Craufurd; Sir Bruce Ingram (Lugt 1405a)
ACQ: 1963 (Acc. No. 63.52.130)

B. *Study of a Woman's Hands*
Colored chalks on brown paper; 11" x 7"
PROV: Sir Joshua Reynolds (Lugt 2364); Sir Bruce Ingram (Lugt 1405a)
ACQ: 1963 (Acc. No. 63.52.129)

There are many Lely portraits with the hands in a very similar relationship, but no one that appears to follow this drawing precisely.

LOGGAN, David (1635-1692)

Although Loggan was born in Danzig and received his artistic training on the Continent, he was of Scottish descent. Loggan came to London in the later 1650's. He was active as a topographical draftsman, particularly at Oxford and Cambridge. His portrait drawings are in the plumbago miniature tradition, of which he is one of the most distinguished practitioners. Presumably he learned this technique in Holland and subsequently passed it on to his pupil Robert White.

A. *Portrait of a Man*
Black lead on vellum; 5¼" x 3⅞"
INSCR: D. Loggan delin. 1666; [also, below the oval in a later hand] Col Strangeways
PROV: Sir Bruce Ingram (Lugt 1405a)
ACQ: 1963 (Acc. No. 63.52.138)

The suggestion that this portrait represents Colonel Giles Strangeways of Melbury appears to be of recent date. Loggan did make a drawing of Strangeways which is now in the Ashmolean Museum and is the source for several engravings. The hair and the eyes are distinctly different from those of the man in the Huntington drawing. There does not in fact appear to be any reason for retaining the identification.

B. *Portrait of a Woman*
Black lead on vellum, the face lightly touched with wash; 5 13/16" x 4¾" (oval)
INSCR: D. L. 166- [last digit obliterated]
EXH: *The Works of British-born Artists of the Seventeenth Century* (Burlington Fine Arts Club, London, 1938), No. 93
PROV: G. C. Williamson; Sir Bruce Ingram (Lugt 1405a)
ACQ: 1963 (Acc. No. 63.52.136)

Dr. Williamson, who owned this drawing at one time, was of the opinion that it represents Oliver Cromwell's mother and is connected with a portrait of her at Hinchinbrooke. The connection with the Hinchinbrooke picture is in fact slight; also the date on the drawing would seem to preclude any direct relation to Elizabeth Cromwell, who died in 1654.

C. *Charles, 6th Duke of Somerset*
Black lead on vellum, the face lightly touched with wash; 4 7/16" x 3¾" (oval)
INSCR: D. L. Delin. 1682
PROV: G. C. Williamson; Sir Bruce Ingram (Lugt 1405a)
ACQ: 1963 (Acc. No. 63.52.137)

The identification of the sitter was apparently suggested by Dr. Williamson. Certainly the resemblance to the full length of the duke by John Riley at Petworth is sufficiently close to justify retaining the connection.

LUTTRELL, Edward (working from about 1673, died after 1723)

Portrait of a Man
Pastel; 15″ x 12″
SIGNED: E Luttrell fe
PROV: Sir Bruce Ingram (Lugt 1405a)
ACQ: 1963 (Acc. No. 63.52.148)

Very little is known about Luttrell's life. He may have been born in Dublin, but he settled in London early in his career. He was one of the pioneers in the development of the mezzotint. Most of his drawings are pastel portraits, rather on the crude and heavy side.

OLIVER, Peter (1594-1647)

Peter was the eldest son of Isaac Oliver and (like his father) was primarily a miniaturist. He exe-

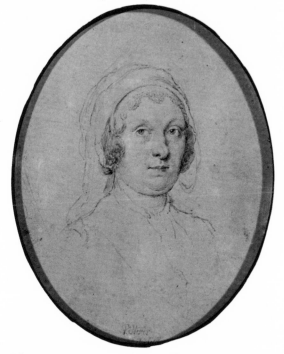

Fig. 10. PETER OLIVER, *Mrs. Oliver* (The Earl of Derby)

cuted miniature narrative pictures and copies after old masters as well as portraits.

A. *Portrait of a Lady* (Mrs. Oliver?)
Pen and brown ink with gray wash; 4″ x 3¼″ (oval)
PROV: According to a note appended to the drawing by G. C. Williamson, it was supposed to have been in the Solly collection (sold in 1940) and previous to that at Welbeck Abbey; G. C. Williamson; Sir Bruce Ingram (Lugt 1405a)
ACQ: 1963 (Acc. No. 63.52.162)

This drawing and the following bear a close relation to the signed portrait in the Earl of Derby's collection, said to represent the artist's wife (Fig. 10).

B. *Portrait of a Lady* (Mrs. Oliver?)
Pen and brown ink with brown wash; 3½″ x 2¾″ (oval)
PROV: as for the preceding
ACQ: 1963 (Acc. No. 63.52.161)

PENN, Stephen (dates unknown; active ca. 1730)

A Prospect of the Ruins of the Castle of Pile of Fouldry
Pen and watercolor; 11⅞″ x 18″
Signed and dated 172[8?]
INSCR: [in scroll at top] A Prospect of the Ruins of the Castle of Pile of Fouldry and the adjacent Islands taken from Ramside. [The features of the drawing are numbered and itemized below as follows] 1. Ramside; 2. Pile of Fouldry; 3. Walney Island; 4. Fordney Island; 5. Rhode Island; 6. St. Michaels I.; 7. Farther point of; 8. Leverpool Harbour; 9. Lancaster Castle; 10. Peel Harbour
PROV: Sir Bruce Ingram (Lugt 1405a)
ACQ: 1963 (Acc. No. 63.52.170)

Very little is known about this artist, evidently an amateur topographical draftsman, most of whose known drawings are associated with the Lake District (see Iolo Williams, *Early English Watercolours* [1952], p. 19).

The area represented is in the vicinity of Barrow and Walney Island, Lancashire, close to the Lake District. The spellings of many of the place names have now changed.

PLACE, Francis (1647-1728)

Place is thought of primarily as a topographical draftsman, following the manner of Hollar, whom he greatly admired although he was not actually Hollar's pupil. Place lived much of his life at York. He was not dependent on his art for his livelihood, but he took his work seriously, accepted commissions, and collaborated as a printmaker with both Hollar and Griffier. He was also an early experimenter with mezzotint.

His drawings are normally in pen and wash. The strictly topographical ones are close to Hollar, but the line is finer, almost to the point of becoming finicky. The more general seascapes and views resemble contemporary Netherlandish work. Evidence offered by drawings in the Huntington collection (previously in the collection of Sir Bruce Ingram) indicates that Place may have visited the Low Countries. He also traveled extensively throughout the British Isles.

I am indebted to Mr. Richard E. G. Tyler for information relating to several of the drawings by Place in the Huntington collection.

A. *The Yacht, "Cleveland"*

Pen and sepia wash over pencil; 3½" x 8¼"
INSCR: The Cleviland Yacht
EXH: *Charles II Exhibition* (London, 1932); *The Works of British-born Artists of the Seventeenth Century* (Burlington Fine Arts Club, London, 1938), No. 112
PROV: Sir Bruce Ingram (Lugt 1405a)
ACQ: 1963 (Acc. No. 63.52.173)

"The Royal Yacht, *Cleveland,* named after the celebrated Barbara, Duchess of Cleveland, was built by Pepys's friend, Sir Anthony Deane, at Portsmouth in 1671. She had a tonnage of 107, and carried 8 guns and a crew of 30 men. In 1672, after the Battle of Sole Bay, Charles II paid a visit in her to the Fleet, which was lying in the Swin, a channel at the mouth of the Thames. The *Cleveland* was sold out of the Service in 1716" (quoted from *The Works of British-born Artists of the Seventeenth Century,* p. 48).

Horace Walpole in his *Catalogue of Engravers* mentions that Place was offered a pension by Charles II to draw the Royal Navy "but declined accepting it as he could not endure confinement or dependence" (see Horace Walpole, *Anecdotes of Painting in England* [London, 1862], III, 904).

B. *Ruins of Easby Abbey* (near Richmond, Yorkshire)

Pen and brown wash, with some pencil; 6" x 18¼" (on two sheets of paper glued together)
INSCR: pt of Easby abie
EXH: *Three Centuries of British Water-colours and Drawings* (The Arts Council, London, 1951), No. 136
PROV: Sir Bruce Ingram (Lugt 1405a)
ACQ: 1963 (Acc. No. 63.52.174)

Another drawing of Easby Abbey is in the British Museum (*British Drawings,* I [1960], 462), and yet another in the Whitworth Art Gallery, Manchester.

C. *Landguard Fort, Harwich*

Pen and india-ink wash slightly tinted with watercolor; 2½" x 9⅛"
INSCR: Langor fort by Harwich; [at the end of a long spit of land some buildings inscribed] Langer fort; [beyond the spit] ousley bay; [woods inscribed] part of Suffolke
EXH: *Masters of Maritime Art* (Colnaghi, London, 1936), No. 1; *The Works of British-born Artists of the Seventeenth Century* (Burlington Fine Arts Club, London, 1938), No. 111; *Three Centuries of British Water-colours and Drawings* (The Arts Council, London, 1951), No. 137
ILLUS: *Illustrated London News,* March 14, 1936
PROV: Patrick Allan Fraser; Sir Bruce Ingram (Lugt 1405a). Several of the drawings by Francis Place that were in Sir Bruce Ingram's collection seem previously to have been in the possession of Patrick Allan Fraser of Hospitalfield, a descendant of the artist (see *Transactions of the English Ceramic Circle,* III, No. 1, p. 65).
ACQ: 1963 (Acc. No. 63.52.176)

D. *West Gate, Newcastle*

Pen and brown ink with brown wash; 4 9/16" x 7⅛"
INSCR: [in ink] West gate Newcastle; [in pencil] the west port; [in a later hand in pencil] at Newcast—

PROV: Patrick Allan Fraser (?); Sir Bruce Ingram (Lugt 1405a)
ACQ: 1963 (Acc. No. 63.52.177)

E. *Scarborough Castle from the Beach*
Pen over pencil; 8⅜" x 11⅜"
INSCR: part of Scarborough Castle / with [a view?] of the Peere 1701
PROV: Patrick Allan Fraser; Sir Bruce Ingram (Lugt 1405a)
ACQ: 1963 (Acc. No. 63.52.181)

There are also drawings of Scarborough in the British Museum (*British Drawings*, I [1960], 465-466) and in a sketchbook by Place in the Victoria and Albert Museum (E 1496-1931), but these last date from 1717.

F. *Part of Scarborough Castle*
Gray wash over pencil; roundel 5" in diam. on sheet 7½" x 5¾"
INSCR: pt. of Scarborough Castle
PROV: Patrick Allan Fraser (?); Sir Bruce Ingram (Lugt 1405a)
ACQ: 1963 (Acc. No. 63.52.180B)

This drawing is apparently adapted from the preceding.

G. *A Tower at The Hague* (?)
Pen and brown wash; roundel 3¾" in diam. on sheet 4" x 4¾"
INSCR: One of ye Towers at ye Entrance of ye harbor of Heauke [?] / far ground; [verso, in a later hand] One of the Towers at the Entrance of the Harbour of the Hague
PROV: Patrick Allan Fraser (?); Sir Bruce Ingram (Lugt 1405a)
ACQ: 1963 (Acc. No. 63.52.180A)

The name of the town in the inscription is difficult to decipher and remains conjectural.

H. *View of a Town*
Pen and brown ink with gray wash; 4¾" x 7¾"
INSCR: [top left] The other side of the River a little below th Bridg; [top right, in pencil] A The Cathedrall / B The College / C The Towne Hall / E and Hospitall [this is evidently a key to the principal buildings in the drawing, although the buildings are not now lettered]; [bottom] High
EXH: *Stuart Drawings* (Bristol, 1952), No. 47

ILLUS: John Woodward, *Tudor and Stuart Drawings* (London, 1951), Pl. 57
PROV: Sir Bruce Ingram (Lugt 1405a)
ACQ: 1963 (Acc. No. 63.52.175)

This drawing was at one time considered to represent The Hague, but the buildings do not correspond to those in that city. Nevertheless, the view does appear to be in the Low Countries rather than in England and implies that Place visited the Continent. This suggestion is further supported by a view of Le Havre in the Leeds City Art Gallery.

I. *Ship in a Storm*
Pen and brown ink with gray wash; 7 11/16" x 12¼"; watermark Heawood 413 (?)
EXH: Masters of Maritime Art (Colnaghi, London, 1936), No. 6, illus.; *The Works of British-born Artists of the Seventeenth Century* (Burlington Fine Arts Club, London, 1938), No. 113
ILLUS: *Burlington Magazine*, LXVIII (1936), 193; *Illustrated London News*, March 14, 1936
PROV: Sir Bruce Ingram (Lugt 1405a)
ACQ: 1963 (Acc. No. 63.52.182)

A drawing of similar character, which might be a companion to this one, is in the Whitworth Art Gallery, Manchester.

J. *A Ruff*
Pen and brown wash over pencil; 5⅜" x 4"
EXH: *Animal Drawings through Three Centuries* (Colnaghi, London, 1953), No. 20, illus.
PROV: Sir Bruce Ingram (Lugt 1405a)
ACQ: 1963 (Acc. No. 63.52.179)

Another drawing of a ruff by Place, the bird striding to left, is in the Victoria and Albert Museum (E 1503-1931). Place etched a plate entitled "Ruffs" (see Henry M. Hake, "Some Contemporary Records relating to Francis Place," *Walpole Society*, X [1922], 55, No. 108).

PLACE, Francis (1647-1728), possibly by

K. *Beach Scene with Boats*
Pen and gray wash; 6 13/16" x 12⅜"
EXH: *Masters of Maritime Art* (Colnaghi, London, 1937), No. 62, illus.
PROV: Sir Bruce Ingram (Lugt 1405a)
ACQ: 1963 (Acc. No. 63.57.172)

This drawing resembles the work of Place but is not characteristic of him in all respects. There is

less penwork, and it is less finicky than usual. The costumes of the figures suggest the Low Countries.

RICHARDSON, Jonathan, Sr. (1665-1745)

Richardson is one of the most interesting of early eighteenth-century English artists, not so much for his art itself as for his writings and his historical position in relation to other English artists. In particular his ideas are of importance for Reynolds, who was influenced both by what Richardson wrote and by his practice (as transmitted through Hudson, Richardson's pupil, Reynolds' teacher).

Most of Richardson's drawings are portraits in pencil on vellum, but not in the highly worked earlier tradition of the plumbago drawing. Many of the drawings are either self-portraits or portraits of his son.

A. *Gilbert Burnet, Bishop of Salisbury*
Pen and black wash over pencil; 11⅞" x 10⅛" (oval) on a sheet 12⅜" x 10⅜"
INSCR: [on a separate paper pasted with the drawing] Gilbert Burnet Bp. of Sarum Done by my Father from the picture of Mr. Riley, & under His Direction, for the Print in MessoTinto.
ENGR: I. Smith, in reverse, not dated
PROV: Jonathan Richardson, Sr. and Jr. (bears both their marks)
ACQ: 1926 (in Richard Bull's extra-illustrated copy of Burnet's *History of His Own Time*, Vol. I, following list of subscribers)

The portrait is known in many oil versions, but it is not certain which is the original. An early copy is in the National Portrait Gallery (see David Piper, *Catalogue of the Seventeenth Century Portraits in the National Portrait Gallery* [Cambridge, 1963], pp. 46-47).

B. *Self-portrait* (with cap)
Pencil on vellum; 7⅛" x 5¼"
INSCR: [verso] J. R. Senr; [in pencil] painted abt 1707; J. B. [mark of John Barnard]
PROV: John Barnard (Lugt 1419); G. C. Williamson; Sir Bruce Ingram (Lugt 1405a)
ACQ: 1963 (Acc. No. 63.52.202)

C. *Self-portrait* (bareheaded)
Pencil on vellum; 6⅛" x 5¼"

INSCR: [verso] 5 July 1734
PROV: Jonathan Richardson, Sr. (Lugt 2184); Sir Bruce Ingram (Lugt 1405a)
ACQ: 1963 (Acc. No. 63.52.203)

D. *Dr. William Harvey* (discoverer of the circulation of the blood)
Pencil on vellum; 6" x 3⅝"
INSCR: Dr Harvey, from Dr Meads original, 29 July 1738 JR [in monogram] fec
PROV: Jonathan Richardson, Jr.; Richard Bull; Estelle Doheny
ACQ: 1951 (in Bull's Granger, gift of Estelle Doheny, VIII, 62v)

Dr. Mead appears to have owned two versions of a portrait of Harvey, either of which might have been the source for the Huntington drawing. The better known version is now in the Hunterian Collection, University of Glasgow; the second is in St. Bartholomew's Hospital, London. Apparently Richardson did at least one other drawing based on Dr. Mead's portrait of Harvey (see Geoffrey Keynes, *The Portraiture of William Harvey* [London, 1949], pp. 32-33).

E. *Mr. James Morgan*
Pencil on vellum; 6¾" x 5½"
INSCR: [verso] Mr. James Morgan from a Portrait (his own Hair) 1 Mar 1737
PROV: Jonathan Richardson, Sr. (Lugt 2148); Dr. J. Percy (Lugt 1504); Herbert Horne; Sir Edward Marsh
ACQ: 1963 (Acc. No. 63.42)

Nothing seems to be known about Mr. James Morgan.

ROBINSON, Thomas (died about 1722)

Head of a Man
Red chalk; 12" x 7½"
INSCR: Mr Robinson del; [verso] 2 Nr.36 / Robinson Father to the Countess of Peterborough fec.
EXH: *The Works of British-born Artists of the Seventeenth Century* (Burlington Fine Arts Club, London, 1938), No. 122; *Drawings from the Bruce Ingram Collection* (The Arts Council, London, 1946-47), No. 49
PROV: Earl of Abingdon; Sir Bruce Ingram (Lugt 1405a)
ACQ: 1963 (Acc. No. 63.52.205)

Not much is known about this artist. According to Redgrave (*Dictionary of Artists of the English School*), he was a portrait painter who practiced in London in the early eighteenth century. He had the misfortune to go blind and was supported by the musical talents of his daughter, Anastasia Robinson, secretly married to the Earl of Peterborough.

ROSS (ROSSE), Thomas (active 1730-1757?)

Group of Figure Studies
Pen and wash; 3⅝″ x 6½″
ACQ: 1966 (Acc. No. 66.52)

Ross is a nebulous figure. The little that is known about him will appear in Edward Croft-Murray, *Decorative Painting in England*, Vol. II. He seems to have cooperated with the topographical draftsmen Samuel and Nathaniel Buck by supplying figures for some of their engraved views, and the Huntington drawing may be connected with such a project.

RYSBRACK, John Michael (1694-1770)

Rysbrack and Roubiliac, both foreigners by birth, are the two major sculptors active in England during the mid-eighteenth century. Both practiced as portraitists, but Rysbrack also did a considerable quantity of sculpture of a more decorative nature. Most of Rysbrack's drawings are connected with sculpture, particularly monumental and decorative pieces.

A. *Design for a Pediment* (probably for the Mansion House)

Pen and brown wash over red pencil; 7⅞″ x 21½″
Signed: [on mount] Michl. Rysbrack Sculpr.
INSCR: [following beneath the figures represented] The Tame & Isis joyning make the Thames. Justice with the Sword and Scales. Britania crown'd by Fame holding the Arms of London. Cornucopia of plenty. the Ax and Fasces concord and authority. A Whale and Tritons to represent the Sea; [above the pediment] The Cap of maintenance; [verso, in a different hand] A Drawing made for the Pediment in the Front of the Mansion House.
PROV: Paul Sandby (Lugt 2112); Sir Bruce Ingram (Lugt 1405a)
ACQ: 1963 (Acc. No. 63.52.214)

The executed pediment of the Mansion House is by Robert Taylor, who obtained the commission in May 1744 in competition with many of his elder, better known contemporaries. Vertue indicates that designs were submitted by Gravelot, Cheere, Roubiliac, and Scheemakers in addition to Rysbrack (Vertue Notebooks III in *Walpole Society*, XXII [1934], 122).

B. *A Sacrifice*

Pen and brown wash, heightened with white; 5 11/16″ x 8 7/16″
Signed: [on old mount] Michl. Rysbrack Sculptor
PROV: Thomas Hudson (Lugt 2432); W. T. B. Ashley; Sir Robert Mond (Lugt 2813a); Sir Bruce Ingram (Lugt 1405a)
ACQ: 1963 (Acc. No. 63.52.215)

The drawing does not appear to be directly connected with any sculpture executed by Rysbrack, but the theme is one he used frequently for overmantel carvings at such houses as Stourhead, Clandon Park, Godmersham Park, Houghton Hall, and Woburn Abbey.

C. *Henry Herbert* (later Earl of Carnarvon)

Red and black pencil heightened with white, on buff paper mounted on oak panel; 10¾″ x 8″ (oval)
INSCR: [on back of oak panel] by Rysbrack the Sculptor 1747 done at Wilton six years old; [on a piece of paper affixed to back of oak panel] Henry Herbert now earl of Carnarvon 1810
PROV: by family descent to P. G. D. Mundy
ACQ: 1966 (Acc. No. 66.12)

Mrs. M. I. Webb in her book *Michael Rysbrack* (pp. 185-186) discusses this and the companion drawing. Because there are no comparable drawings that can with confidence be attributed to Rysbrack and because there is no record of Rysbrack working at Wilton, Mrs. Webb is inclined to doubt the accuracy of the description. She suggests instead that the drawings may be by Roubiliac. Mrs. Webb states that the inscription is an early nineteenth-century addition. Examination suggests, however, that while the paper label was probably added when dated (1810), the inscription on the panel itself is contemporary with the drawing. The information about the date and age of the boy checks with the known facts. In the absence of any positive evidence that would contradict the inscription, there seems no valid reason for not accepting the attribution to Rysbrack.

D. *William Herbert*

Red and black pencil heightened with white, on buff paper mounted on oak panel; 10¾" x 8" (oval)
INSCR: [on back of oak panel] by Rysbrack the Sculptor 1747 done at Wilton four years old; [on a piece of paper affixed to back of oak panel] Mr W Herbert brother to Earl of Carnarvon [18]10
PROV: by family descent to P. G. D. Mundy
ACQ: 1966 (Acc. No. 66.13)
See under preceding.

SCOTT, Samuel (ca. 1702-1772)

Scott is the most attractive of the mid-eighteenth-century English topographical painters. His drawings appear to be of two general types. Some are studies directly connected with his paintings. These drawings are usually careful depictions of buildings and are executed in pen or pencil with wash and touches of watercolor. A second group of drawings, mostly maritime scenes, are much freer in handling, resembling contemporary Dutch work, particularly that of the Van de Veldes. This second type (to which E, F, and G belong) is generally accepted as by Scott, although there is not much clear documentary evidence supporting the attribution.

A. *A Shipbuilder's Yard*
Watercolor and pencil; 9¾" x 18⅜"
EXH: *Masters of Maritime Art* (Colnaghi, London, 1937), No. 59, illus.; *Samuel Scott* (Guildhall, London, 1955), No. 71
PROV: Sir Bruce Ingram (Lugt 1405a)
ACQ: 1963 (Acc. No. 63.52.227)

B. *Men Unloading a Ship's Barge*
Pen, watercolor, and pencil; 5¼" x 14⅛"
Signed: Scott delt
EXH: *Masters of Maritime Art* (Colnaghi, London, 1937), No. 54, illus.; *Samuel Scott* (Agnew, London, 1951), No. 44; *Samuel Scott* (Guildhall, London, 1955), No. 85
PROV: J. A. Fuller-Maitland; Sir Bruce Ingram (Lugt 1405a)
ACQ: 1963 (Acc. No. 63.52.222)

C. *Study of Buildings by the Thames at Deptford*
Pencil and gray wash; 6¼" x 13⅛"

Fig. 11. SAMUEL SCOTT, *The Thames at Deptford* (The Tate Gallery)

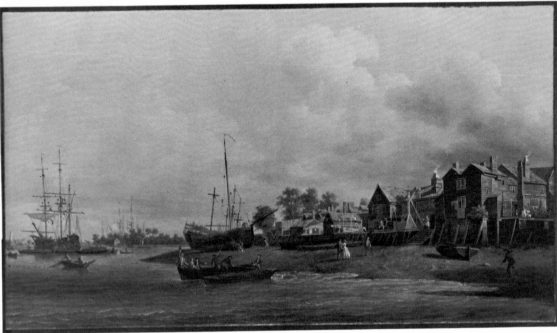

EXH: *Samuel Scott* (Agnew, London, 1951), No. 48; *Samuel Scott* (Guildhall, London, 1955), No. 67
PROV: Sir Bruce Ingram (Lugt 1405a)
ACQ: 1963 (Acc. No. 63.52.224)

The drawing is a study for the right half of a painting, "The Thames at Deptford," in the Tate Gallery (Fig. 11). I am indebted to Mr. Richard Kingzett for pointing out the connection.

D. *Study of a Ship's Boat*
Pencil and gray wash; 4⅝″ x 9¼″
EXH: *Samuel Scott* (Guildhall, London, 1955), No. 55
ILLUS: *Illustrated London News*, July 23, 1955, p. 151
PROV: Earl of Warwick; Sir Bruce Ingram
ACQ: 1963 (Acc. No. 63.52.223)

This drawing is a study for a detail in a painting in the National Maritime Museum, Greenwich, of the flagship *Britannia*. The painting is signed and dated 1736. There are two other drawings known that are related to the painting, one in the collection of Mr. L. G. Duke, the other in the collection of Mr. Paul Mellon. I am indebted for this information to Mr. Richard Kingzett.

E. *Men-o'-War in the Thames*
Pen and gray wash; 7¾″ x 12″
EXH: *Drawings by Old Masters* (Royal Academy, London, 1953), No. 442; *Samuel Scott* (Guildhall, London, 1955), No. 62
ILLUS: *Illustrated London News*, July 23, 1955, p. 151
PROV: J. Thane (Lugt 1544); William Esdaile (Lugt 2617); Gilbert Davis (Lugt 757a)
ACQ: 1959 (Acc. No. 59.55.1155)

F. *Seascape with Men-o'-War Firing a Salute, and Other Small Craft*
Black chalk heightened with white on blue-gray paper; 9½″ x 14⅜″
EXH: *Samuel Scott* (Guildhall, London, 1955), No. 84
PROV: Sir Bruce Ingram (Lugt 1405a)
ACQ: 1963 (Acc. No. 63.52.225)

G. *Seascape with Sailing Vessels*
Brown ink; 4⅜″ x 7 11/16″
EXH: *Samuel Scott* (Agnew, London, 1951), No. 46; *Samuel Scott* (Guildhall, London, 1955), No. 86

PROV: Sir Bruce Ingram (Lugt 1405a)
ACQ: 1963 (Acc. No. 63.52.226)

SEYMOUR, James (1702-1752)
Horse with Rider
Pencil; 6¾″ x 8⅞″
ACQ: 1967 (Acc. No. 67.47)

Seymour is among the earliest of the native English sporting artists. His spirited pen and pencil drawings, like those of his contemporary, Wootton, are reminiscent of drawings by Jan Wyck, a Dutch artist who settled in England in the late seventeenth century.

This is an entirely typical Seymour pencil drawing, exhibiting clearly the broken, somewhat angular pencil strokes with which he normally constructs animals and figures.

SEYMOUR, James (1702-1752), follower of
Three Racing Sketches (1. Groom holding a horse; 2. Horse racing to right with jockey up; 3. Horse racing to left with jockey up)
Pencil; (1) 4⅛″ x 6″; (2) 4⅛″ x 5″; (3) 4⅛″ x 5″
PROV: Gilbert Davis (Lugt 757a)
ACQ: 1959 (Acc. No. 59.55.1159)

These drawings closely resemble the work of Seymour in all respects, except that they lack his crisp, rather angular pencil strokes.

SEYMOUR, Col. John (active early eighteenth century)
A. *Head of a Man*
Pen and brown ink; 4⅜″ x 3¼″
INSCR: Col: Seymore
PROV: John Thane (Lugt 1544); Comtesse Rosa Piatti-Lochis (Lugt 2026c); Ferruccio Asta (Lugt 116a); Sir Bruce Ingram (Lugt 1405a)
ACQ: 1963 (Acc. No. 63.52.230)

There seems no reason to doubt that this drawing is by a little known, seemingly amateur draftsman by the name of John Seymour, who was active in the early eighteenth century. The drawing was at one time attributed to Isaac Oliver, whose work it resembles. The three other heads in the collection given to Seymour have also been at one time attributed to Oliver. They all seem clearly to be by the same artist; one is on paper bearing a portion of

the early eighteenth-century "Pro-Patria" watermark. Other drawings by the same hand are in the British Museum and the Ashmolean Museum.

B. *Head of a Monk*
Pen and brown ink; 3⅞″ x 2 15/16″
PROV: Earl of Warwick (as Isaac Oliver); Sir Bruce Ingram (Lugt 1405a)
ACQ: 1963 (Acc. No. 63.52.160 A)

C. *Head of a Woman*
Pen and brown ink; 3⅞″ x 3⅛″
PROV: Earl of Warwick (as Isaac Oliver); Sir Bruce Ingram (Lugt 1405a)
ACQ: 1963 (Acc. No. 63.52.160 B)

D. *Head of a Youth*
Pen and brown ink; 3¼″ x 2½″
INSCR: [There is an inscription along the left margin which has been clipped in such a way as to become largely illegible.]
PROV: Gilbert Davis (Lugt 757a)
ACQ: 1959 (Acc. No. 59.55.978)

SKELTON, Jonathan (active 1750's, died 1759)
Landscape with Farmhouse and Buildings
Watercolor; 5⅝″ x 8½″
PROV: Gilbert Davis (Lugt 757a)
ACQ: 1959 (Acc. No. 59.55.1186)

Skelton is known by a group of drawings made in England and Italy during the 1750's and by a series of letters from Rome in 1758 to his patron William Herring of Croydon.

Skelton stands with Taverner among the earliest English practitioners of the pure watercolor landscape. His drawings resemble those of Taverner but are in some respects more accomplished. The Huntington drawing, although neither signed nor dated, agrees stylistically with the established works of Skelton. It was purchased by Gilbert Davis in 1948 from the Walker Galleries, which in turn had been the principal purchaser of Skelton drawings when a major cache came up in a Sotheby sale of 1925.

See S. Rowland Pierce, "Jonathan Skelton and His Water Colours," *Walpole Society*, XXXVI (1960), 10-22.

SPENCER, Thomas (1700-1763), possibly by
A. *A Hound*
Red chalk; 10″ x 15⅛″
Signed with a monogram to right
INSCR: 4/33/8
PROV: Sir Bruce Ingram (Lugt 1405a)
ACQ: 1963 (Acc. No. 63.52.229)

This and the following drawing, which are companion pieces, were at one time attributed to James Seymour, primarily on the strength of a monogram, smudged and indistinct, which may read JS or TS. The drawings are more fully and elaborately worked out than is normal for Seymour. Also he usually presents animals in full profile without the comparatively sophisticated spatial organization found in the Huntington drawings.

In technique the drawings are somewhat closer to the work of Seymour's contemporary, Thomas Spencer, as found in the British Museum. Spencer also seems occasionally to have signed his drawings with a monogram. But his personality as a draftsman is not yet fully known, and the association of the Huntington drawings with him is only a tentative suggestion.

B. *A Deer*
Red chalk; 10⅛″ x 15⅛″; unrecorded watermark: D C L
PROV: Sir Bruce Ingram (Lugt 1405a)
ACQ: 1963 (Acc. No. 63.52.228)

This drawing is a companion to the preceding.

TAVERNER, William (1703-1772)
Taverner, a lawyer by profession, remained an amateur painter. He is historically among the most interesting of the early English landscapists in watercolor and gouache. Many of Taverner's drawings are imaginary scenes with an Italianate flavor, but he also drew the English countryside. Although his English views appear to be topographically accurate, they have much more pictorial interest and strength of design than the normal topographical drawing of the time.

A. *The Gazebo*
Watercolor over pencil; 7½″ x 12″
PROV: Gilbert Davis (Lugt 757a)
ACQ: 1959 (Acc. No. 59.55.1244)

B. *A Town by a Lake*
Watercolor over pencil; 12⅝″ x 15¾″
INSCR: [on mount] Taverner
PROV: Gilbert Davis (Lugt 757a)
ACQ: 1959 (Acc. No. 59.55.1245)

C. *Landscape with Two Horsemen*
Watercolor over pencil; 11⅝″ x 18¾″
INSCR: [on old mount] Taverner; [there are several almost obliterated pencil inscriptions on the drawing that appear to be color notes]
PROV: Gilbert Davis (Lugt 757a)
ACQ: 1959 (Acc. No. 59.55.1246)

D. *English Landscape*
Watercolor over pencil; 12¼″ x 15⅜″
INSCR: [on mount] Taverner
PROV: Gilbert Davis (Lugt 757a)
ACQ: 1959 (Acc. No. 59.55.1243)

E. *Classical Architectural Capriccio*
Watercolor over pencil with touches of white body color; 21¼″ x 14⅞″
PROV: Gilbert Davis (Lugt 757a)
ACQ: 1959 (Acc. No. 59.55.1241)

This drawing is in the manner of the typical mid-eighteenth-century architectural capriccio. Clerisseau executed some similar drawings in England, but the type is very common. Although the subject is quite unlike any of the other works by Taverner in the collection, the actual handling resembles his closely. The design probably derives from one by Panini, but Panini's original painting is not known at present.

A similar architectural capriccio by Taverner of approximately the same size was exhibited at the Leeds City Art Gallery (*Early English Water Colours* [1958], No. 91).

TAVERNER, William (1703-1772), attributed to

F. *Wooded Landscape*
Pen and watercolor touched with body color; 12⅝″ x 16½″
PROV: Sir Bruce Ingram (Lugt 1405a)
ACQ: 1963 (Acc. No. 63.52.255)

The use of pen and body color is unlike other works by Taverner in the collection, but with this exception the picture is characteristic of him.

TAVERNER, William (1703-1772), attributed to

G. *Castle by a Lake*
Pencil with some gray wash; 4⅝″ x 7″
INSCR: [on mount in an old hand] Taverner
PROV: Gilbert Davis (Lugt 757a)
ACQ: 1959 (Acc. No. 59.55.1240)

TAVERNER, William (1703-1772), attributed to

H. *Classical Landscape*
Pencil with some gray wash; 4⅝″ x 7″
INSCR: [on mount in an old hand] Taverner
PROV: Gilbert Davis (Lugt 757a)
ACQ: 1959 (Acc. No. 59.55.1242)

THORNHILL, Sir James (1675/6-1734)
Thornhill is the major English exponent of the late baroque style of decorative mural painting. Most of his drawings are preparatory studies for these paintings. He was prolific and inventive, often trying many permutations and combinations of the same elements in his drawings in order to find a satisfying composition. The drawings, normally in pen and monochrome wash, are much freer, more lively and sparkling in effect, than the large finished mural decorations. Stylistically the drawings are transitional between baroque and rococo, retaining the grandiloquent themes of the earlier period but with more of the restless, rippling movement of the rococo than the grand sweep and spatial development of baroque design. The drawings are much in the manner of the contemporary continental decorators working in England such as Verrio, Laguerre, Pellegrini, and Sebastiano Ricci. Probably Thornhill formed his style by studying their works, although not much is known about his formal artistic education.

I am indebted to Mr. Edward Croft-Murray for much information concerning the Thornhill drawings in the Huntington collection.

A. *Britannia Enthroned* (probably an early design connected with the Upper Hall at Greenwich Hospital)

Pen and brown ink with brown wash; 10½″ x 11 3/16″

VERSO: pencil sketch of essentially the same composition

INSCR: [verso, in a later hand] Britania Emblematical by Sir Jas. Thornhill

EXH: *Drawings from the Bruce Ingram Collection* (The Arts Council, London, 1946-47), No. 55; *Old Master Drawings* (Colnaghi, London, Jan.-Feb. 1952), No. 17, illus.; *Sir James Thornhill* (Guildhall, London, 1958), No. 65

LIT: Edward Croft-Murray, *Decorative Painting in England*, I (London, 1962), 268

PROV: Sir Bruce Ingram (Lugt 1405a)

ACQ: 1963 (Acc. No. 63.52.259)

The Great Hall or so-called "Painted Hall" at Greenwich Hospital is Thornhill's most important work and has been described by Edward Croft-Murray as "certainly the finest example of decorative painting of the Baroque period carried out by an Englishman."

Thornhill was given the commission to decorate the hall in 1707. Work apparently began in 1708 and continued until 1727. The decorative scheme underwent considerable modification as it developed. In particular, following the death of Queen Anne, many of the allusions to her were replaced by references to George I.

B. *Design for the West Wall of the Upper Hall, Greenwich Hospital* (view through an arch to a colonnade with Queen Anne seated on a throne, surrounded by courtiers; ships beyond)

Pen and brown ink with brown wash; 7″ x 5¾″

INSCR: [in later hand] Thornhill; [and on verso in Thornhill's hand] Faith hope Charity attend her / Nept. on ye Shore veiling his Trident / The Queen sitting on a Throne, Sr Wm Gifford bringing a Plan of a new Ch. she touches it with her Royal Scepter Q. Attended by ye Chief of the Lds of ye Admiralty that rep [?] their endeavoring for ye same at a Distance ye Royal Navy Eternity holding ye Queens Motto Semper Eadem [?] Victory Honr Generosity attend also Her Liberality to ye Church & Government etc exprest Q & Pr together under a Canopy & Sr. Wm introd. poor Criples & a paper for a Grant for ye Ch.

EXH: *Old Master Drawings* (Colnaghi, London, Jan.-Feb. 1952), No. 20; *Sir James Thornhill* (Guildhall, London, 1958), No. 64

LIT: Croft-Murray, *Decorative Painting in England*, I (London, 1962), 268

PROV: Sir Bruce Ingram (Lugt 1405a)

ACQ: 1963 (Acc. No. 63.52.265)

Apparently an early idea for the decoration of the Great Hall, before the death of Queen Anne. In the painting as executed, George I and his family take her place.

Sir William Gifford was the governor of Greenwich Hospital, appointed 1708.

C. *Sketch for the Ceiling of the Upper Hall, Greenwich Hospital* (the Queen and Prince George seated, surrounded by numerous figures; Neptune offers his trident)

Pen and brown ink with gray-green wash; 7⅝″ x 10¾″

INSCR: No A
Qualities of ye Queen—Religious, Vertuous, Musical, Charitable, Zealous, Peace, Pious
Qualities of Pr. George—Vertuous, Honest, Generous, Constant, Just, Affectionate
Vertues reciprocal to both Princes
Amity, Love of Vertue, Concord Conjugale— Q & Prince; Concord pacifick; Harmony of Love; Love towards God; Desire towards God; Equality; Hospitality; Liberality; Piety; Religion; Sincerity of Love
The Q & Pr. [?] together in a Gold Chain hold a heart in their hands.
Nept. profers his Trident to P. George
Ld. High Adm. assigning [?] his power of ye Seas to him. He shows him ye produce of ye 4 Quarters of ye World, who bring their offerings. All ye Sea Deities follow etc. [?] still ye winds etc. Juno ye Goddess of Air sitting by him.

———

Here: or Vertue heroick attend ye Q & Prince

———

Victory crowns Heroick Vertue wch is common to ye Royal Pair Charity, Religion

EXH: *Sir James Thornhill* (Guildhall, London, 1958), No. 68

LIT: Croft-Murray, *Decorative Painting in England*, I (1962), 268

PROV: Sir Bruce Ingram (Lugt 1405a)

ACQ: 1963 (Acc. No. 63.52.257)

D. *Two Designs for Pediments for Queen's College, Oxford* (in both, Queen Anne, in the

character of Britannia, is surrounded by various allegorical figures)

Pen and brown ink with gray-green wash; 8¼" x 12⅞"

INSCR: To the Revd. Dr. Lancaster

[upper pediment] The Queen sitting like Brittania leaning [?] on an Altar. Showing her Zeal for Religion, Peace & Plenty bring their offerings, on her right is Concord wth ye Fasces—on her left is an old River pouring forth Streams of water, denoting ye flourishing affairs of Learning etc.

[lower pediment] The Queen sitting on a Brittish Lyon denoting mercy. On her head is ye Helmet of Pallas showing her Wisdom, wth her left hand she holds ye Ballance of Power, as well as Justice, in her right hand is the Guardian [?] or Sword of Mercy. On her right is Cebele or ye Earth offering up her Moral [?] Coronet filld wth fruit; by her a Cornucopia. — On her left hand is Neptune wth his Trident pointed downward to show that Qn. Anne is his Souveraigne

[A measured Scale is given]

INSCR: [verso] This Sketch of Sir Jase Thornhill for the Revd Dr Lancaster

EXH: *Sir James Thornhill* (Guildhall, London, 1958), No. 146

PROV: Sir Bruce Ingram (Lugt 1405a)

ACQ: 1963 (Acc. No. 63.52.267)

"Lancaster" is probably William Lancaster (1650-1717), closely associated with Queen's College, Oxford. A similar drawing, in the Oppé collection, is inscribed: "for ye Pediment of Qu. Coll. Oxon/J. Thi 1716" and "The Qu: sitting on a Lyon denot-ing Mercy" (see Croft-Murray, *Decorative Painting in England*, I [1962], 272).

The second (lower) of the two designs on the Huntington sheet of studies is closely related to the actual pediment in the center of the Front Quadrangle, North Range of Queen's College (Fig. 12).

E. *Design for a Staircase for Sir James Bateman* (complete layout for four walls and ceiling)

Pen and brown ink with brown wash; 11" x 17⅞"

INSCR: For Sr J. Bateman / Ld Mayr of London / Historys for ye ceiling wth four figures, ye Sides wth Architecture, Landskip, Perspectives etc.

> Bacchus & Ariadne
> Zephyrus & Flora
> Boreas & Orythya
> Birth of Minerva
> Mars Venus and Vulcan
> Phaeton suit [?] to Apollo
> Jup: Leda

[Some of the measurements are also indicated on the sheet.]

EXH: *Sir James Thornhill* (Guildhall, London, 1598), No. 73

LIT: Croft-Murray, *Decorative Painting in England*, I (1962), 270, No. 25

PROV: Sir Bruce Ingram (Lugt 1405a)

ACQ: 1963 (Acc. No. 63.52.271)

Sir James Bateman was lord mayor of London 1716-1717. The painted decoration, now destroyed, was presumably for his house in Soho Square.

Thornhill experimented with similar schemes involving perspectives of landscape and architecture at Roehampton House (drawings in the British Museum) and for the Saloon at Blenheim (drawing in the collection of the Duke of Marlborough).

F. *Design for a Passageway at Blenheim* (layout for three walls and three ceiling roundels. Four subjects are suggested for the walls with inscriptions beneath: Jupiter and Danae; Vertumnus and Pomona; Pan and Syrinx; Bacchus and Erigone. Three subjects are suggested for the roundels with inscriptions beneath: Zephyrus and Flora; Boreas and Oreithyia; Bacchus and Ariadne)

Pen and brown ink with gray wash; 10¾" x 16¼"

INSCR: [roundels] Zephyrus & Flora / Boreas & Orythia / Bacch & Ariadne.

Fig. 12. *Pediment, Front Quadrangle, North Range, Queen's College, Oxford*

[panels] Jup: & Danae / Vertumnus & Pomona / Pan & Syrinx / Bacch & Erigone. [two cartouches in cove] Blenheim / Hochstet [A scale measure is given]
LIT: Croft-Murray, *Decorative Painting in England*, I (1962), 266
PROV: Sir Robert Witt (Lugt 2228b); Sir Bruce Ingram (Lugt 1405a)
ACQ: 1963 (Acc. No. 63.52.258A)

In the Thornhill sketchbook in the British Museum there are references to decorations for two passageways at Blenheim each 44 ft. long and 10 ft. high (fol. 50). A drawing in the Witt Collection at the Courtauld Galleries (3501) appears to be for the same scheme.

On Thornhill's work at Blenheim see David Green, *Blenheim Palace* (London, 1951), pp. 306-308.

G. *Design for the Ceiling of the Hall at Blenheim* (the Duke of Marlborough lower right surrounded by various allegorical figures; a circular temple in left background)
Pen and brown ink with brown wash heightened with white on buff paper; 12½″ x 10½″ (oval) on sheet 13⅞″ x 10⅝″
INSCR: [There is an inscription in Thornhill's hand describing the scene, but it has been trimmed. A possible reconstruction might be:]

 [Wisdom] & Vertue
 [represented] by Pallas &
 [? ?] direct ye Hero towards
 [the Temple] of Honour, where the
 [Ancient] Heros sitt in Triumph
 [?] Ceasar, Pompey etc.
 [?] a Vice etc pulling him back etc.

LIT: Croft-Murray, *Decorative Painting in England*, I (1962), 266
PROV: Sir Bruce Ingram (Lugt 1405a)
ACQ: 1963 (Acc. No. 63.52.258)

The Thornhill sketchbook in the British Museum contains related designs for the Hall and Saloon at Blenheim (fol. 50r and v).

H. *Design for a Staircase Wall* (the Rape of Europa enframed by columns and other architectural elements)
Pen and brown ink with gray wash; 10¼″ x 12″ (irregular)

VERSO: pencil sketch of the same subject
EXH: *Sir James Thornhill* (Guildhall, London, 1958), No. 78
PROV: Sir Bruce Ingram (Lugt 1405a)
ACQ: 1963 (Acc. No. 63.52.263)

This drawing may be connected with a project for the Earl of Winchelsea at Eastwell, Kent (Croft-Murray, *Decorative Painting in England*, I [1962], 268). The general layout of the architecture and theme suggest that this drawing may be associated with the next study.

A pencil sketch labeled "Winchelsea" with a very similar layout (although the subject is undeveloped) is in the British Museum sketchbook by Thornhill, fol. 53v.

I. *Design for a Staircase Wall* (a roundel with the subject of Danae and the shower of gold; numerous putti; two panels with military trophies; architectural enframement)
Pen and brown ink with gray wash; 10⅝″ x 12 5/16″
INSCR: Sr. James Thornhill [in a later hand]; [verso] WE Genl. Doudeswell's coll. P N Sr James Thornhill [all presumably in the hand of William Esdaile]
EXH: *Sir James Thornhill* (Guildhall, London, 1958), No. 77
PROV: Gen. Doudeswell; William Esdaile (Lugt 2617); Sir Robert Witt (Lugt 2228b); Sir Bruce Ingram (Lugt 1405a)
ACQ: 1963 (Acc. No. 63.52.261)

The general layout of the drawing implies that it is a companion to the preceding, representing the adjoining staircase wall.

J. *Wall Design with Diana and Actaeon* (central panel with Actaeon discovering Diana and her attendants; niche to left with standing figure of Apollo; niche to right with standing figure of Diana)
Pen and brown ink with gray wash; 6⅜″ x 11⅜″
INSCR: [below in ink] Apollo / Diana / 20 ftt 8 in [above in pencil] Diana and Acteon. Ovid Metamorph: Lib. 3
[verso in pencil in a later hand] Hall [?] Th Willough [?]
LIT: Croft-Murray, *Decorative Painting in England*, I (1962), 274

PROV: Sir Robert Witt (Lugt 2228b); Sir Bruce Ingram (Lugt 1405a)
ACQ: 1963 (Acc. No. 63.52.262)

Possibly a design for Sir Thomas Willoughby at Wollaton Hall, where Thornhill is known to have worked. But this subject does not appear in the decorative scheme as executed.

K. *Design for a Spandrel*
Pen and brown ink with brown wash; 5⅝" x 5½"
INSCR: Genll. Withers [a measured scale is given]
PROV: Sir Bruce Ingram (Lugt 1405a)
ACQ: 1963 (Acc. No. 63.52.270)

General Withers is probably Henry Withers, who was appointed lieutenant in the Duke of Monmouth's Regiment of Foot, Feb. 10, 1678, and eventually rose to the rank of lieutenant general in 1707. He fought at Blenheim and distinguished himself at the taking of Tournay, 1709. Died Nov. 11, 1729.

L. *Design for a Chimney Wall* (possibly for the Prince of Wales [now the Queen's] Bedchamber, Hampton Court; a wall with a fireplace and door, decorated with a sketch of Britannia holding the scales of justice, receiving the homage of Europe, surrounded by other figures; architectural enframement, and a smaller roundel over the door)
Pen and brown ink over pencil with gray wash; 10¾" x 13⅛"
INSCR: [with the measurement] 30 ft 6 in, [and] ye chimney
VERSO: pencil sketch of the same subject
EXH: *Old Master Drawings* (Colnaghi, London, Jan.-Feb. 1952), No. 15
LIT: Croft-Murray, *Decorative Painting in England*, I (1962), 269
PROV: Sir Bruce Ingram (Lugt 1405a)
ACQ: 1963 (Acc. No. 63.52.260)

M. *Queen Anne's Patronage of the Arts*
Pen and brown ink with gray wash; 8¼" x 9⅞"
VERSO: a sketch of the area covered by the drawing on the recto, with measurements
EXH: *Old Master Drawings* (Colnaghi, London, Jan.-Feb. 1952), No. 19; *Sir James Thornhill* (Guildhall, London, 1958), No. 135
PROV: Sir Bruce Ingram (Lugt 1405a)
ACQ: 1963 (Acc. No. 63.52.256)

The decorative scheme to which this drawing belongs has not yet been identified. The measurements on the verso of the drawing indicate that the room was 54' 8" wide; it also seems probable from the verso sketch that the three small circles were part of the architecture of the room, either windows or wall recesses; the distance of each from the edge of the space is given. The design might possibly be for the proscenium arch of a theater.

N. *An Allegory of Time* (a Cupid holding a scythe and mounted on a horse being led by a female figure; other cupids flying above)
Pen and brown ink with gray wash; 7" x 6⅜"
INSCR: [verso] Saturn transforms himself into a horse for [cut]

Neptune & Perimole
Neptune transf. himself into a horse for [cut]
Nept. & Ceris
———
Birth of Pegasus
Ocyrod
Europa & Jupit.
Bellerophon on Pegas. kills Chyrmen
Nept. & Melanthe on a Dolphin
———
4 Ages of ye world
4 Seasons of ye year
Ceph & Aurora)
Bacch: Ariadne)
 4pt of ye day
Zeph Flora)
Dian Endymion)

PROV: Sir Bruce Ingram (Lugt 1405a)
ACQ: 1963 (Acc. No. 63.52.272)

O. *Design for a Staircase Wall* (two panels with allegorical figures. One represents the coronation of a medallion-portrait, above which hovers a cupid with a scroll showing the plan of a fortress, inscribed "Dunkirk." The second represents Neptune, Ceres [?], and Mercury bringing the commerce of the World to London; the tower of the second Royal Exchange in the background.)
Pen and brown ink with brown wash; 10" x 13⅜" (irregular)
ACQ: 1934 (Acc. No. 34.20)

The decorative scheme to which this design be-

longs has not been definitely established. The reference to Dunkirk, the fortifications of which were to be demolished as a result of the Treaty of Utrecht (1713), suggests that the design might be for Blenheim or some royal or public building.

P. *Bacchus and Erigone*
Pen and brown ink with gray-green wash; 7¼" x 6½"
INSCR: Bacchus & Erigone
PROV: Gilbert Davis (Lugt 757a)
ACQ: 1959 (Acc. No. 59.55.1264)

Another drawing of this subject, but with many differences in composition, is in the Victoria and Albert Museum (D3-1891, No. 54).

Q. *Ceiling Decoration with Triumph of Flora*
Pen and brown ink with gray wash; 13" x 5"
PROV: Gilbert Davis (Lugt 757a)
ACQ: 1959 (Acc. No. 59.55.1265)

R. *Ceiling Design with Decorated Cove and Central Panel with an Assembly of the Gods* (reading from bottom up: Mercury, Minerva, Vulcan, Jupiter attended by Hebe)
Pen and brown ink with brown wash; 6 13/16" x 5¾"
PROV: Sir Bruce Ingram (Lugt 1405a)
ACQ: 1963 (Acc. No. 63.52.264)

The preponderance of military trophies in the coves suggests the design may have been for a military patron.

S. *Ceiling Design with an Assembly of the Gods* (reading from bottom up: Neptune, Mars, Venus, Cupid, Diana, Vulcan, Jupiter, Hebe, Minerva)
Pen and brown ink with gray wash; 14⅛" x 5⅝"
PROV: Sir Bruce Ingram (Lugt 1405a)
ACQ: 1963 (Acc. No. 63.52.266)

Perhaps connected with one of the passage ceilings at Blenheim.

T. *Numa Refusing the Roman Crown*
Pen and brown ink with blue-gray wash; 4" x 5"
INSCR: Numa refusing ye Roman Crown
PROV: Gilbert Davis (Lugt 757a)
ACQ: 1959 (Acc. No. 59.55.1266)

There are several Thornhill drawings in the Victoria and Albert Museum all employing the same rather unusual color washes and also representing Roman subjects. The enframements of the V. and A. drawings all have bulges on the top margins. The drawings might be associated with decorations for Moor Park (Herts.), where there were eight inset pictures representing the Heroic Virtues. These have now disappeared, having been dismantled about 1732 and replaced by paintings by Jacopo Amigoni.

U. *Ptolemy Giving Demetrius Directions to Build the Alexandrian Library*
Pen and brown ink over pencil with brown wash; 6" x 6"
INSCR: Ptolemy giving Demetrius Directions to build the Alexandrian Library; [and in a later hand] Sr James Thornhill
EXH: *Sir James Thornhill* (Guildhall, London, 1958), No. 127
PROV: William Esdaile (Lugt 2617); Sir Robert Witt (Lugt 2228b); Sir Bruce Ingram (Lugt 1405a)
ACQ: 1963 (Acc. No. 63.52.268)

A second drawing of this subject (with a different composition) is in the British Museum, and a third is in the Lyman Allyn Museum, New London, Conn. The B. M. drawing is inscribed "Library Chimney" and "Sr. Thos. Hanmer." The latter probably refers to the man who was Speaker of the House of Commons and editor of Shakespeare, but no decorative paintings by Thornhill for Hanmer are now known.

V. *Shell Ornament* (three putti supporting a basket of fruit and foliage in a shell niche)
Pen and brown ink over pencil with gray-green wash; 6⅛" x 8⅞"
INSCR: [verso, several proper names, stroked out] Henet Ekly Contronler P. Eugene Memda Hawkhurst Bently Greel Sund: Thompson Mond: Biggs Sr. G. Walse — Draper Mr. G. Clarke — Seb Rizzi

Eeels
George
Grayham
EXH: *Sir James Thornhill* (Guildhall, London, 1958), No. 137

PROV: Sir Robert Witt (Lugt 2228b); Sir Bruce Ingram (Lugt 1405a)
ACQ: 1963 (Acc. No. 63.52.269)

W. *Arthur Onslow*

Pen and wash; 6½″ x 5¼″

EXH: *Five Centuries of Drawings* (Museum of Fine Arts, Montreal, 1953), No. 225 (as a portrait of Grinling Gibbons by Kneller)
PROV: J. G. Schumann (Lugt 2344); Comte J. von Ross? (Lugt 2693); Edward Habich (Lugt 862); Victor Spark
ACQ: 1963 (Acc. No. 63.37)

The drawing is connected, but not very closely, with the painting by Thornhill and Hogarth of Arthur Onslow as Speaker of the House of Commons. Other drawings of the same subject are in the British Museum and in the Paul Mellon Collection.

X. *Sheet with Thirteen Studies of Susanna and the Elders*

Pen and wash; 7½″ x 12 5/8″

INSCR: [there was an inscription along the bottom margin but it has been largely trimmed off and cannot be deciphered]
PROV: This sheet of studies comes from an extra-illustrated set of John Kitto's translation of the Bible. The set, in sixty volumes, was made up principally in the mid-nineteenth century by a J. Gibbs. It was subsequently in the possession of Theodore Irwin.
ACQ: before 1925 (in the "Kitto" Bible, XXIX, fol. 5611)

These studies do not seem to be related to any of Thornhill's decorative schemes. They appear to be simply an exercise ringing various changes possible with the theme. Thornhill evidently enjoyed this type of experiment; there are several sheets in the 1699 sketchbook (British Museum) in which he tries out variations on a motif (fols. 5v and 6r; 13v and 14r).

Y. *Eighty-nine Illustrations to the New Testament*

Pen and wash; the drawings vary in size but are approximately 3¼″ x 2¾″ on ten sheets, most of them approximately 4″ x 15″

LIT: C. H. Collins Baker, "Sir James Thornhill as Bible Illustrator," *Huntington Library Quarterly*, X (1947), 323-327
PROV: See under Thornhill, No. X (*Sheet with Thirteen Studies of Susanna and the Elders*)
ACQ: before 1925 (in the "Kitto" Bible)

These little drawings, which are numbered and identified as to book, chapter, and verse in Thornhill's hand, are not known to be directly connected with any larger project. The numbering runs to 91; there are two drawings numbered "31" (but of different subjects); there are no drawings with the numbers 80, 81, and 82. In his note on the drawings in 1947 Mr. Baker overlooked a sheet with twelve studies that fill the principal gaps he records in the series. The drawings are mounted and bound with a large extra-illustrated set known as the "Kitto" Bible. They are to be found in the following volumes: XXXI, fol. 5852; XXXVI, fol. 6802; XLIII, fols. 7792 and 7793; LII, fol. 9469; LV, fol. 10005; LX, fols. 10993, 11004, and 11009.

The drawings are on both recto and verso of the sheets. Those on the verso are more summary in treatment.

The subjects represented are as follows:

Sheet I

St. Matthew

 1. St. Matthew writing
 2. (ch ii) The Nativity [really closer to Luke ii.7]
 3. [verso] [ch ii.11] Adoration of the Magi
 4. (iii.13) Baptism of Christ
 5. [verso] (iv.3) Temptation of Christ
 6. (v.2) The Sermon on the Mount
 [7] [verso] [viii.3 ?] Christ and the Leper
 8. (viii.5) Christ and the Centurion

Sheet II (no drawings on verso)

 9. (xii.38) The Pharisees ask a sign
10. (xiii.3) The Sower
11. (xiv.30) Christ saves Peter from the Sea
12. (xv.22) Miracle of Loaves and Fishes [should be xv.34]
13. (xvii.2) Transfiguration
14. (xxi.8) Entry into Jerusalem

Sheet III

[15] [verso] (xxii.35) Christ tempted by the Lawyer
16. (xxvi.20) The Last Supper
[17] [verso] (xxvi.51) Peter strikes off the ear of Malchus

18. (xxvi.57) Christ before Caiaphas
19. (xxvii.1) "Fin. Math." Christ before Pilate

St. Mark

20. St. Mark seated writing
21. (iv.38) Christ stills the Tempest
[22] (vi.2) Christ teaching in the Synagogue

Sheet IV

23. (vii.25) Christ and the Syrophoenician woman
24. (xiv.3) "Fin. Mark" Christ in the house of Simon

St. Luke

25. St. Luke writing
26. [verso] (i.22) Zachariah issuing from the Temple
27. (i.28) The Annunciation
28. (i.43) Elisabeth hails Mary
29. [verso] (ii.9) The Angel appears to the Shepherds
30. [verso] (ii.21) Circumcision
31. [verso] (v.3) Christ standing in Simon's ship
31. [sic] [verso] (x.30) The Good Samaritan

Sheet V

32. (xv.20) The Prodigal Son
[33] [verso] (xvi.19) Lazarus at the Rich Man's Table
34. [verso] (xxii.42) Agony in the Garden
[35] [verso] (xxiii.26) Road to Calvary
36. [verso] (xxiii.33) Crucifixion
37. [verso] (xxiv.13) Journey to Emmaus

St. John

38. St. John writing
39. (i.43) Christ calling Philip
40. (ii.3) Feast at Cana
41. (ii.15) Christ driving out the Traders

Sheet VI

42. (viii.6) Christ and the woman taken in adultery
43. [verso] (viii.59) Jews prepare to stone Christ
44. (xi.44) Raising of Lazarus
45. (xiii.5) Christ washing the Disciples' Feet
46. [verso] (xix.1) Christ scourged
47. [verso] (xix.2) Crowning with Thorns
48. [verso] (xix.5) Ecce Homo
49. (xx.17) Noli me tangere
50. (xx.27) "Fin Johan" Incredulity of St. Thomas

Sheet VII

Acts of the Apostles

51. (i.9) Ascension
52. (ii.3) Pentecost
53. [verso] (iii.7) Peter and John cure the lame man
54. [verso] (vii.60) Stoning of Stephen
55. [verso] (viii.31) Philip and the Eunuch
56. [on sheet VIII] (ix.4) Conversion of Saul
57. (x.11) Vision of Peter
58. [on sheet VIII] (xii.6) Peter in Prison
59. [on sheet VIII] (xiv.13) Priests of Jupiter bring oxen
60. (xvi.15) Paul and Lydia
61. [on sheet VIII] (xx.9) Fall of Eutychus
62. [verso] (xxviii.4) "Fin. Act. Ap." Paul and the Barbarians
63. St. Paulus
64. St. Jacobus
65. [verso] St. Petrus
66. [verso] St. Thaddeus

Sheet VIII

Revelation

67. (i.13) Seven Candlesticks and the Son of Man
68. (iv.2) Throne in Heaven
69. (vi.2) The Four Riders
70. (vi.9) Opening of the Fifth Seal
71. (vi.12) Opening of the Sixth Seal
72. (vii.3) The Angel with the Seal

Sheet IX

73. (viii.2) Seven Trumpets
74. (viii.7) The first angel sounded
75. (viii.8) The second angel sounded
76. (viii.10) The third angel sounded

[Sheet X]

77. (viii.12) The fourth angel sounded
78. (ix.1) A Star falls unto the Earth
79. (ix.13) The sixth angel sounded
83. (xiii.8) The worship of the Beast
84. (xiv.6) The angel flying with the Gospel
85. (xiv.17) The angel with the Sickle

Sheet XI

86. (xvi.4) The angel with the Vial
87. (xviii.21) The angel with the Millstone
88. (xix.11) The white horse
89. (xx.1) The angel with the Key and Chain
90. (xx.9) and fire came down from God
91. (xxi.1) "Et fin: Pict" and I saw a new Heaven and a new Earth

THORNHILL, Sir James (1675/6-1734), attributed to

Z. *Design for a Wall*
Pen and brown wash; 4⅝″ x 5⅛″
PROV: Sir Bruce Ingram (Lugt 1405a)
ACQ: 1963 (Acc. No. 63.52.298A)

This drawing was previously attributed to Joseph Wilton, but it is closer to Thornhill and might even have some connection with the Saloon at Blenheim.

TILLEMANS, Peter (1684-1734)

Town and Estuary
Watercolor over light pencil; 11½″ x 17½″
SIGNED: P. Tillemans f.
PROV: Gilbert Davis (Lugt 757a)
ACQ: 1959 (Acc. No. 59.55.1267)

This drawing has not much connection with Tillemans' known work after he came to England in 1708. But there seems no reason to doubt the signature, and there is no other P. Tillemans to whom the drawing might be assigned. Although the scene appears to be imaginary, the architecture is Continental in style, and this suggests that the drawing may predate Tillemans' move to England.

TOPSELL, Edward (1572-1625)

The Fowles of Heaven (one hundred and twenty-four drawings of birds)
Pen and watercolor; on sheets of paper irregular in size, varying from approximately 6″ x 6″ to 2″ x 4″, pasted in the MS of "The Fowles of Heaven"
PROV: Ellesmere (Bridgewater House Library)
ACQ: 1917 (El 1142)

Topsell is remembered as the author of two zoological manuals: *The History of Foure-footed Beastes* (1607) and *The Historie of Serpents* (1608). The Huntington MS is for a third work, on birds, that was not published.

This unique copy is of considerable interest in the history of ornithology and has been the object of study from that point of view. (See *John White and Edward Topsell: The First Water Colors of North American Birds*, ed. Thomas P. Harrison [Austin, 1964]). The drawings themselves are amateurish copies derived for the most part from Ulysses Aldrovandi, *Ornithologiae* (Bologna, 1599-1603), and Conrad Gesner, *Historiae Animalium*, Lib. III: *De avium natura* (Zürich, 1555).

A few of the drawings of American birds are derived from the work of John White. An edition of the MS, including illustrations of most of the drawings, is being prepared by Thomas P. Harrison and F. D. Hoeniger for the University of Texas Humanities Research Center.

VANDERBANK, John (1694-1739)

Vanderbank, son of a tapestry weaver of the same name, is known primarily as a portraitist active in England during the 1720's and 1730's. He also did a series of illustrations to *Don Quixote*. His drawings, normally in pen and monochrome wash over pencil, are frequently portrait studies but also range over different types of subjects.

A. *Man on Horseback*
Gray wash over pencil; 9½″ x 6⅝″
SIGNED: J. Vanderbank Fecit 1728 [the "2" has been clipped, but there can be little doubt concerning the date]
PROV: Sir Bruce Ingram (Lugt 1405a)
ACQ: 1963 (Acc. No. 63.52.274)

B. *Portrait of a Lady*
Brown pen and wash over pencil; 14½″ x 8″
Signed with initials and dated 1737
PROV: Gilbert Davis (Lugt 757a)
ACQ: 1959 (Acc. No. 59.55.1367)

C. *A Military Review*
Brown pen and wash; 7⅜″ x 7⅛″
Signed with initials and dated 1737
PROV: Sir Bruce Ingram (Lugt 1405a)
ACQ: 1963 (Acc. No. 63.52.276)

D. *Lady and Gentleman*
Brown pen; 6⅞″ x 6⅞″
Signed with initials
PROV: Sir Bruce Ingram (Lugt 1405a)
ACQ: 1963 (Acc. No. 63.52.275)

E. *Horsemen and a Waggon*
Brown pen and wash over pencil; 12¾″ x 18¼″
SIGNED: J. Vanderbank [the signature has been partially scratched out but is still legible]
INSCR: [twice, in a later hand] Parocel
PROV: Gilbert Davis (Lugt 757a)
ACQ: 1959 (Acc. No. 59.55.1366)

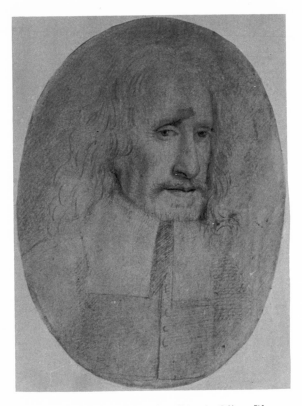

Fig. 13. EDWARD LUTTRELL (attrib. to), *Oliver Plunket* (Ashmolean Museum)

There has been an attempt to associate this drawing with Parrocel, presumably Charles (1688-1752), son of Joseph (1646-1704). But, even without the scratched signature, the drawing is clearly in Vanderbank's style, although the design is somewhat more ambitious than usual.

VAN DER VAART, Jan (1647-1727), attributed to

Oliver Plunket (Catholic divine, executed for treason in 1681)
Black pencil and chalk, heightened with white; considerably rubbed; 12¼" x 10¼"
PROV: in Richard Bull's extra-illustrated copy of Burnet's *History of His Own Time*, III, facing 502
ACQ: 1926

This drawing is closely related to the various prints and paintings of Oliver Plunket, all of which clearly derive from one source. This source is con-

sidered to be a small plumbago drawing (Fig. 13) attributed to Edward Luttrell in the Ashmolean Museum (Sutherland Coll. B I 502; see C. F. Bell and Rachel Poole, "English Seventeenth-Century Portrait Drawings in Oxford Collections," *Walpole Society*, XIV [1926], 71 ff. and Pl. XL [c]).

The Huntington drawing faces in the same direction as the plumbago but is much larger in scale. The firm, rather tight contours of the Huntington drawing suggest an engraver's study, but there is no known print that is unquestionably derived from it. In many respects, however, the drawing is very close to the mezzotint of Plunket issued, undated, with the subscription "G. Morphey, pinx; I. Van der Vaart fec; T. Donbar Ex." (Fig. 14). The print (which is the reverse of the drawing) is slightly smaller in scale, and Plunket has been given elaborate ecclesiastical vestments which are absent in the drawing. But the relationship is sufficiently close to justify an attribution of the drawing to Van der Vaart, a rather obscure artist of Dutch birth who came to England in the 1670's and worked under William Wissing. Late in life he experimented with mezzotint.

Fig. 14. T. DONBAR, *Oliver Plunket* (mezzotint)

54

VAN DE VELDE, William, the Younger (1633-1707)

The younger Van de Velde, born and trained in Amsterdam, probably came to England with his father in 1672. Both were active as marine painters. They cooperated closely with each other, and their works (both in painting and drawing) are not always distinguishable.

A. *Seascape with Men-o-War*
Gray wash over pencil; 6⅞" x 11"
Signed with initials: W.V.V.J.
PROV: Gilbert Davis (Lugt 757a)
ACQ: 1959 (Acc. No. 59.55.1368)

B. *Seascape with Shipping*
Gray wash; 5¾" x 9⅛" (the paper carries a portion of a watermark with the arms of Amsterdam)
PROV: Gilbert Davis (Lugt 757a)
ACQ: 1959 (Acc. No. 59.55.1369)

VERTUE, George (1684-1756)

Vertue is now remembered primarily for his voluminous notebooks, which are an important source of data related to English art for the seventeenth and the first half of the eighteenth century. He was also a prolific engraver, particularly of portraits. Most of his drawings are portraits, frequently copies after paintings or prints, and these drawings in turn are often the sources upon which he based his own engravings. The drawings are usually of important people, and the sketches are particularly valuable, as many of the portraits on which they are based are now missing.

A. *John Milton*
Pen and wash, on paper mounted on canvas (the canvas is a fragment of what appears to be a late-seventeenth-century portrait); 7⅝" x 6½" (oval)
ENGR: by George Vertue in 1725, in reverse
LIT: *Milton Tercentenary* (Cambridge, 1908), pp. 25f., 38, No. 32; John Rupert Martin, *The Portrait of John Milton at Princeton and Its Place in Milton Iconography* (Princeton, 1961), passim and fig. 10
PROV: George Vertue; Horace Walpole; Thomas Brand Hollis; Dr. Disney; G. C. Williamson

ACQ: before 1927, precise year not known (Acc. No. 60.6A)

George Vertue made several portrait engravings of Milton, the two most important and interesting being one in 1720 as the Frontispiece to Tonson's edition of the *Poetical Works*, and one in 1725 for Vertue's series "The Twelve Poets." The earlier engraving is derived directly from Faithorne's famous print of 1670, of which it is a reverse image (Fig. 15). The 1725 engraving is based on the drawing now in the Huntington collection. The problem is to determine Vertue's source for the drawing.

The drawing, although closely related to the Faithorne print, is not taken directly from it. The image in the drawing is the reverse of the print, and there are also other differences: the print suggests an older man; the form of the drapery and collar are different; there is no indication in the print of the hand on the chest which Vertue clearly originally included in the drawing but subsequently painted over. Nevertheless, in the position of the head and its features the drawing is close to what one surmises must have been the appearance of Faithorne's own preliminary study or drawing (which presumably would also have been the reverse of the 1670 print).

Between the execution of the 1720 and 1725 engravings Vertue paid a visit to Milton's one surviving daughter (on August 10, 1721). He showed her several portraits of her father for her opinion. His remarks about them in his diary (*Walpole Society*, XVIII [1930], 79) are rather carelessly written and subject to different interpretations. But it is surely significant that Vertue perceptibly changed his source for the later engraving. Mr. Martin argues that Vertue's drawing for the 1725 engraving is a copy of a pastel portrait at Princeton. The two drawings are closely related, but there are significant differences. Neither the visual nor the documentary evidence will really support the contention that the Huntington study is copied from the one at Princeton. The treatment of the hair is much more particularized in the Huntington drawing; none of the neck is exposed; the drapery is differently organized. There is no suggestion in the Princeton pastel of the hand on the chest, which one strongly suspects (from Vertue's normal practice) was present in whatever portrait of Milton he was copying. It is tempting to con-

clude that Vertue was copying a now lost drawing by Faithorne that was preparatory to the 1670 print. The Princeton pastel may have been derived independently from the same source.

Associated with the drawing, but on a separate piece of paper, are the following comments in Horace Walpole's handwriting:

"The Epitaph
Here lyes the body of George Vertue
 late Engraver
And fellow of the Society of Antiquaries,
Who was born in London anno 1684
And departed this life on the 24th of July 1756

With manners gentle and a gratefull heart,
And all the genius of the graphic art;
His fame shall each succeeding artist own
Longer by far than monuments of stone.

Vertue was a rigid Roman Catholic & ordered his body to be buried in the Cloysters of Westminster Abbey, as near as possible to a spot where he had found a monk of his name had anciently

Fig. 15. WILLIAM FAITHORNE, *John Milton* (engraving)

been buried." Walpole supplies essentially the same information in the life of Vertue which he appended to the *Anecdotes of Painting.*

B. *William Dobson* (painter)

Wash over pencil; 6⅛" x 4½"
INSCR: G.V.del
ENGR: in reverse by A. Bannerman in the 1762 edition of Walpole's *Anecdotes of Painting*, II, facing 106
ACQ: 1906 (Rare Book 83528, II, facing 257)

This and the following thirteen drawings by Vertue are in an extra-illustrated copy of Walpole's *Anecdotes of Painting*, the 1826 edition with additions by Dallaway. The drawings appear for the most part to be the sources from which the related plates in the 1762 edition were engraved. Other drawings from the same series are in the collection of Wilmarth Lewis.

Vertue's drawing of Dobson is based on the self-portrait, of which several versions exist. Vertue may have followed a version in Walpole's collection, which may be the one now in the National Portrait Gallery (David Piper, *Catalogue of the Seventeenth Century Portraits in the National Portrait Gallery* [Cambridge, 1963], p. 108).

C. *Simon Dubois* (painter)

Pen and wash; scored and squared for transfer; 7" x 5"
INSCR: Mr Simon Du Bois painter / se ipse pinx G.V.
ENGR: in reverse and with Henry Cooke added by A. Bannerman for the 1762 edition of Walpole's *Anecdotes of Painting*, III, facing 118
ACQ: 1906 (Rare Book 83528, III, facing 241)
See under B.

Vertue (*Walpole Society*, Vertue Notebooks I, 67) refers to a self-portrait by Dubois "an Oval ¾ . the face painted by himself &. so left when he died. being just newly done then. the drapery finisht by another hand."

The Vertue Notebooks to which reference is made in this and several following entries were published by the Walpole Society as follows: Vertue Notebooks I in *Walpole Society*, XVIII (1930); Vertue Notebooks II in *Walpole Society*, XX (1932); Vertue Notebooks III in *Walpole Society*, XXII (1934); Vertue Notebooks IV in *Walpole Society*, XXIV (1936); Vertue Note-

books V in *Walpole Society*, XXVI (1938); Vertue Notebooks I-V, Index, in *Walpole Society*, XXIX (1947); Vertue Notebooks VI in *Walpole Society*, XXX (1955).

D. *Isaac Fuller* (painter)
Red wash; 6″ x 4⅜″ (mounted on sheet 7⅝″ x 4¾″)
INSCR: I. Fuller / Isaac Fuller. pictor. orig. pinx. / in Poses. Dr. Geo. Clarke. Oxon G.V.d.
ENGR: in reverse by T. Chambers for the 1762 edition of Walpole's *Anecdotes of Painting*, III, facing 4
ACQ: 1906 (Rare Book 83528, III, facing 6)
See under B.

Based on the self-portrait by Fuller in Queen's College, Oxford, given to the college by Dr. Clarke (see Mrs. Reginald Lane Poole, *Catalogue of Portraits in the Possession of the University, Colleges, City and County of Oxford* [Oxford, 1925], II, 120).

E. *George Geldorp* (painter)
Pencil; 5⅜″ x 4⅛″
INSCR: Geldorp painter from a limning in Poses Mr M. Rosse
ENGR: in reverse by A. Bannerman for the 1762 edition of Walpole's *Anecdotes of Painting*, II, facing 101, combined with Van Belcamp
ACQ: 1906 (Rare Book 83528, II, facing 233)
See under B.

Vertue (*Walpole Society*, Vertue Notebooks I, 116) refers to "a limning a head of Geltrop, ye painter or Geldorp" in Mr. Rosse's sale April 1723.

F. *Richard Gibson* (painter)
Pencil with touches of pen and wash; 6½″ x 5¼″ (mounted on sheet 7¾″ x 5½″)
INSCR: Gibson / Little Mr. Richard Gibson painter. / P. Lilly. pinx. Ob 16g Æat 7.5. G.V.
ACQ: 1906 (Rare Book 83528, III, facing 124)
See under B.

Although the drawing is related to the print in the 1762 edition of the *Anecdotes*, the print does not appear to have been copied directly from this drawing.

Another drawing by Vertue of Gibson, full length and not related to the print, is in the collection of Wilmarth Lewis. The Huntington drawing seems to derive from the double portrait of Gibson

and his wife by Lely, of which a version was in the Sir Berkeley Sheffield collection (Christie's, July 16, 1943, photo National Portrait Gallery).

G. *Mrs. Gibson* (wife of Richard Gibson)
Black and red pencil on tinted paper; 7⅜″ x 5″
INSCR: G.V. [and on verso] Mrs Gibson [twice]
ENGR: in reverse by A. Walker for the 1762 edition of Walpole's *Anecdotes of Painting*, III, facing 64, combined with Mr. Gibson
ACQ: 1906 (Rare Book 83528, III, following 124)
See under B.

Vertue, in his notebooks, refers on several occasions to the double portrait of Mrs. Gibson and her husband by Lely, but this drawing (unlike that of Mr. Gibson) does not derive from that source.

H. *John Greenhill* (painter)
Wash over pencil; scored; 7″ x 5″
INSCR: Mr. John Greenhill . painter / se ipse pinx G.V.
ENGR: in reverse and with John Gaspars added by A. Bannerman for the 1762 edition of Walpole's *Anecdotes of Painting*, III, facing 21
ACQ: 1906 (Rare Book 83528, III, facing 48)
See under B.

The drawing does not appear to be derived directly from a known portrait of Greenhill, but it has a rather close relation to the self-portrait at Dulwich College.

I. *Louis Laguerre* (painter)
Wash over pencil; 7¼″ x 5″
INSCR: Mr Lewis Laguerre history painter / Kneller pinx G.V.
ENGR: by A. Bannerman for the 1771 edition of Walpole's *Anecdotes of Painting*, IV, facing 3
ACQ: 1906 (Rare Book 83528, IV, facing 4)
See under B.

Vertue (*Walpole Society*, Vertue Notebooks IV, 140) refers to a self-portrait by Laguerre at Blenheim.

J. *Bernard Lens* (miniature painter)
Wash over pencil; 6¼″ x 4½″
INSCR: BL [in monogram] 1718 / Mr Bernard Lens Limner G.V. / Drawing-master to the Duke & Princesses Obiit xt 1740
ENGR: in reverse by A. Bannerman for the 1771

edition of Walpole's *Anecdotes of Painting*, IV, facing 3, on same plate with Laguerre and Jervas
ACQ: 1906 (Rare Book 83528, IV, facing 181)
See under B.

This drawing appears to be based on the self-portrait miniature by Lens at Welbeck Abbey. It was certainly seen by Vertue and included in the catalog he made of the miniatures there (see *Walpole Society*, IV [1916], No. 148, Pl. XVII and p. 3).

K. *Peter Oliver* (miniature painter)
Wash over pencil; 5¾" x 4¾" (mounted on sheet 7 3/16" x 4⅞")
INSCR: Peter Oliver Limner / P. O. pinx [crossed out] delin. / from an Orig GV [in monogram]
ENGR: by T. Chambers for the 1762 edition of Walpole's *Anecdotes of Painting*, II, facing 12. The hat and dress have been changed, but the head is as in Vertue's drawing.
ACQ: 1906 (Rare Book 83528, II, facing 30)
See under B.

Vertue (in his notebooks) refers to several self-portrait drawings by Peter Oliver.

L. *Robert Streater* (painter)
Wash over pencil; 6⅝" x 5"
INSCR: Robert Streeter Seargeant-Painter / to K. Ch.2. G.V.
ENGR: in reverse by A. Bannerman for the 1762 edition of Walpole's *Anecdotes of Painting*, III, facing 8
ACQ: 1906 (Rare Book 83528, III, facing 14)
See under B.

Vertue (*Walpole Society*, Vertue Notebooks II, 69) refers to a self-portrait by Streater.

M. *John Van Wyck* or Jan Wyck (painter)
Pen and wash over pencil (unfinished); 7¼" x 5⅛"
INSCR: Mr John Wyck / Battle Painter Ob. 1702 / Kneller. p. G.V.
ENGR: in reverse and combined with Thomas Wyck by A. Bannerman for the 1762 edition of Walpole's *Anecdotes of Painting*, III, facing 133
ACQ: 1906 (Rare Book 83528, III, facing 267)
See under B.

Apparently based on the portrait painted by Kneller in 1685 (see *Dictionary of National Biography* on Wyck). Vertue is mistaken about the date of

Wyck's death; he was buried on Oct. 26, 1700. The finished drawing by Vertue of Jan Wyck is in the collection of Wilmarth Lewis.

N. *Thomas Van Wyck* (painter)
Pen and wash; 7" x 4¾"
INSCR: Thomas Van Wyke Painter / Father of John Wyke painter / G.V.
ENGR: in reverse and combined with Jan Wyck by A. Bannerman for the 1762 edition of Walpole's *Anecdotes of Painting*, III, facing 133
ACQ: 1906 (Rare Book 83528, III, facing 266)
See under B.

Vertue (*Walpole Society*, Vertue Notebooks IV, 45) refers to portraits of Thomas Wyck and of his wife both by Frans Hals, in the possession of Captain Laroon. The present whereabouts of the Hals original is undetermined, and indeed the painting seems to be known only through Vertue's drawing and subsequent print.

O. *Robert White* (engraver and miniaturist)
Wash and pencil; 4 5/16" x 3⅝" (oval) on sheet 7" x 5"
INSCR: Mr Robert White ad Vivum / delineator et Sculptor / se ipse delin
ENGR: in reverse by A. Bannerman for the 1763 edition of Walpole's *A Catalogue of Engravers*, facing p. 92
ACQ: 1906 (Rare Book 83528, facing 179)
See under B.

This drawing appears to be based on the self-portrait miniature by White at Welbeck Abbey, which was certainly seen by Vertue and included in the catalog he made of the miniatures there (see *Walpole Society*, IV [1916], No. 143, Pl. XXI and p. 3).

VERTUE, George (1684-1756), attributed to
P. *Abraham Van der Dort* (painter and antiquarian)
Wash; 7½" x 3½"
INSCR: [verso] A. Van der dort
ENGR: A closely related engraving by T. Chambers appeared in the 1762 edition of Walpole's *Anecdotes of Painting*, II, facing 48
ACQ: 1906 (Rare Book 83528, II, facing 101)
Stylistically this drawing is unlike the others by

Vertue in the extra-illustrated set of Walpole's *Anecdotes of Painting* in the Huntington Library. But its association with the other Vertue drawings in the volumes provides some basis for assigning it to him. The drawing is clearly derived from one of the two known versions of the Van der Dort portrait by Dobson (Hermitage, Leningrad, and National Portrait Gallery, London). The Hermitage version was at Houghton in the mid-eighteenth century and was among the pictures purchased by Catherine II in 1779.

VERTUE, George (1684-1756), attributed to

Q. *Admiral Sir Joseph Jordan*
Red chalk; 4⅛" x 3"
INSCR: [verso] Adm Jordan / No 3 Sept 4 87 p. Lely ft.
PROV: R. P. Roupell (Lugt 2234); Sir Bruce Ingram (Lugt 1405a)
ACQ: 1963 (Acc. No. 63.52.128)

The drawing is closely related to the painting of Jordan by Lely in the National Maritime Museum, Greenwich, but is in reverse. The drawing appears to be copied from one of the prints based on the painting. Stylistically the drawing closely resembles the work of Vertue; especially the portrait of Isaac Fuller (see D). The inscription on the verso probably applies to the Roupell sales, which took place in 1887, but in July rather than September.

WHITE, Robert (1645-1703)

White was probably the most popular English portrait engraver of the last thirty-five years of the seventeenth century. Most of his drawings are portraits made in connection with his prints. Often the drawings are based on the work of other artists, but sometimes they are independent *ad vivum* studies. In technique White follows his teacher Loggan, using pencil (or plumbago) on vellum, sometimes with touches of wash.

The group of White drawings in the Huntington Library are all contained in an elaborate extra-illustrated biographical dictionary prepared by Richard Bull in the late eighteenth century and known as "Bull's Granger." Bull apparently acquired his White drawings at the sale of James West (1773). West is known on the authority of Vertue to have had many White drawings.

A. *Self-portrait*
Black lead on vellum in feigned oval; 4 9/16" x 3½"
INSCR: Aetat 16 March 1 1661 R W; [also on the vellum sheet] R. White, drawn while an apprentice L. W.; [numbered in top right corner] 19
[On the margin of the mount in Bull's printing] I bought this curious drawing at Wests sale Vid. Walpole's Engrs. P 102 where mention is made of it, as well as many others now mine
LIT: Horace Walpole and James Dallaway, *A Catalogue of Engravers Who Have Been Born or Resided in England* (London, 1828), p. 206. George Vertue (*Walpole Society*, Vertue Notebooks V, 24) mentions the drawing as in the possession of West, and says it was retouched by White's son.
PROV: James West; Richard Bull; Estelle Doheny
ACQ: 1951 (in Bull's Granger, gift of Estelle Doheny, XVI, 89v)

B. *Richard Baxter* (Presbyterian divine)
Black lead on vellum, touched with wash on the face; 5 3/16" x 3 5/16"
INSCR: RW [in a later hand]
ENGR: by Robert White, 1670
PROV: James West (?); Richard Bull; Estelle Doheny
ACQ: 1951 (in Bull's Granger, gift of Estelle Doheny, XIV, 26v)

This drawing apparently derives from an anonymous engraving of 1667, the frontispiece to Baxter's *Reasons of the Christian Religion*.

C. *Henry Coley* (mathematician and astrologer)
Black lead on vellum; 5" x 3½"
INSCR: John Coley; [numbered] 55; [in a later hand] R.W.
ENGR: by Robert White, 1690
PROV: James West (?); Richard Bull; Estelle Doheny
ACQ: 1951 (in Bull's Granger, gift of Estelle Doheny, XVI, 47v)

Probably White's *ad vivum* study for the print.

D. *Josiah Keeling* (conspirator, involved with the Rye House plot)
Black lead on vellum; 5⅛" x 3⅞"
INSCR: Mr. Keeling; [and in a later hand] RW
ENGR: by Robert White, 1683(?)
PROV: James West (?); Richard Bull; Estelle Doheny
ACQ: 1951 (in Bull's Granger, gift of Estelle Doheny, XVII, 111v)

The Catalogue of Engraved British Portraits . . . in the British Museum gives White as both artist and engraver of this Keeling portrait. The drawing may be White's *ad vivum* design.

E. *Sir Patrick Lyon* (lord of session, and Scottish genealogist)
Black lead on vellum; face touched with wash; 4¾" x 3⅜"
INSCR: 22 [in top right corner]; Sr Patrick Lyon [and] R W [both in later hand]
ENGR: by Robert White *ad vivum* (no date)
PROV: James West (?); Richard Bull; Estelle Doheny
ACQ: 1951 (in Bull's Granger, gift of Estelle Doheny, XIV, 77v)

The drawing appears to be White's *ad vivum* sketch for the engraving.

F. *Richard Meggot, Dean of Winchester*
Black lead on vellum; 5½" x 4"
INSCR: Dr Meggot; [numbered] 6; [in later hand] R W
ENGR: by Robert White (no date)
PROV: James West (?); Richard Bull; Estelle Doheny
ACQ: 1951 (in Bull's Granger, gift of Estelle Doheny, XVIII, 87)

According to the caption on the print, the drawing must be derived from a Kneller painting.

G. *James, Duke of Monmouth*
Black lead on vellum; 6" x 4⅜"
INSCR: 4; [in a later hand] R. W.
PROV: James West (?); Richard Bull; Estelle Doheny
ACQ: 1951 (in Bull's Granger, gift of Estelle Doheny, XII, 102v)

Another much more highly finished drawing by White of the Duke of Monmouth is in the collection of the Duke of Portland (see *Walpole Society*, IV [1916], Pl. XXI). The Huntington drawing is similar to several engravings of the Duke of Monmouth but is not indubitably derived from any particular one.

H. *Samuel Pepys* (diarist)
Black lead on vellum; 4⅝" x 3⅝"
INSCR: Secretary Pepys; [numbered] 25; [in a later hand] R W
PROV: James West (?); Richard Bull; Estelle Doheny
ACQ: 1951 (in Bull's Granger, gift of Estelle Doheny, XIX, 2)

This drawing is related to Pepys's *ex libris* plate, engraved by White from a portrait by Kneller (Fig. 16). The drawing, however, has the head turned more to the right and differs in other details; it may be an *ad vivum* study.

Fig. 16. ROBERT WHITE, *Samuel Pepys* (engraving)

I. *Peter John Potemkin* (Russian ambassador to Great Britain)
Black lead on vellum; 5½" x 3⅞"
INSCR: Russian Ambassadore; [numbered] 9; [in a later hand] RW
ENGR: by Robert White, 1682
PROV: James West (?); Richard Bull; Estelle Doheny
ACQ: 1951 (in Bull's Granger, gift of Estelle Doheny, XVII, 138v)

The inscription on the print gives Kneller as the painter and White as engraver. The drawing is thus apparently after a Kneller portrait.

J. *John Williams, Archbishop of York*
Black lead on vellum; 5½" x 4 3/16" (oval)
ENGR: by Robert White, 1693
PROV: James West (?); Richard Bull; Estelle Doheny
ACQ: 1951 (in Bull's Granger, gift of Estelle Doheny, VII, 42)

This is apparently the preliminary drawing for White's engraving of Williams. It is clearly not an *ad vivum* portrait, but is probably derived ultimately from the portrait by C. Janssen.

WOOTTON, John (died 1765), attributed to
Wootton, Tillemans, and Seymour are the three prominent sporting artists active in England during the first half of the eighteenth century, and Wootton is probably the most attractive and versatile of the group. His style as a draftsman is unfortunately not clear-cut or well known. The two drawings in the Huntington collection can be classified only as "attributed to" Wootton.

A. *A Greyhound*
Pencil on blue-gray paper; 7⅝" x 7"
INSCR: Mr Wotton
PROV: There is a collector's mark on the drawing which appears to be Lugt 474, assigned by him to Crozat; Sir Bruce Ingram (Lugt 1405a)
ACQ: 1963 (Acc. No. 63.52.302)

B. *Before the Chase*
Gray wash over pencil; 6¾" x 10⅜"

PROV: Gilbert Davis (Lugt 757a)
ACQ: 1959 (Acc. No. 59.55.1471)

WORLIDGE, Thomas (1700-1766)
Worlidge was a prolific draftsman and etcher. He copied and imitated Rembrandt prints successfully and also etched designs after antique gems. Most of his drawings are portrait heads, for which he seems to have enjoyed a particular reputation during the mid-eighteenth century.

A. *Head of a Boy*
Red pencil over black; 8 1/16" x 6 1/16"
Signed with initials
PROV: Sir Bruce Ingram (Lugt 1405a)
ACQ: 1963 (Acc. No. 63.52.303)

B. *Four Studies of Heads* (on one sheet)
Black pencil; 7⅞" x 6⅛"
Signed with initials, and on mount: Worlidge fect.
PROV: Gilbert Davis (Lugt 757a)
ACQ: (Acc. No. 59.55.1472)

WYCK, Jan (ca. 1645-1700)
Wyck was born in Haarlem and likely came to England with his father, Thomas Wyck, shortly after the Restoration. Jan is known primarily as a battle and sporting painter. As the teacher of John Wootton, Wyck is one of the primary founders of English sporting painting.

A. *Charles II at Newmarket Races*
Soft black pencil; 6¾" x 13¾"
INSCR: ye King Charles at Newmarket Races J. Wyck
PROV: In Richard Bull's extra-illustrated copy of Antoine Hamilton, *Mémoires du Comte de Grammont*, III, following 294
ACQ: 1951

WYCK, Jan (ca. 1645-1700), attributed to
B. *Hare Hunting*
Pen and brown ink over red pencil; 3½" x 11⅞"
PROV: Viscount Knutsford; John F. Keane; Gilbert Davis (Lugt 757a)
ACQ: 1959 (Acc. No. 59.55.1474)

ZUCCARELLI, Francesco (1702-1788)

Zuccarelli, Italian by birth and training, was in England on two occasions, once during the 1740's, and again from 1752 to 1773. His influence on English art was considerable, particularly on those draftsmen (like Gainsborough) interested in imaginative landscape.

A. *A Farm Girl*
Wash and body color over red pencil; 7⅜″ x 5½″
PROV: Gilbert Davis (Lugt 757a)
ACQ: 1959 (Acc. No. 59.55.1478)

Zuccarelli often used a gourd as a signature, a play on his own name. The gourd on the ground in this drawing could be interpreted in this way.

ZUCCARELLI, Francesco (1702-1788), attributed to

B. *Classical Landscape*
Black crayon heightened with black and white wash; 9½″ x 14⅜″
INSCR: Francis Zucarella [on old mount; there are initials on the drawing but they are not readily decipherable and do not appear to be those of the artist]
PROV: Sir Bruce Ingram (Lugt 1405a)
ACQ: 1963 (Acc. No. 63.52.307)

PLATES

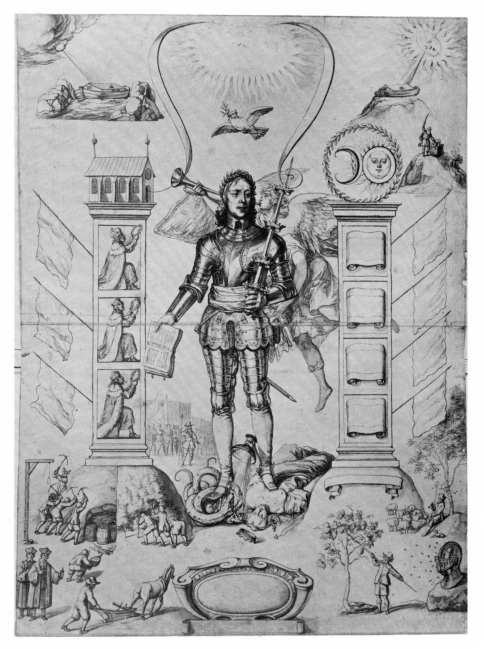

FRANCIS BARLOW
A. *Emblematic Portrait of Oliver Cromwell*

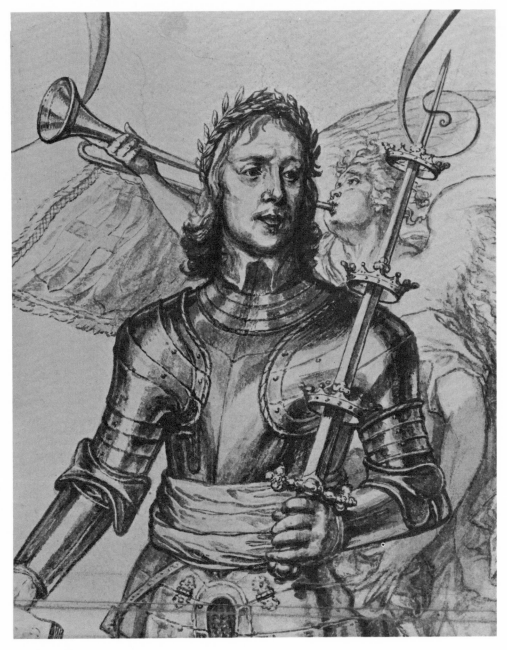

FRANCIS BARLOW
A. *Emblematic Portrait of Oliver Cromwell* (detail)

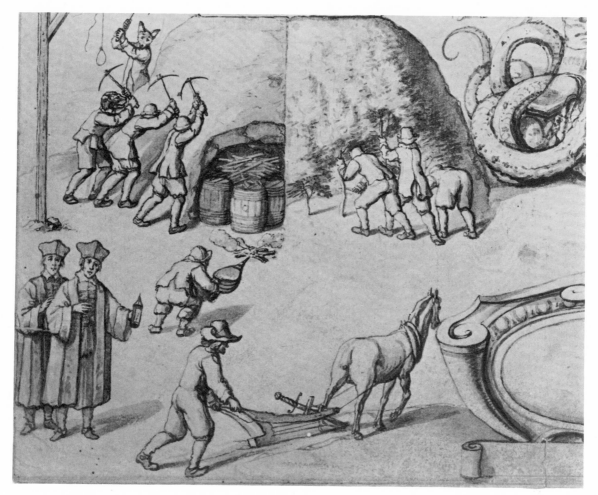

FRANCIS BARLOW
A. *Emblematic Portrait of Oliver Cromwell* (detail)

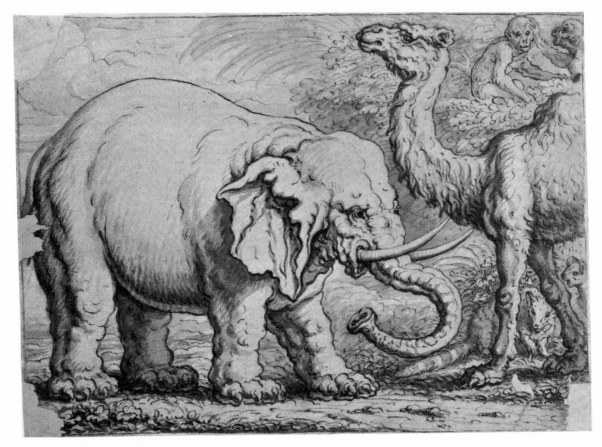

FRANCIS BARLOW
B. *An Elephant and a Camel*

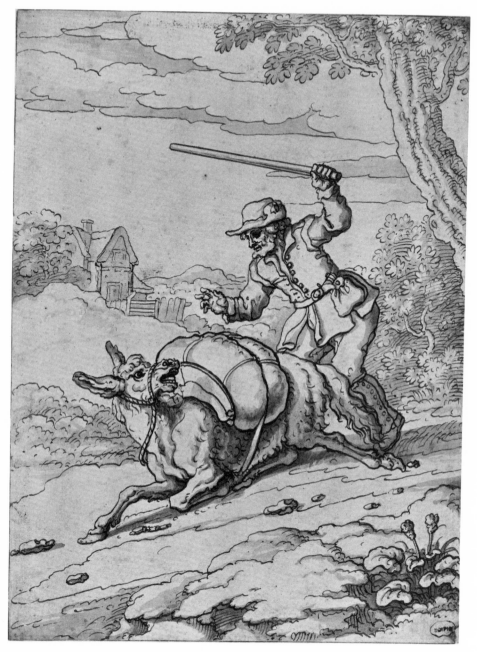

FRANCIS BARLOW
c. *The Pedlar and His Ass*

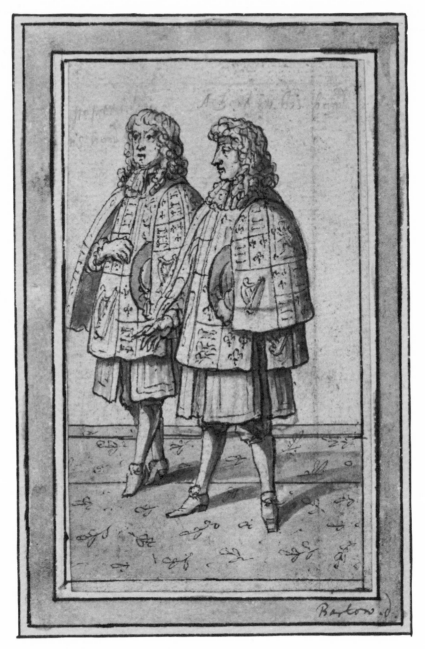

FRANCIS BARLOW
D. *Two Heralds*

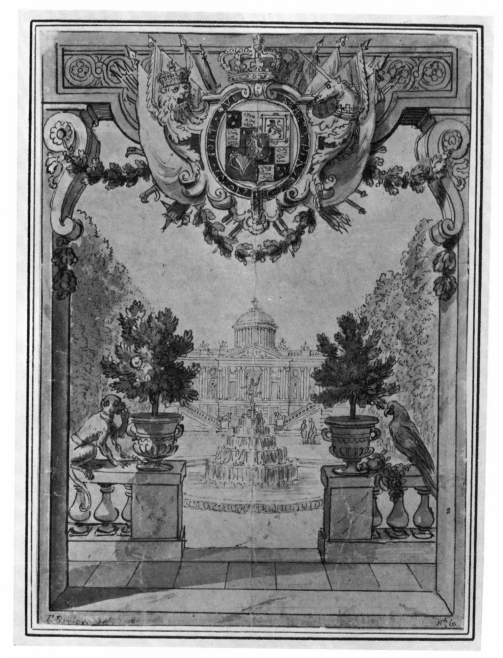

FRANCIS BARLOW
E. *Design for a Title Page or Decorative Panel*

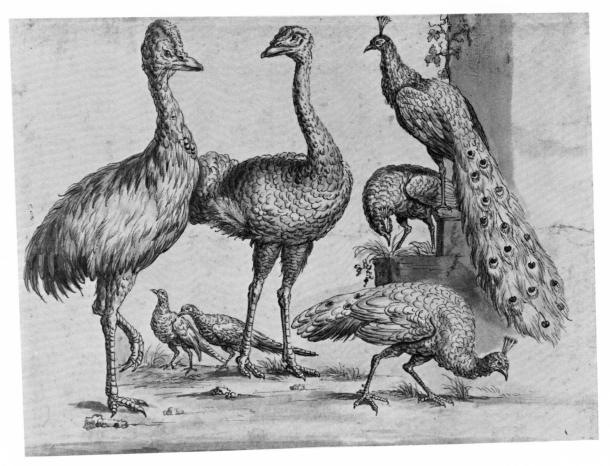

FRANCIS BARLOW, after,
Group of Birds

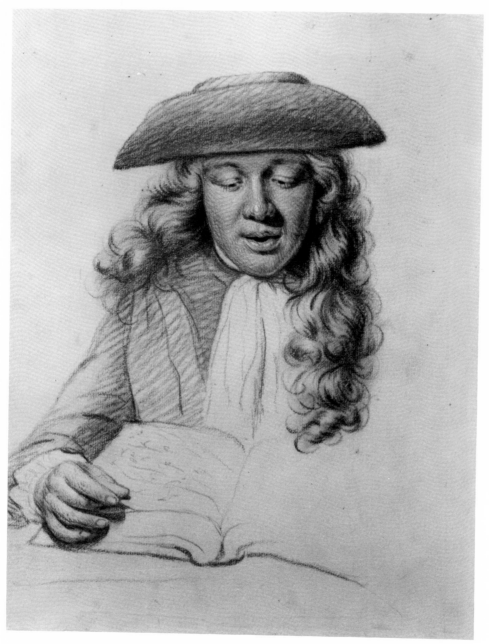

CHARLES BEALE II
A. *Portrait of a Man Reading*

CHARLES BEALE II
B. *Anthony Ashley Cooper, 1st Earl of Shaftesbury*

CHARLES BEALE II, attributed to
c. *Head of a Man*

ISAAC BECKETT, attributed to,
Portrait of a Man

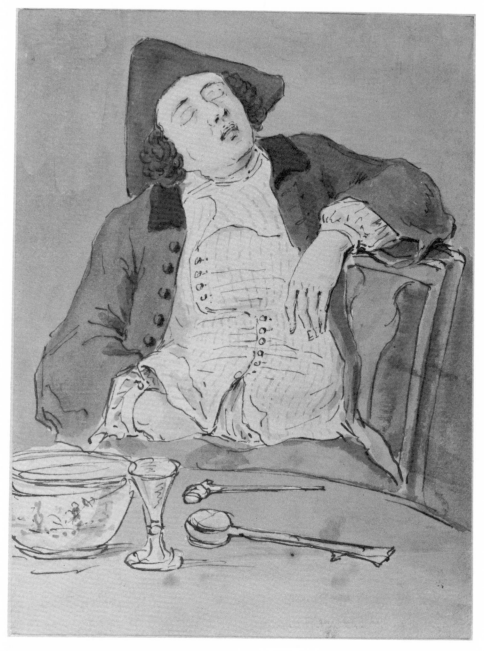

LOUIS PHILIPPE BOITARD
Man Asleep at a Table

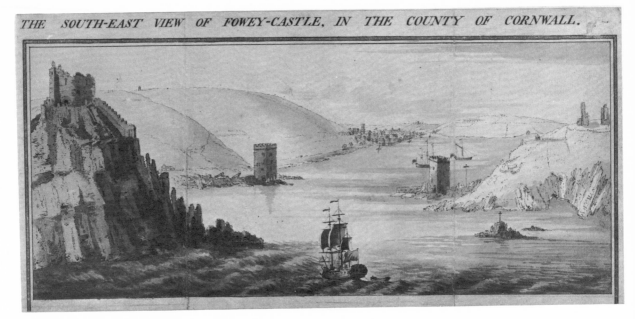

SAMUEL AND NATHANIEL BUCK
A. *The Southeast View of Fowey Castle*

THE EAST VIEW OF Sᵗ MAWS CASTLE.

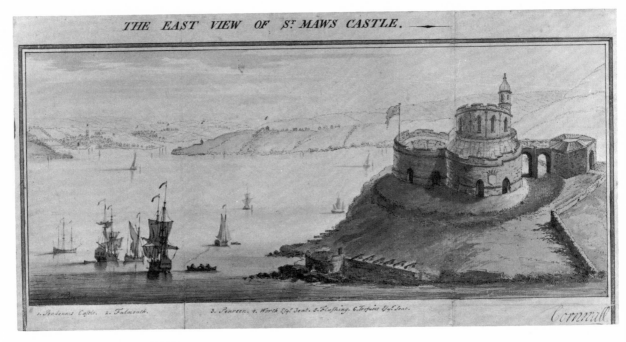

SAMUEL AND NATHANIEL BUCK
B. *The East View of St. Maws Castle*

JOHN BULFINCH
A. *Thomas Blood*

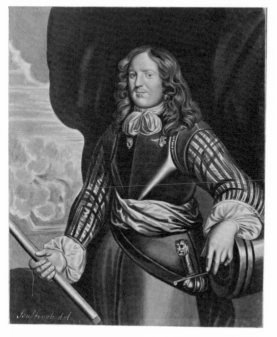

JOHN BULFINCH
B. *Sir John Lawson*

JOHN BULFINCH
C. *Gilbert Sheldon, Archbishop of Canterbury*

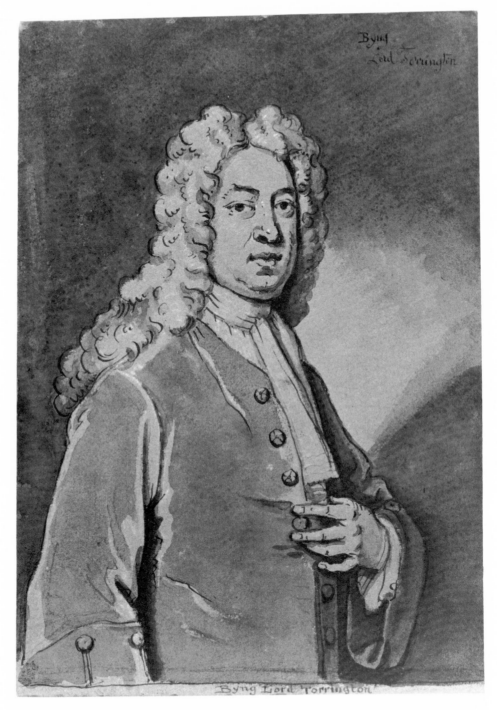

EDWARD BYNG
Lord Torrington

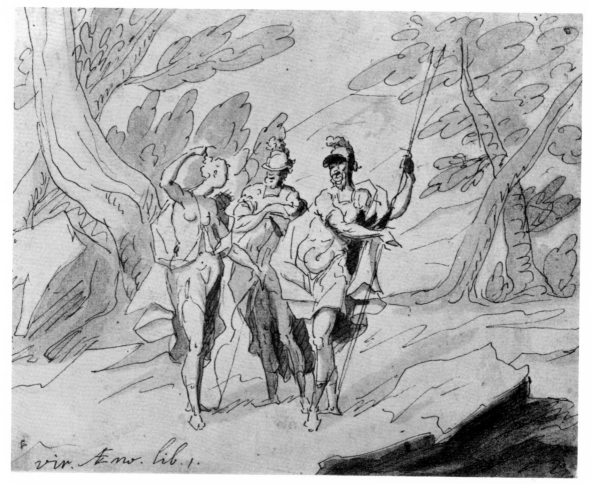

THOMAS CARWITHAM
A. *An Illustration to Virgil's* Aeneid, *Bk. I*

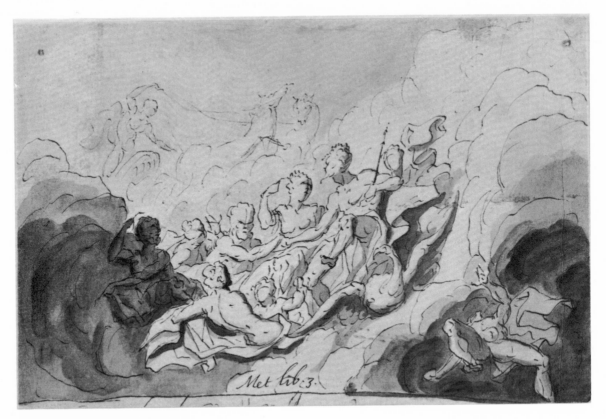

THOMAS CARWITHAM
B. *An Illustration to Ovid's* Metamorphoses, *Bk. III*

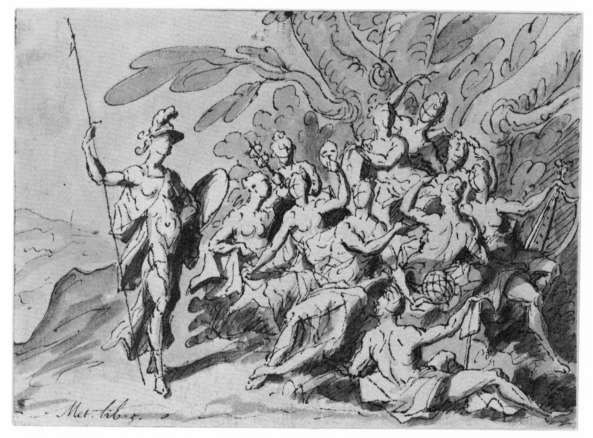

THOMAS CARWITHAM
c. *An Illustration to Ovid's* Metamorphoses, *Bk. V*

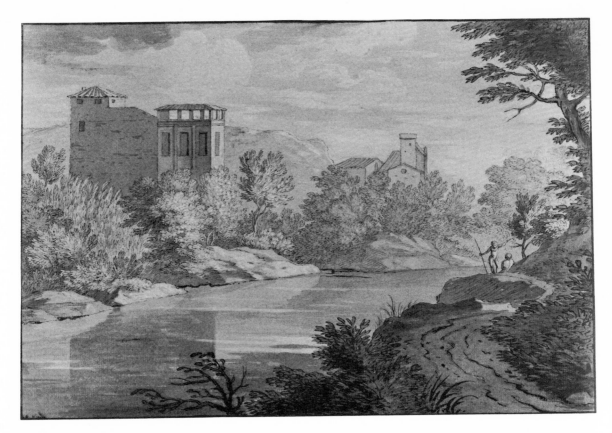

ALEXANDER COZENS
A. *River Landscape with Buildings*

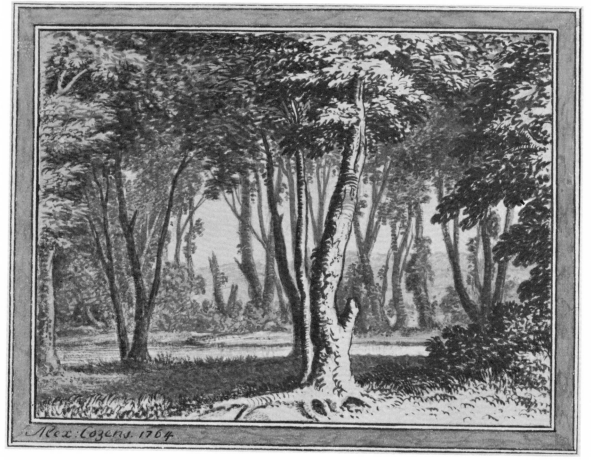

ALEXANDER COZENS
B. *View in a Wood*

ALEXANDER COZENS
c. *Landscape with Ruins*

ALEXANDER COZENS
D. *Landscape with Ruined Castle*

ALEXANDER COZENS
E. *A Rocky Landscape*

ALEXANDER COZENS
F. *Lake Scene*

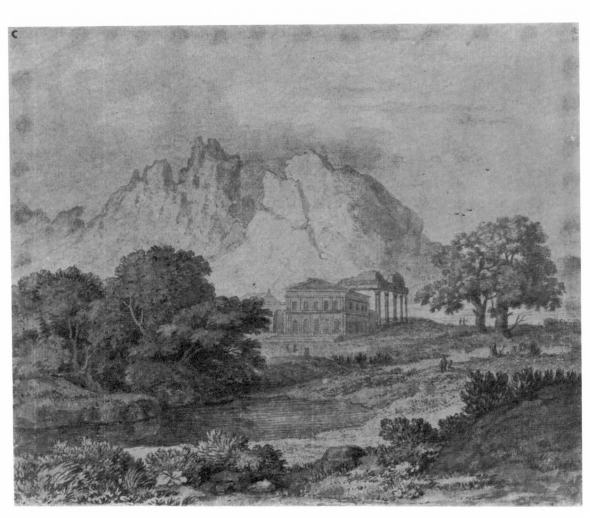

ALEXANDER COZENS
G. *Landscape with Ruined Temple*

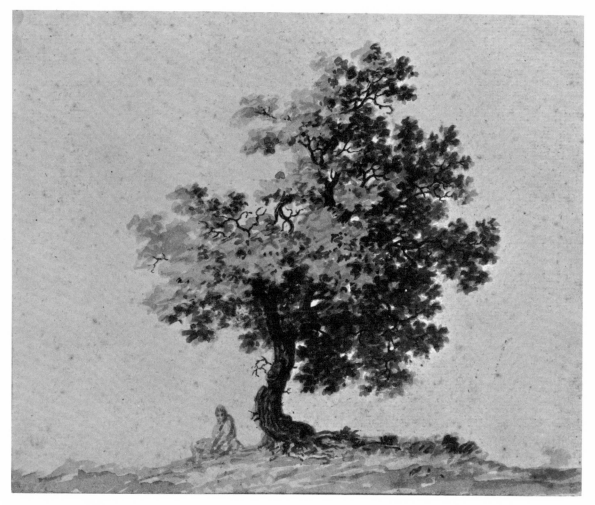

ALEXANDER COZENS
H. *Tree with Seated Figure*

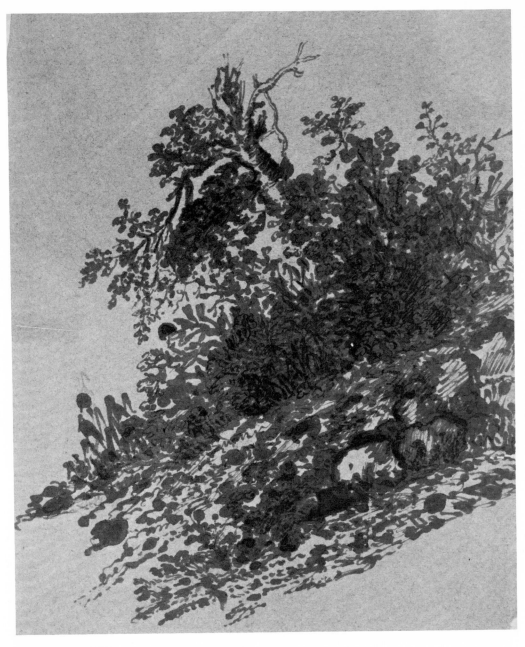

ALEXANDER COZENS
I. *Sunlit Bush*

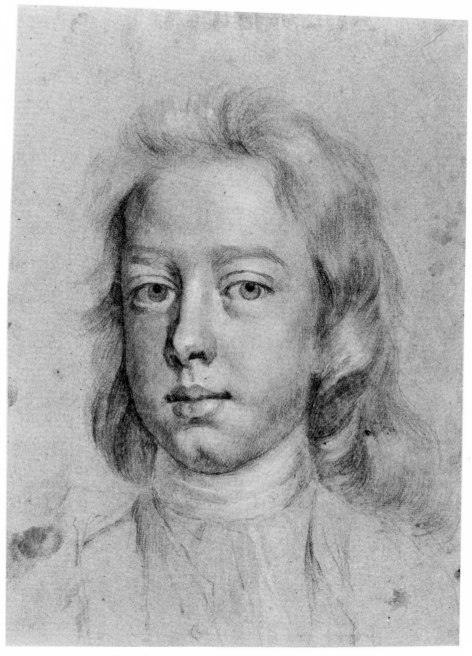

MICHAEL DAHL, attributed to
Head of a Boy

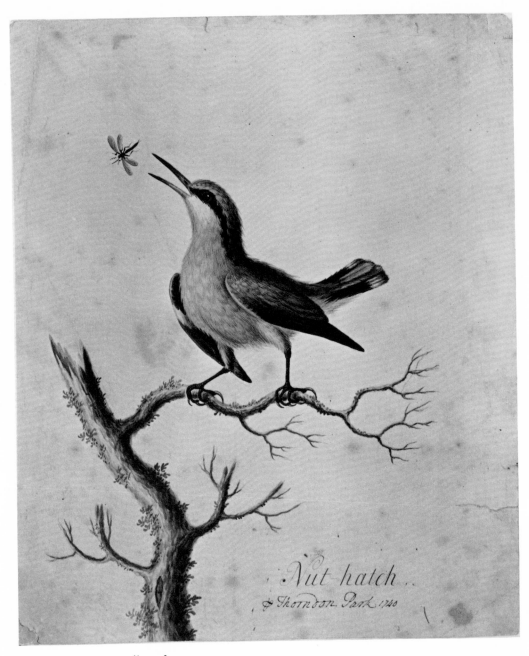

Nut hatch..
& Thorndon. Park 1740

GEORGE EDWARDS, attributed to
A. *Nut-hatch*

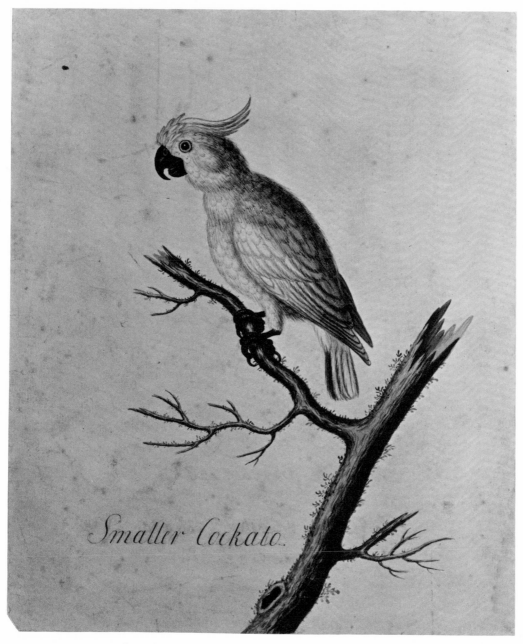

Smaller Cockato.

GEORGE EDWARDS, attributed to
B. *Smaller Cockatoo*

ENGLISH SCHOOL (ca. 1680)
George Villiers, 2nd Duke of Buckingham

ENGLISH SCHOOL (ca. 1680)
A Young Man

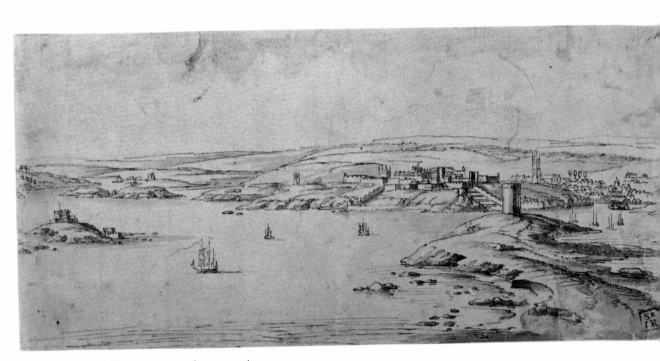

ENGLISH SCHOOL (late seventeenth century)
Plymouth Sound

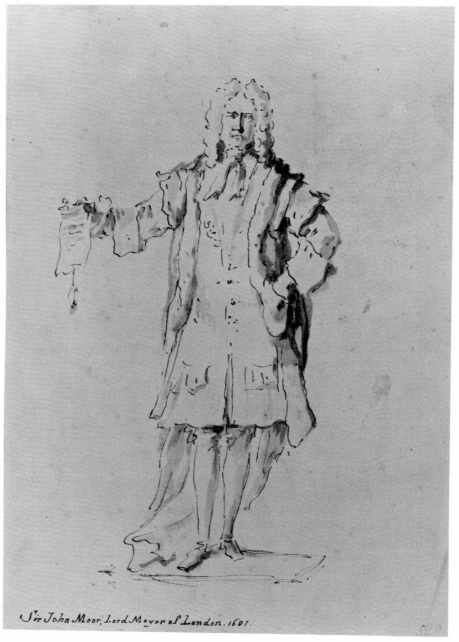

Sir John Moor, Lord Mayor of London. 1681.

ENGLISH SCHOOL (ca. 1700)
Sir John Moore, Lord Mayor of London

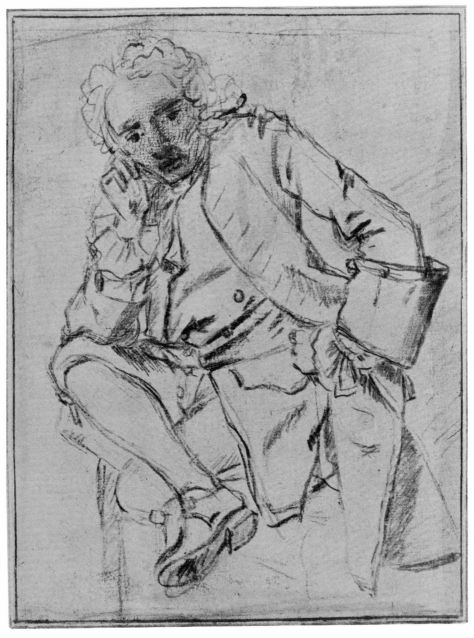

ENGLISH SCHOOL (second quarter of the eighteenth century)
Alexander Pope

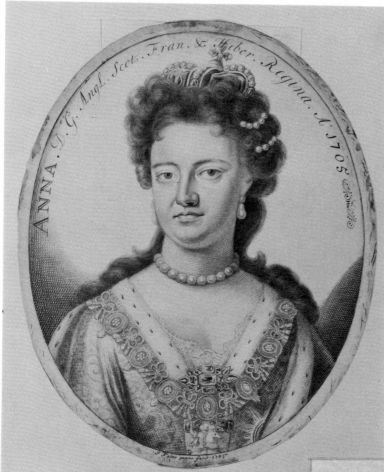

JOHN FABER I
A. *Queen Anne*

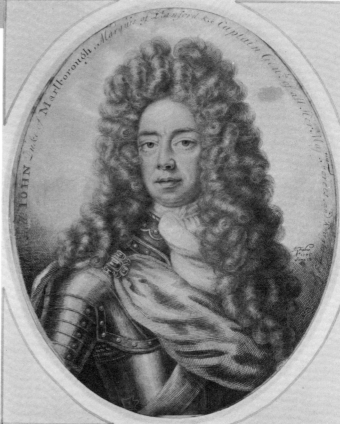

JOHN FABER I
B. *John, Duke of Marlborough*

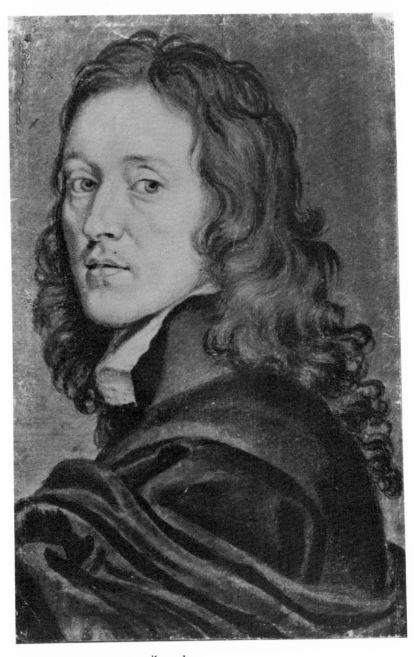

WILLIAM FAITHORNE, attributed to
Self-portrait

JAMES FERGUSON
A. *Portrait of Mrs. Hooth*

JAMES FERGUSON
B. *Portrait of a Woman*

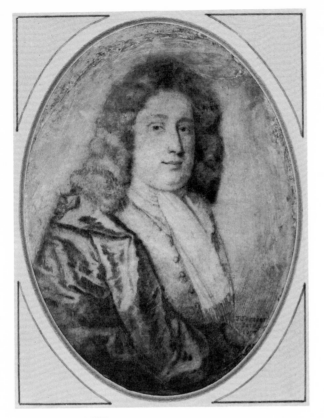

THOMAS FORSTER
A. *Portrait of a Man*

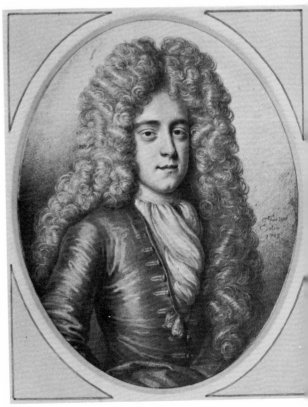

THOMAS FORSTER
B. *Portrait of a Man*

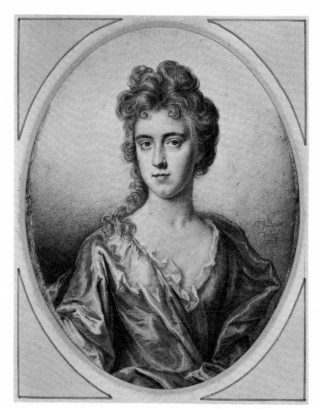

THOMAS FORSTER
C. *Portrait of a Lady*

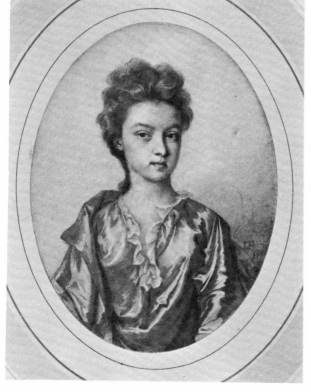

THOMAS FORSTER
D. *Portrait of a Young Woman*

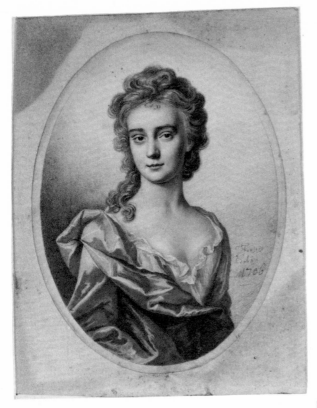

THOMAS FORSTER
E. *Portrait of a Young Lady*

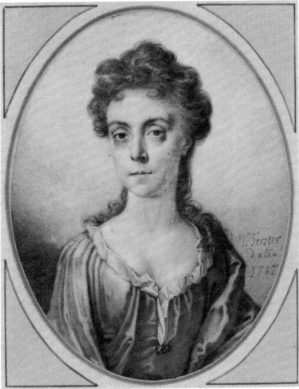

THOMAS FORSTER
F. *Portrait of a Woman*

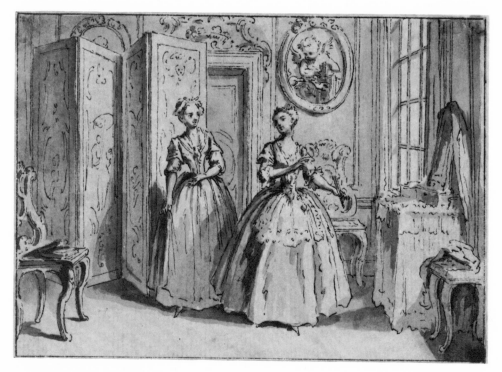

HUBERT FRANÇOIS GRAVELOT
Two Women Standing in a Boudoir

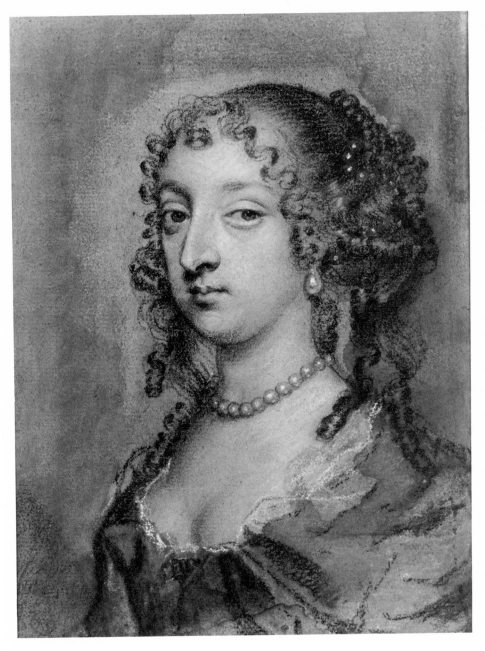

JOHN GREENHILL
Countess of Gainsborough

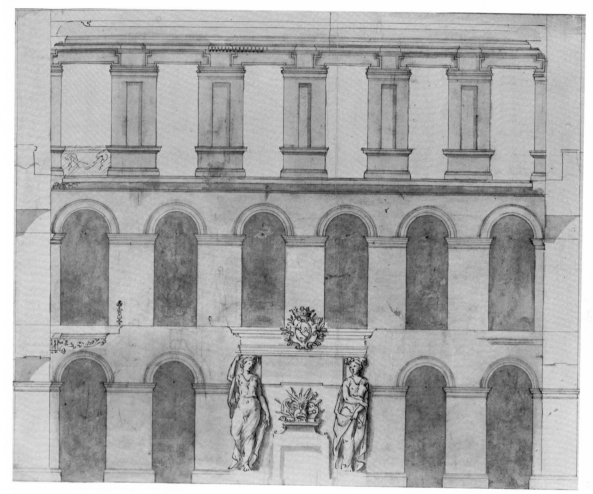

NICHOLAS HAWKSMOOR
Project for the West Wall of the Hall at Blenheim

FRANCIS HAYMAN
The State of Great Britain with Regard to Her Debt

WILLIAM HOGARTH, attributed to
Gin Lane

WENCESLAUS HOLLAR
A. *View of Rye*

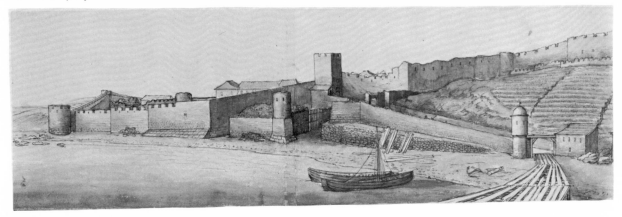

WENCESLAUS HOLLAR
B. *View of the Coast of Tangier, with Fortifications*

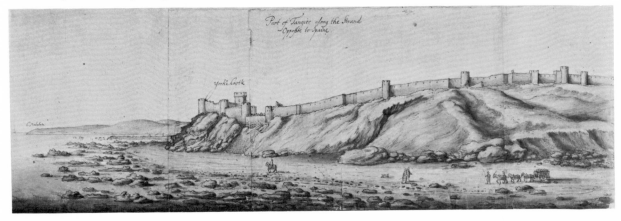

WENCESLAUS HOLLAR
C. *Part of Tangier along the Strand*

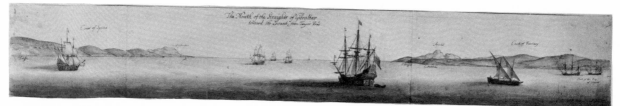

WENCESLAUS HOLLAR
D. *The Mouth of the Straits of Gibraltar, toward the Levant*

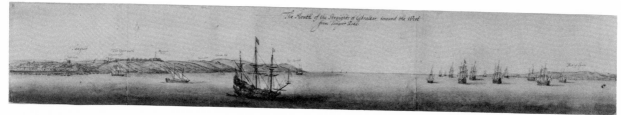

WENCESLAUS HOLLAR
E. *The Mouth of the Straits of Gibraltar, toward the West*

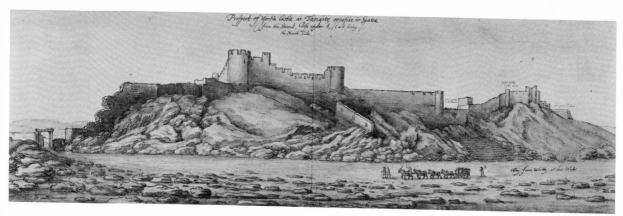

WENCESLAUS HOLLAR
F. *Prospect of Yorke Castle*

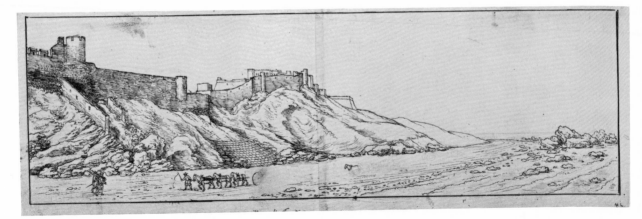

WENCESLAUS HOLLAR
G. *Tangier: the Beach*

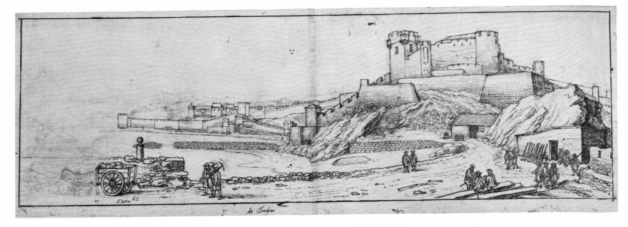

WENCESLAUS HOLLAR
H. *View of Tangier*

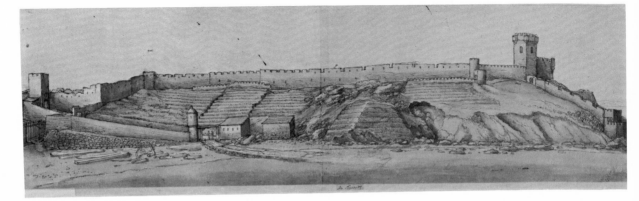

WENCESLAUS HOLLAR
I. *Tangier Fortifications*

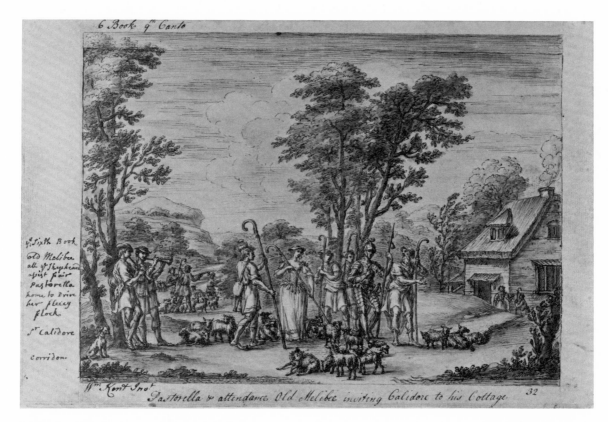

WILLIAM KENT
An Illustration to Spenser's Faerie Queene

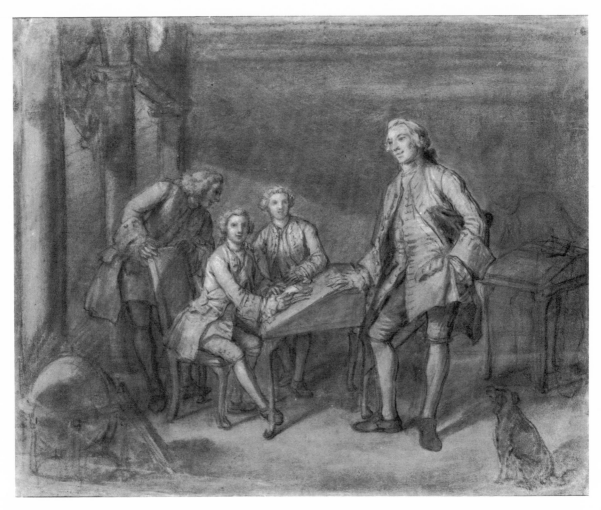

GEORGE KNAPTON
George, Prince of Wales, with His Brother and Tutors

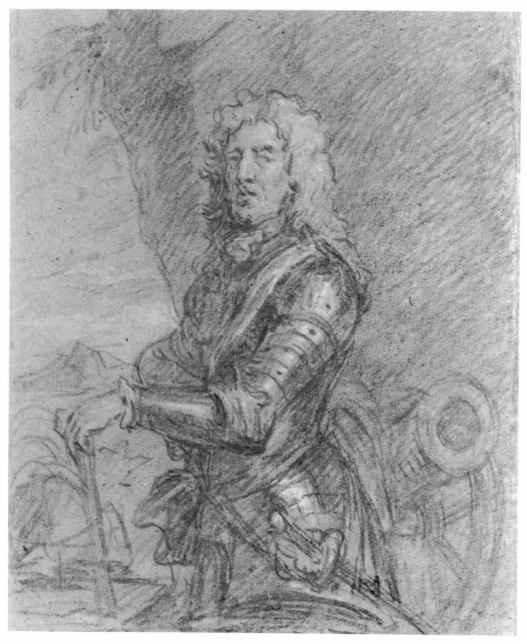

SIR GODFREY KNELLER
Portrait of a General

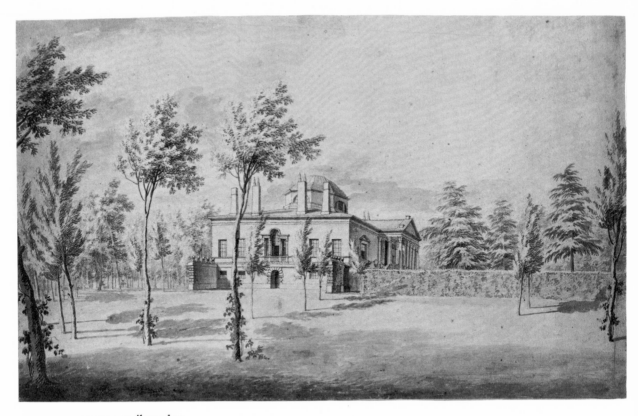

GEORGE LAMBERT, attributed to
A. *View of Chiswick House*

GEORGE LAMBERT, attributed to
B. *View of the Bowling Green at Claremount, Surrey*

GEORGE LAMBERT, attributed to
c. *View in the Park at Claremount, Surrey*

MARCELLUS LAROON, the Younger
A. *A Musical Party*

MARCELLUS LAROON, the Younger
B. *A Family Group*

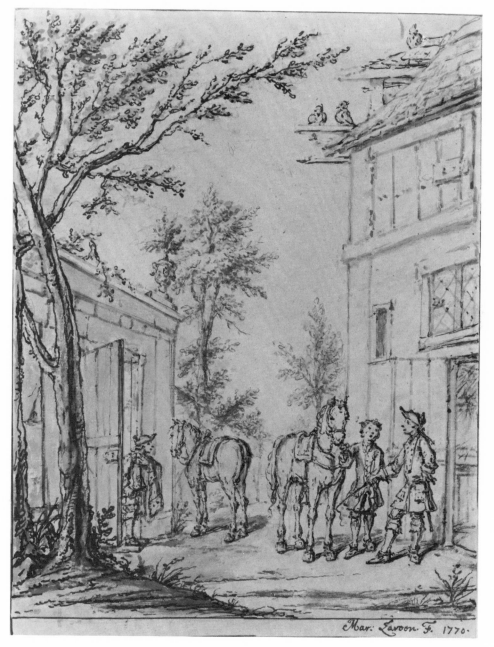

MARCELLUS LAROON, the Younger
c. *The Morning Ride*

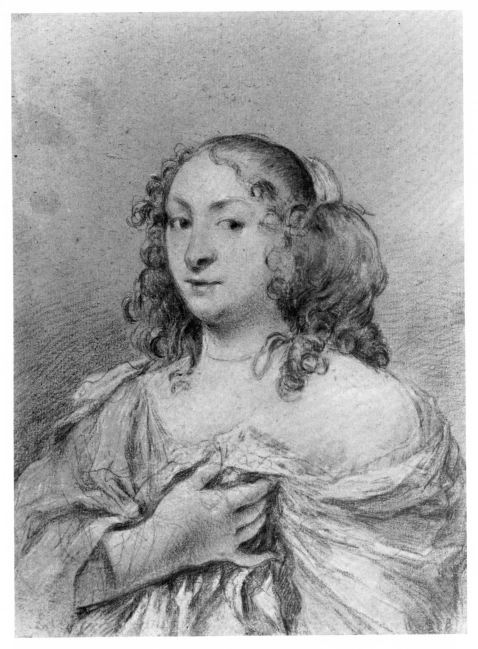

SIR PETER LELY
A. *Portrait of a Lady*

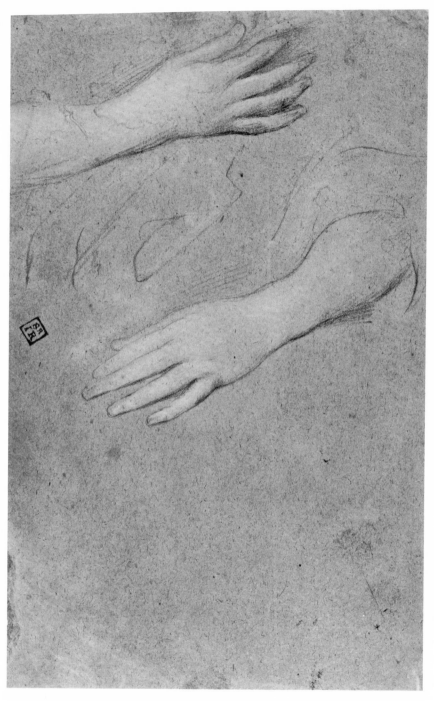

SIR PETER LELY
B. *Study of a Woman's Hands*

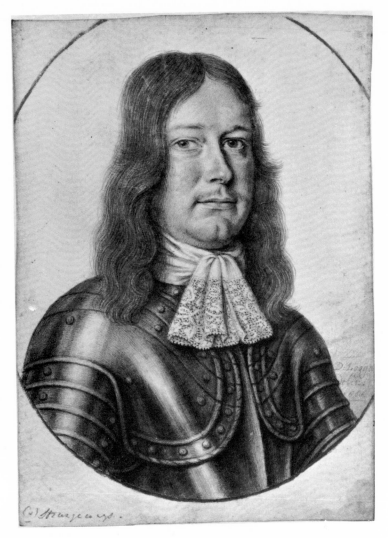

DAVID LOGGAN
A. *Portrait of a Man*

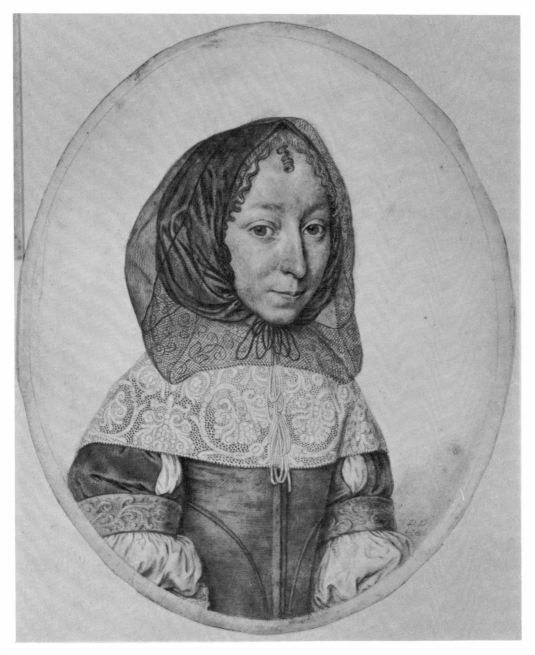

DAVID LOGGAN
B. *Portrait of a Woman*

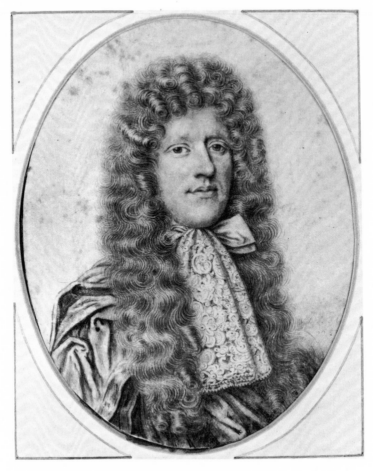

DAVID LOGGAN
C. *Charles, 6th Duke of Somerset*

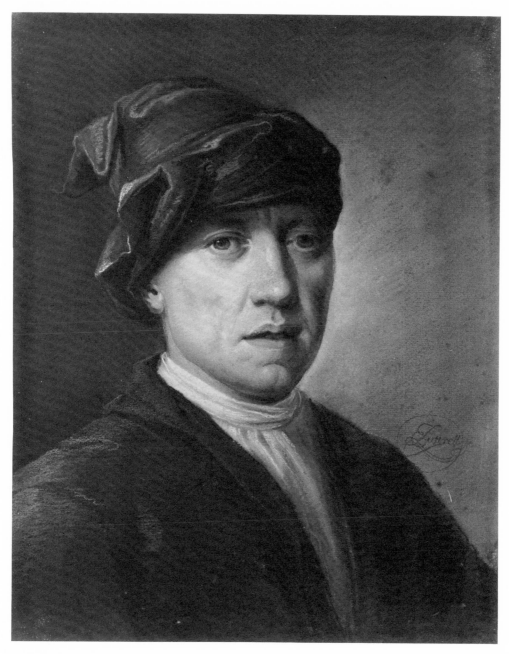

EDWARD LUTTRELL
Portrait of a Man

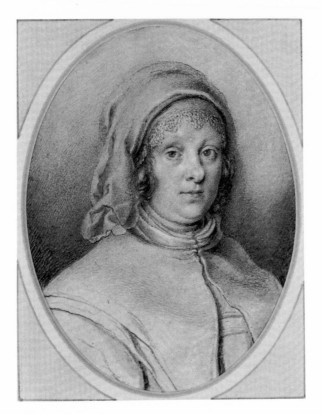

PETER OLIVER
A. *Portrait of a Lady*

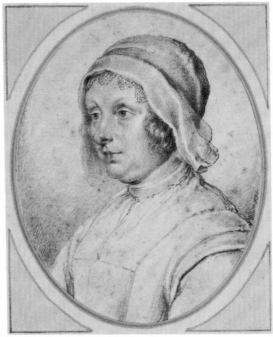

PETER OLIVER
B. *Portrait of a Lady*

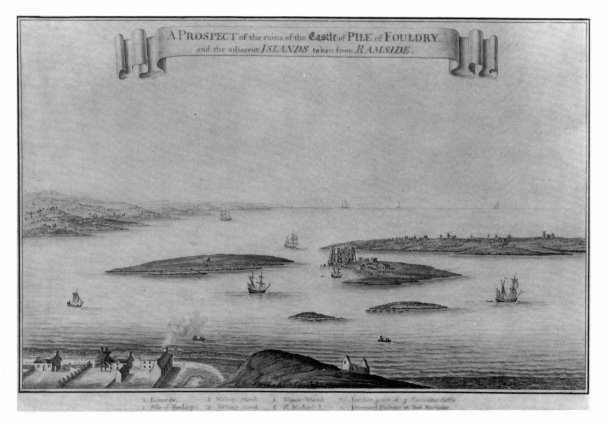

STEPHEN PENN
A Prospect of the Ruins of the Castle of Pile of Fouldry

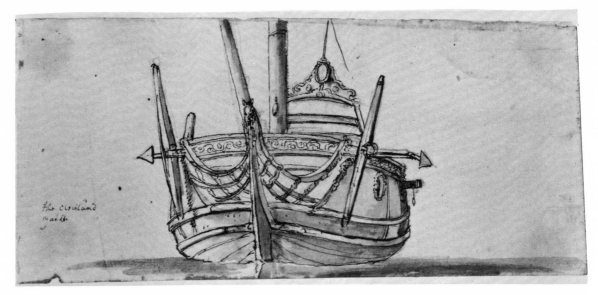

FRANCIS PLACE
A. *The Yacht, "Cleveland"*

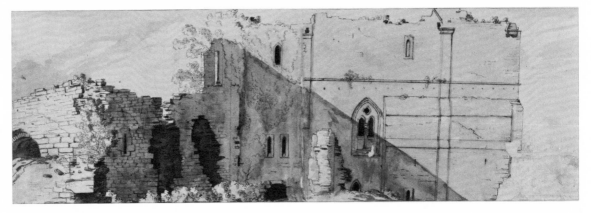

FRANCIS PLACE
B. *Ruins of Easby Abbey*

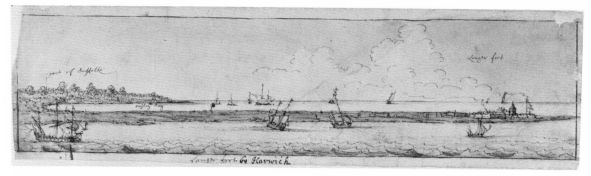

FRANCIS PLACE
c. *Landguard Fort, Harwich*

FRANCIS PLACE
d. *West Gate, Newcastle*

FRANCIS PLACE
E. *Scarborough Castle from the Beach*

pt of Scarborough Castle

FRANCIS PLACE
F. *Part of Scarborough Castle*

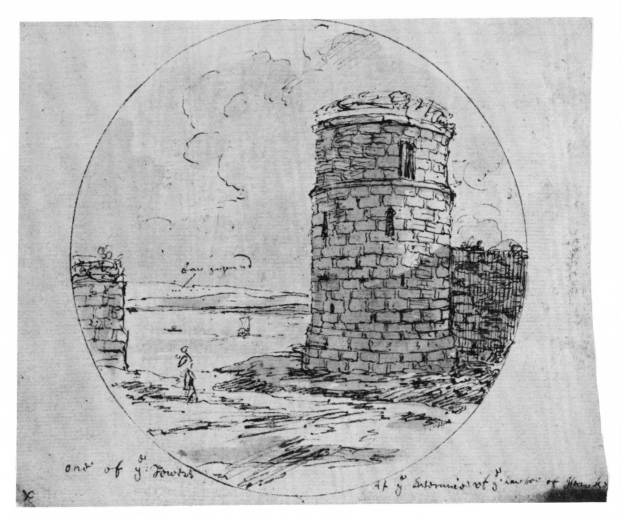

FRANCIS PLACE
G. *A Tower at The Hague* (?)

FRANCIS PLACE
H. *View of a Town*

FRANCIS PLACE
1. *Ship in a Storm*

FRANCIS PLACE
J. *A Ruff*

FRANCIS PLACE, possibly by
Beach Scene with Boats

Gilbert Burnet Bp. of Sarum
done by my Father from the Picture of Mr. Riley, & under
his Direction, for the Print in Mezzo Tinto.

JONATHAN RICHARDSON, SR.
A. *Gilbert Burnet, Bishop of Salisbury*

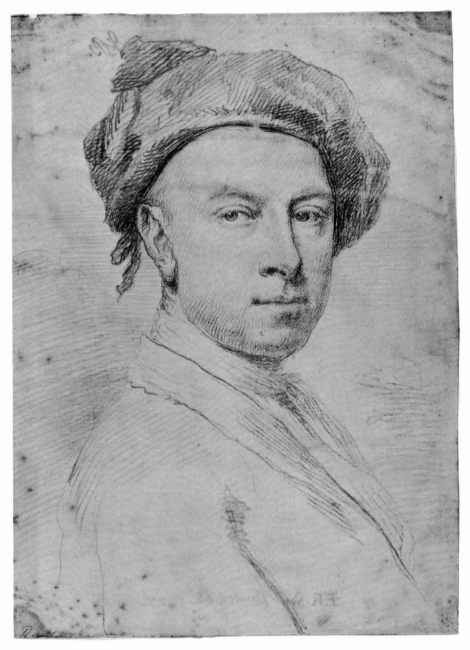

JONATHAN RICHARDSON, SR.
B. *Self-portrait*

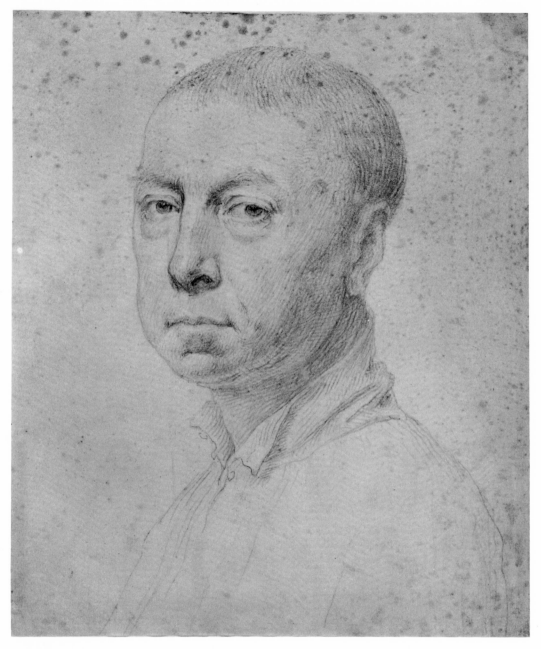

JONATHAN RICHARDSON, SR.
c. *Self-portrait*

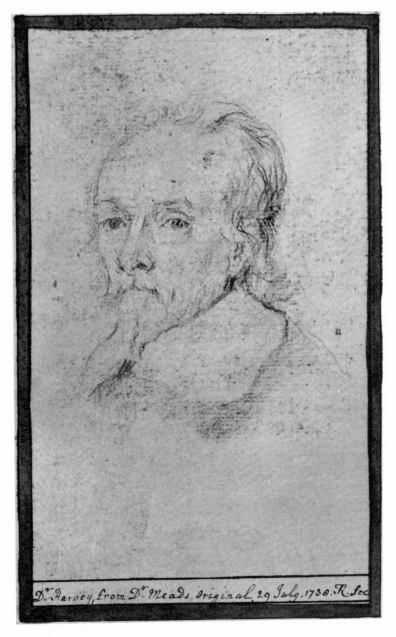

Dr. Harvey, from Dr. Meads original 29 July. 1730. R. fec

JONATHAN RICHARDSON, SR.
D. *Dr. William Harvey*

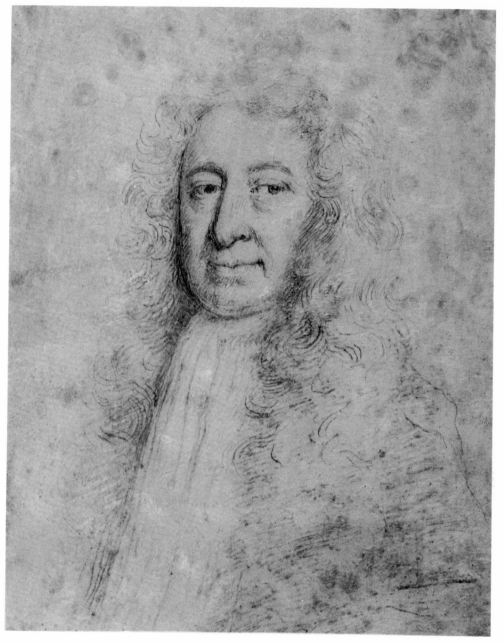

JONATHAN RICHARDSON, SR.
E. *Mr. James Morgan*

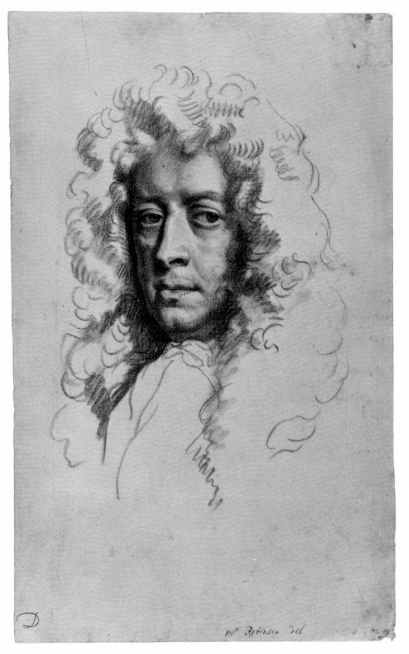

THOMAS ROBINSON
Head of a Man

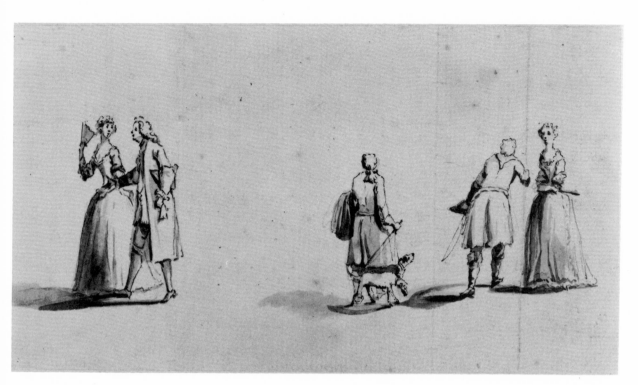

THOMAS ROSS
Group of Figure Studies

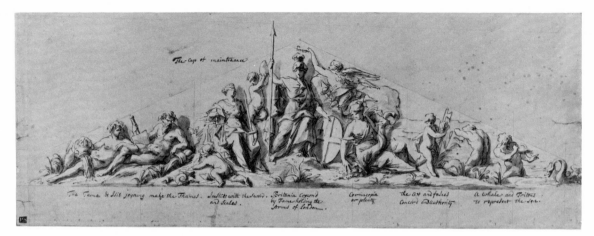

JOHN MICHAEL RYSBRACK
A. *Design for a Pediment*

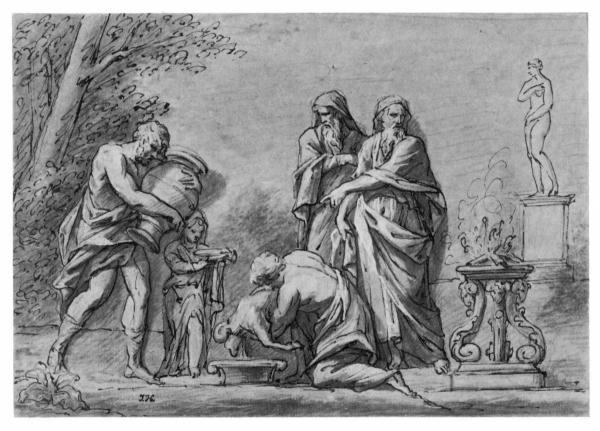

JOHN MICHAEL RYSBRACK
B. *A Sacrifice*

JOHN MICHAEL RYSBRACK
c. *Henry Herbert (later Earl of Carnarvon)*

JOHN MICHAEL RYSBRACK
D. *William Herbert*

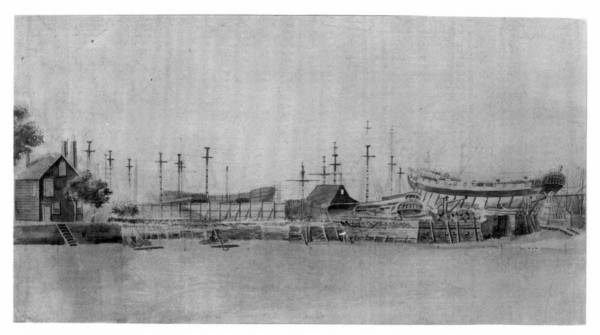

SAMUEL SCOTT
A. *A Shipbuilder's Yard*

SAMUEL SCOTT
B. *Men Unloading a Ship's Barge*

SAMUEL SCOTT
C. *Study of Buildings by the Thames at Deptford*

SAMUEL SCOTT
D. *Study of a Ship's Boat*

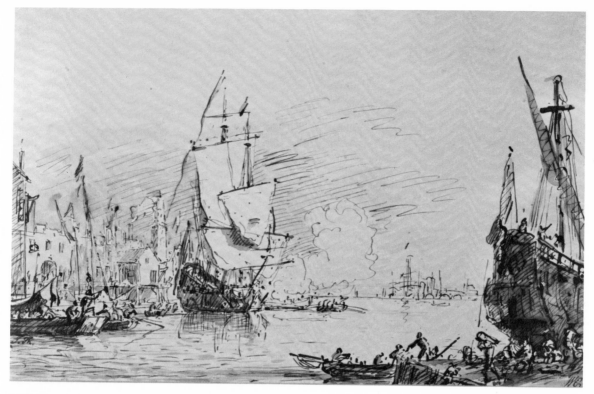

SAMUEL SCOTT
E. *Men-o'-War in the Thames*

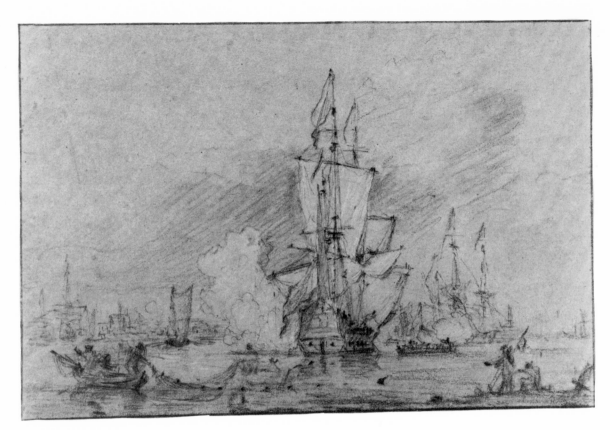

SAMUEL SCOTT
F. *Seascape with Men-o'-War Firing a Salute*

SAMUEL SCOTT
G. *Seascape with Sailing Vessels*

JAMES SEYMOUR
Horse with Rider

JAMES SEYMOUR, follower of
Three Racing Sketches

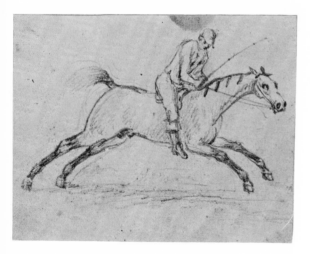

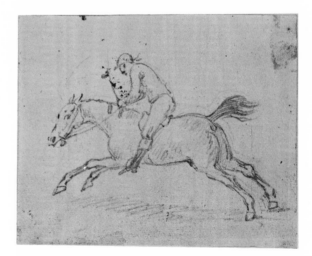

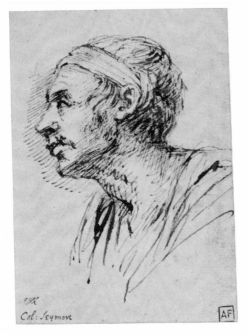

COL. JOHN SEYMOUR
A. *Head of a Man*

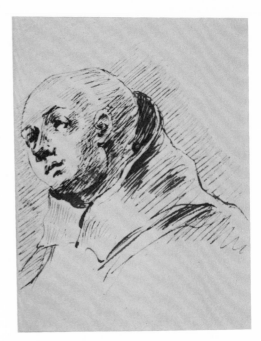

COL. JOHN SEYMOUR
B. *Head of a Monk*

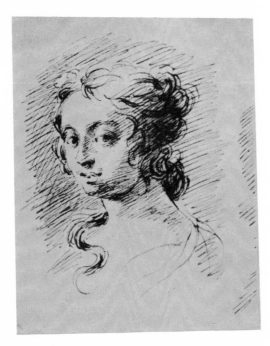

COL. JOHN SEYMOUR
C. *Head of a Woman*

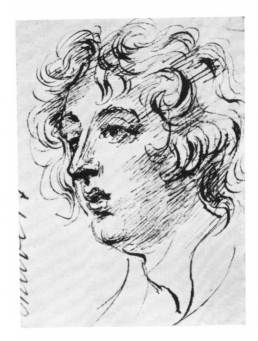

COL. JOHN SEYMOUR
D. *Head of a Youth*

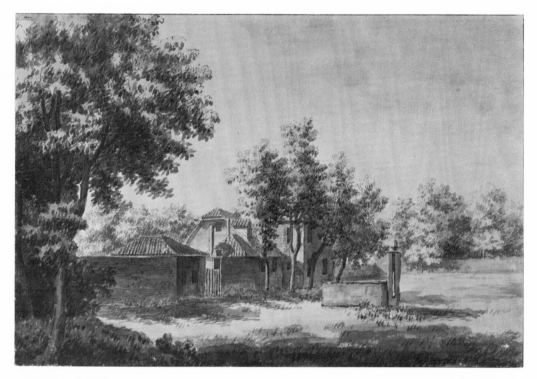

JONATHAN SKELTON
Landscape with Farmhouse and Buildings

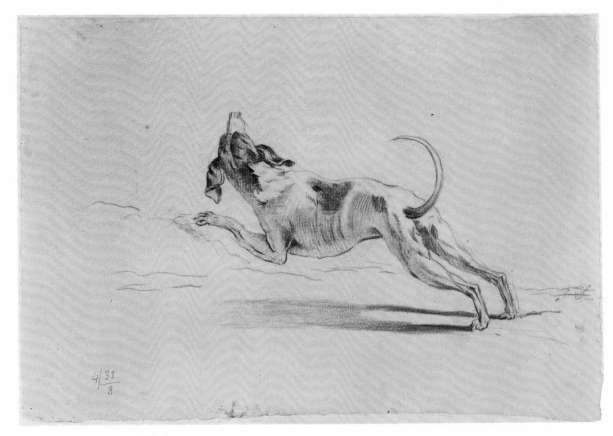

THOMAS SPENCER, possibly by
A. *A Hound*

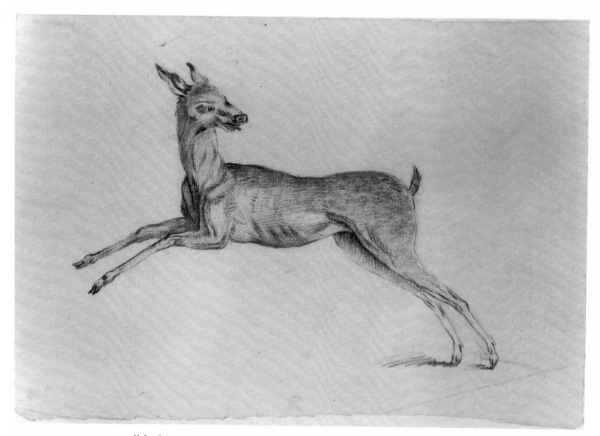

THOMAS SPENCER, possibly by
B. *A Deer*

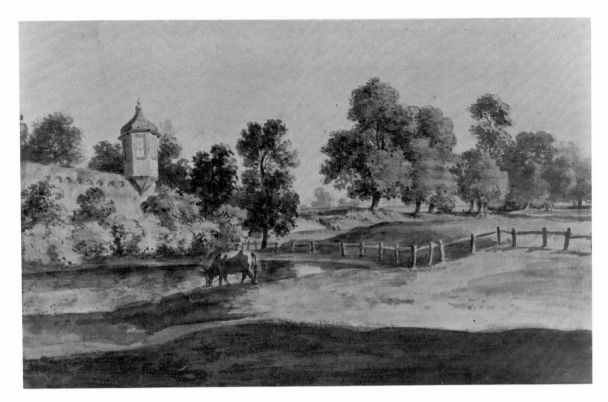

WILLIAM TAVERNER
A. *The Gazebo*

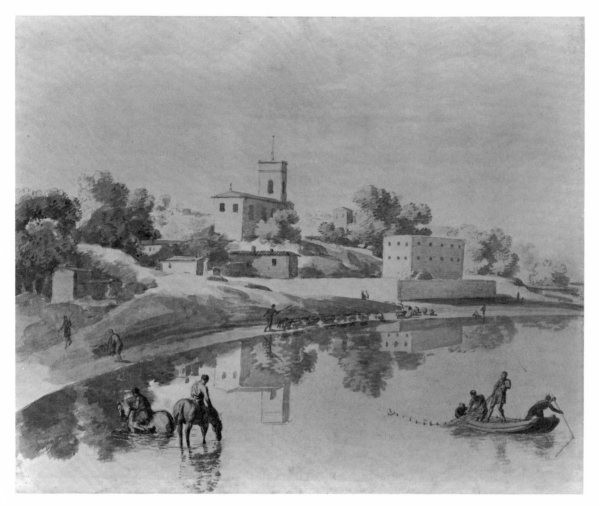

WILLIAM TAVERNER
B. *A Town by a Lake*

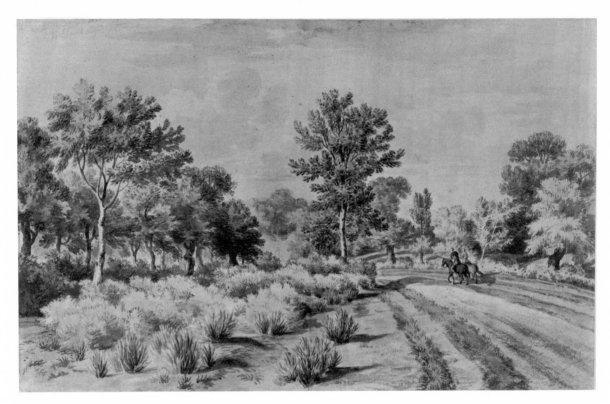

WILLIAM TAVERNER
c. *Landscape with Two Horsemen*

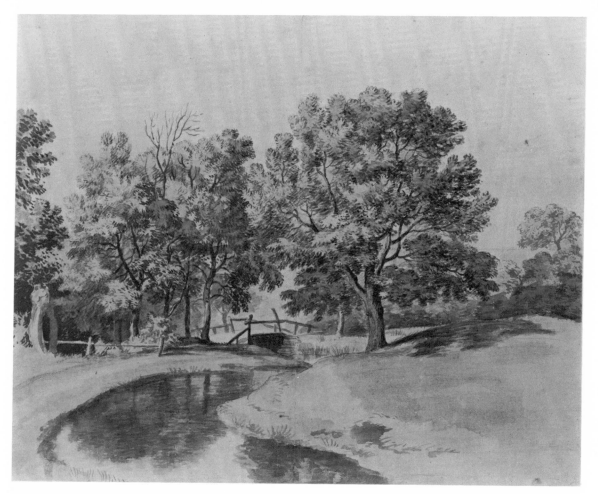

WILLIAM TAVERNER
D. *English Landscape*

WILLIAM TAVERNER
E. *Classical Architectural Capriccio*

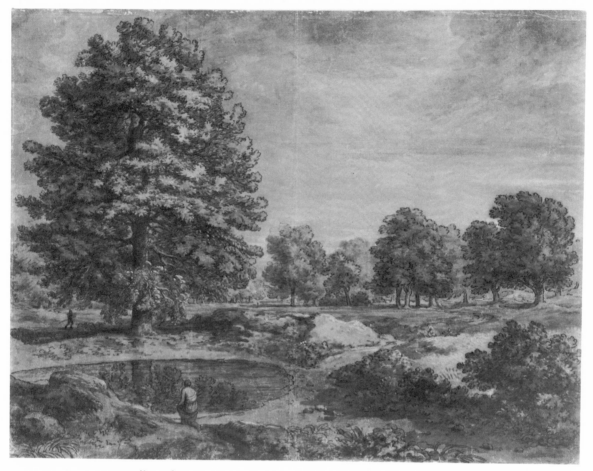

WILLIAM TAVERNER, attributed to
F. *Wooded Landscape*

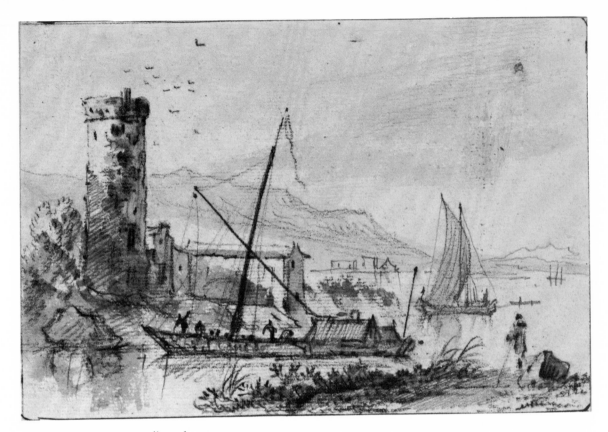

WILLIAM TAVERNER, attributed to
G. *Castle by a Lake*

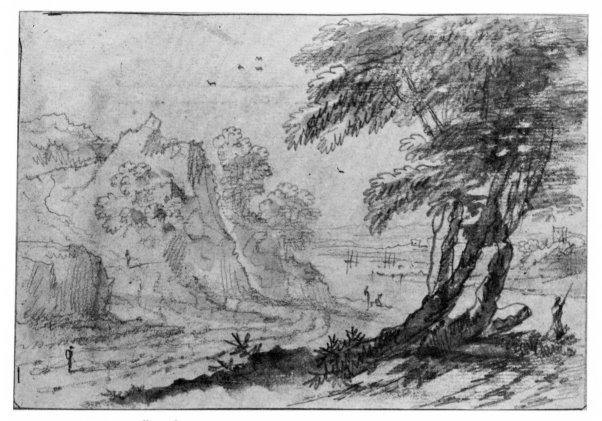

WILLIAM TAVERNER, attributed to
H. *Classical Landscape*

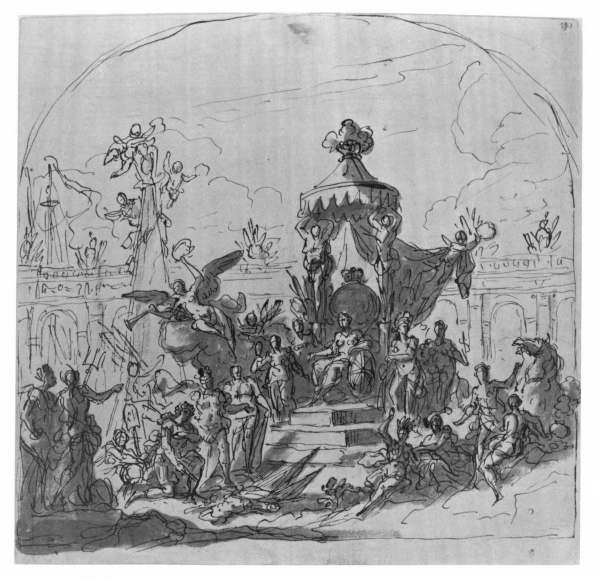

SIR JAMES THORNHILL
A. *Britannia Enthroned*

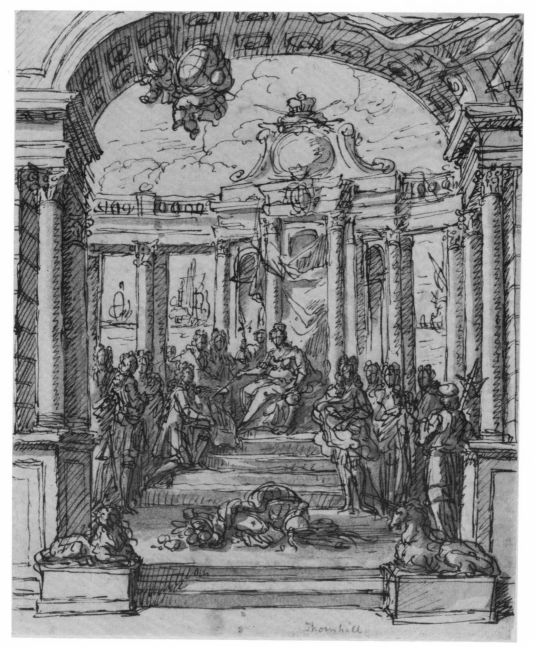

SIR JAMES THORNHILL
B. *Design for the West Wall of the Upper Hall, Greenwich Hospital*

Qualities of yᵉ Queen — Religious, Virtuous, Musical, Charitable, Zealous, Peaced, Pious,

Qualities of Pr: George — Virtuous, Honest, Generous, Constant, Just, Affectionate,

Virtues reciprocal to both Princes.
Amity
Love of Virtue
Concord Conjugale . 2ᵈ Prime
Concord pacifick.
Harmony of Love
Love towards God
Desire towards God.
Equality.
Hospitality —
Liberality
Piety
Religion
Sincerity of Love.

Nº A

The 2 & Pr: linck'd together in a
Gold chain hold a heart in their han...

Nept: presents his Trident to Pr: George
& High Adm: resigning his power of yᵉ
sea to him. He shews him yᵉ Produce of
yᵉ 4 Quarters of yᵉ world. who bring
their Offerings. all yᵉ Sea Deities follow &c
Eolus stills yᵉ winds &c. Juno yᵉ Goddess
of Air sitting by him.

Herc: or Virtue leads in a Hand yᵉ R:
& Prince.

Victory crowns Heroick Virtue wᵗᵉ
yᵉ common ... yᵉ Royal Pair

Charity Religion

SIR JAMES THORNHILL
c. *Sketch for the Ceiling of the Upper Hall, Greenwich Hospital*

SIR JAMES THORNHILL
D. *Two Designs for Pediments for Queen's College, Oxford*

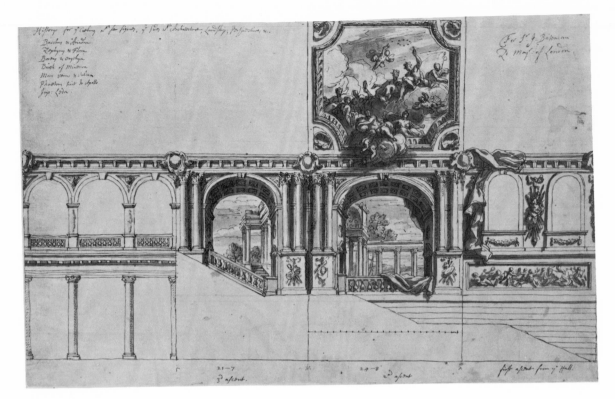

SIR JAMES THORNHILL
E. *Design for a Staircase for Sir James Bateman*

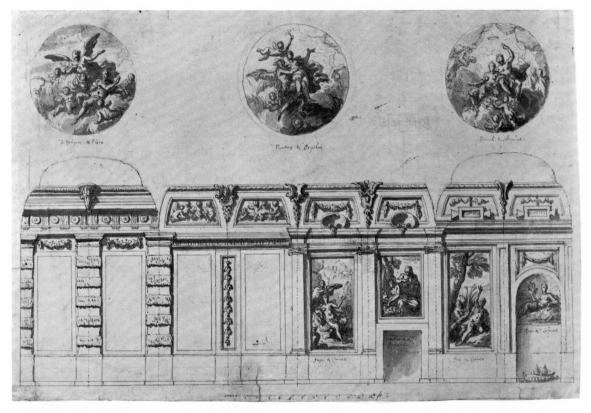

SIR JAMES THORNHILL
F. *Design for a Passageway at Blenheim*

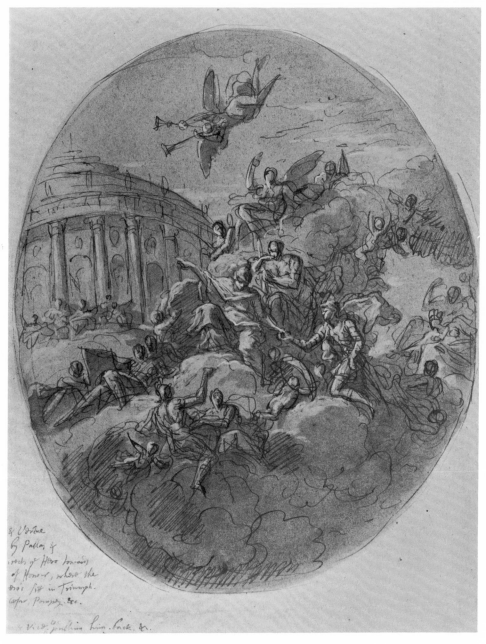

SIR JAMES THORNHILL
G. *Design for the Ceiling of the Hall at Blenheim*

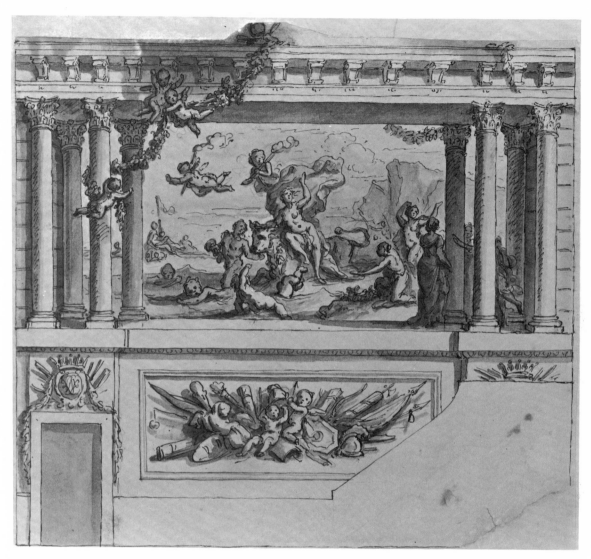

SIR JAMES THORNHILL
H. *Design for a Staircase Wall*

SIR JAMES THORNHILL

1. *Design for a Staircase Wall*

SIR JAMES THORNHILL
J. *Wall Design with Diana and Actaeon*

SIR JAMES THORNHILL
κ. *Design for a Spandrel*

SIR JAMES THORNHILL
L. *Design for a Chimney Wall*

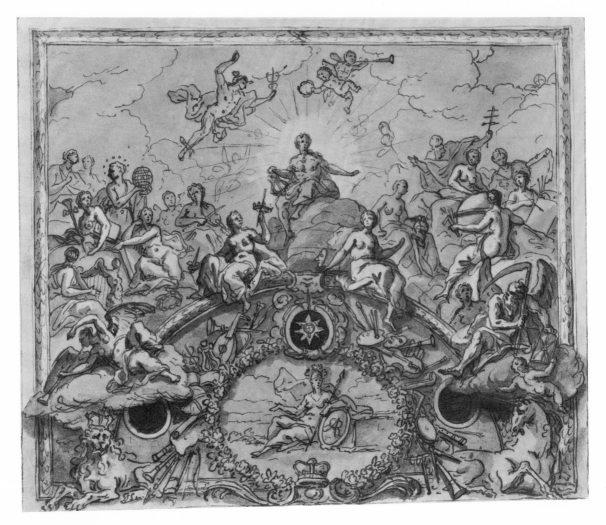

SIR JAMES THORNHILL
M. *Queen Anne's Patronage of the Arts*

SIR JAMES THORNHILL
N. *An Allegory of Time*

SIR JAMES THORNHILL
o. *Design for a Staircase Wall*

SIR JAMES THORNHILL
P. *Bacchus and Erigone*

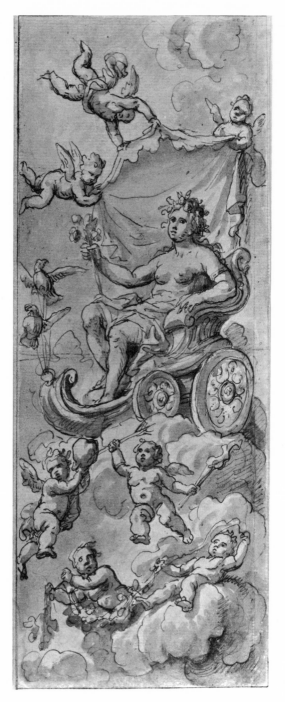

SIR JAMES THORNHILL
Q. *Ceiling Decoration with Triumph of Flora*

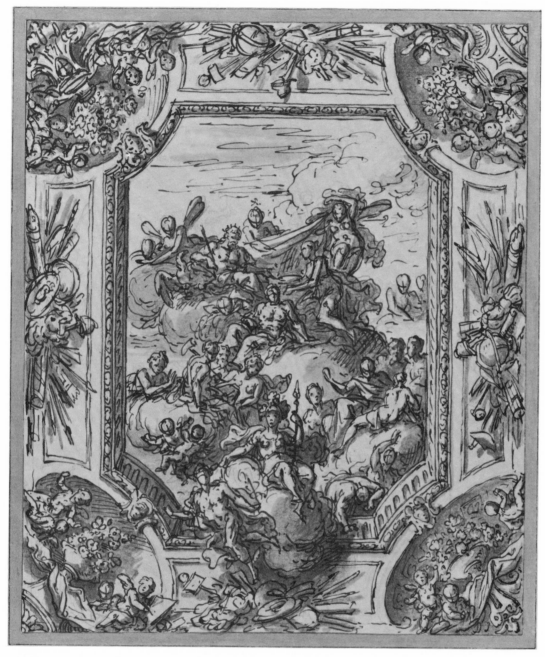

SIR JAMES THORNHILL

R. *Ceiling Design with Decorated Cove and Central Panel with an Assembly of the Gods*

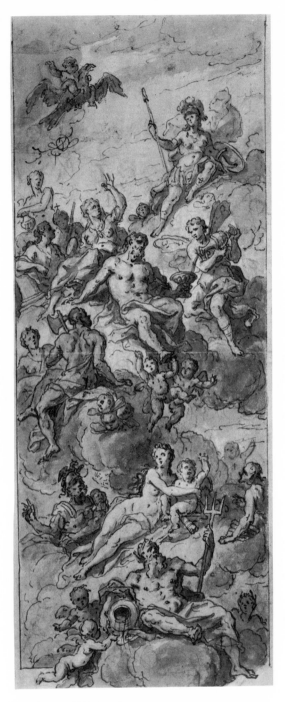

SIR JAMES THORNHILL
s. *Ceiling Design with an Assembly of the Gods*

SIR JAMES THORNHILL
T. *Numa Refusing the Roman Crown*

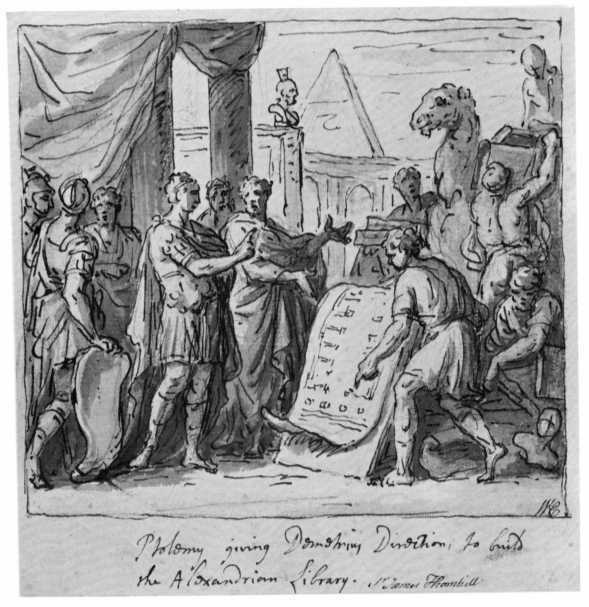

Ptolemy giving Demetrius Direction, to build
the Alexandrian Library. Sir James Thornhill

SIR JAMES THORNHILL
U. *Ptolemy Giving Demetrius Directions to Build the Alexandrian Library*

SIR JAMES THORNHILL
v. *Shell Ornament*

SIR JAMES THORNHILL
w. *Arthur Onslow*

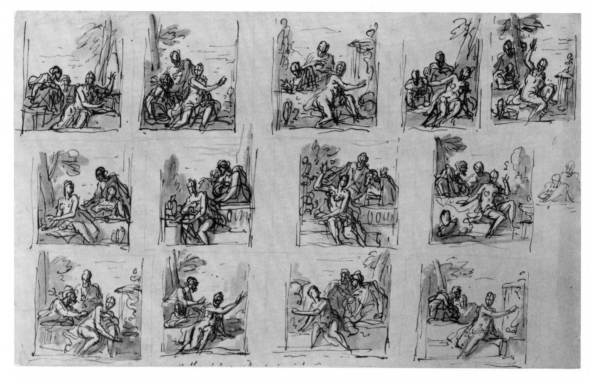

SIR JAMES THORNHILL
x. *Sheet with Thirteen Studies of Susanna and the Elders*

SIR JAMES THORNHILL

Y. *Eighty-nine Illustrations to the New Testament:* 1, 2, 4, 6, 8

SIR JAMES THORNHILL

Y. *Eighty-nine Illustrations to the New Testament:* 3, 5, 7

SIR JAMES THORNHILL

Y. *Eighty-nine Illustrations to the New Testament:* 15, 17, 22

SIR JAMES THORNHILL

Y. *Eighty-nine Illustrations to the New Testament:* 9, 10, 11, 12, 13, 14

SIR JAMES THORNHILL

Y. *Eighty-nine Illustrations to the New Testament:* 16, 18, 19, 20, 21

SIR JAMES THORNHILL

Y. *Eighty-nine Illustrations to the New Testament:* 23, 24, 25, 27, 28

SIR JAMES THORNHILL

Y. *Eighty-nine Illustrations to the New Testament:* 30, 31, 26, 29, 31

SIR JAMES THORNHILL

Y. *Eighty-nine Illustrations to the New Testament:* 32, 38, 39, 40, 41

SIR JAMES THORNHILL

Y. *Eighty-nine Illustrations to the New Testament:* 34, 37, 33, 35, 36

SIR JAMES THORNHILL
Y. *Eighty-nine Illustrations to the New Testament:* 42, 44, 45, 49, 50

SIR JAMES THORNHILL
Y. *Eighty-nine Illustrations to the New Testament:* 43, 46, 47, 48

SIR JAMES THORNHILL
Y. *Eighty-nine Illustrations to the New Testament:* 51, 52, 57, 60, 63, 64

SIR JAMES THORNHILL

Y. *Eighty-nine Illustrations to the New Testament:* 56, 58, 59, 61

SIR JAMES THORNHILL

Y. *Eighty-nine Illustrations to the New Testament:* 62, 65, 66, 53, 54, 55

SIR JAMES THORNHILL

Y. *Eighty-nine Illustrations to the New Testament:* 67, 68, 69, 70, 71, 72

SIR JAMES THORNHILL

Y. *Eighty-nine Illustrations to the New Testament:* 73, 74, 75, 76

SIR JAMES THORNHILL

Y. *Eighty-nine Illustrations to the New Testament:* 77, 78, 79, 83, 84, 85

SIR JAMES THORNHILL

Y. *Eighty-nine Illustrations to the New Testament:* 86, 87, 88, 89, 90, 91

SIR JAMES THORNHILL, attributed to
z. Design for a Wall

PETER TILLEMANS
Town and Estuary

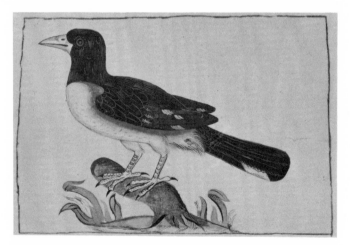

EDWARD TOPSELL
The Fowles of Heaven (Towhee)

JOHN VANDERBANK
A. *Man on Horseback*

JOHN VANDERBANK
B. *Portrait of a Lady*

JOHN VANDERBANK
c. *A Military Review*

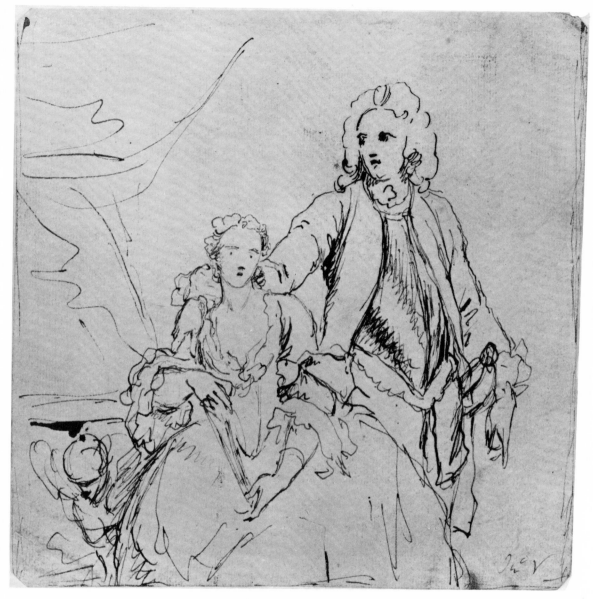

JOHN VANDERBANK
D. *Lady and Gentleman*

JOHN VANDERBANK
E. *Horsemen and a Waggon*

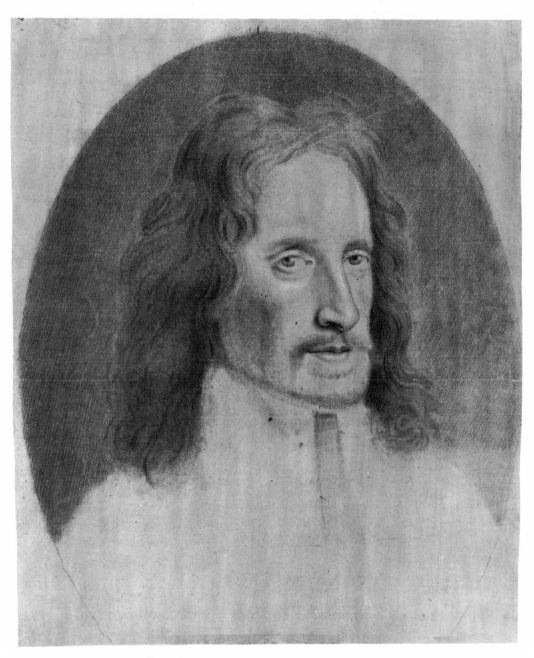

JAN VAN DER VAART, attributed to
Oliver Plunket

WILLIAM VAN DE VELDE, the Younger
A. *Seascape with Men-o'-War*

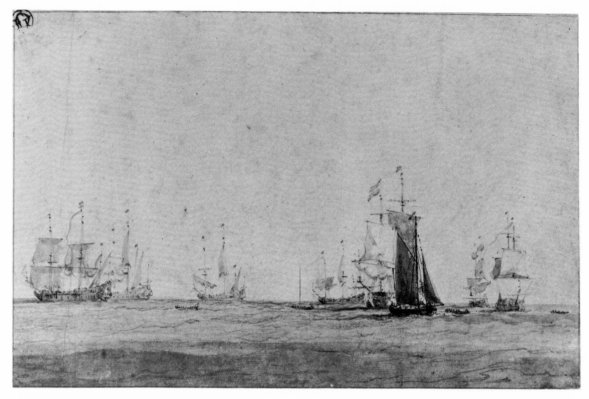

WILLIAM VAN DE VELDE, the Younger
B. *Seascape with Shipping*

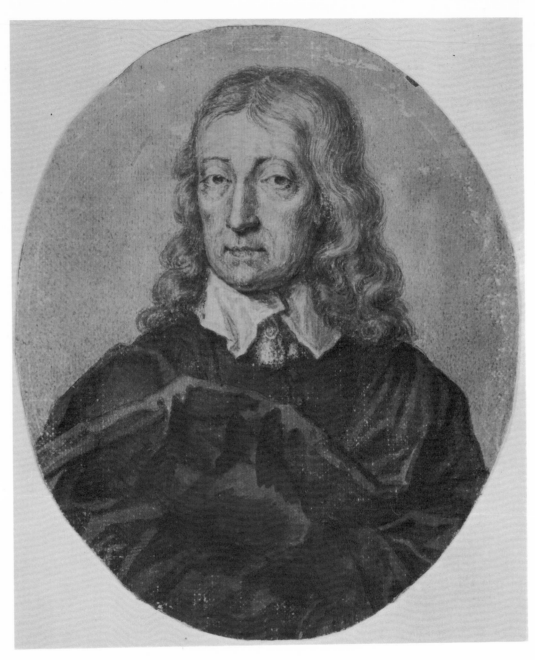

GEORGE VERTUE
A. *John Milton*

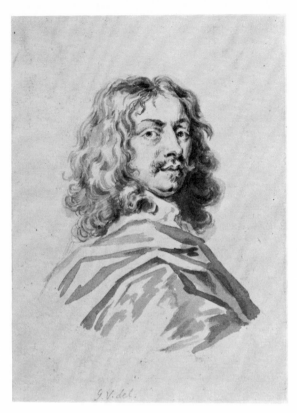

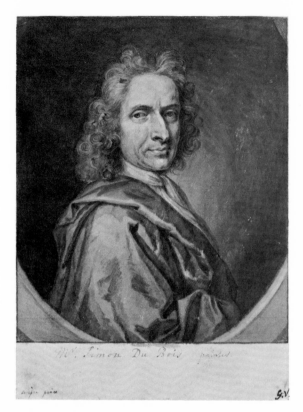

GEORGE VERTUE
B. *William Dobson*

GEORGE VERTUE
C. *Simon Dubois*

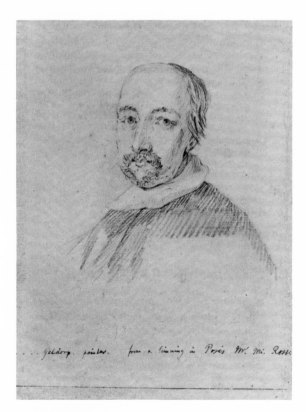

GEORGE VERTUE
D. *Isaac Fuller*

GEORGE VERTUE
E. *George Geldorp*

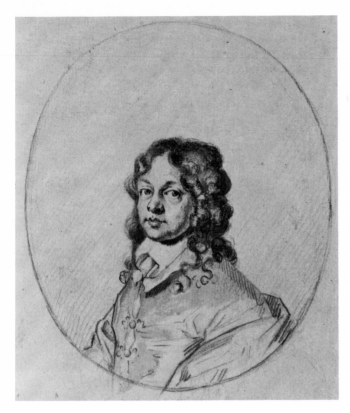

GEORGE VERTUE
F. *Richard Gibson*

GEORGE VERTUE
G. *Mrs. Gibson*

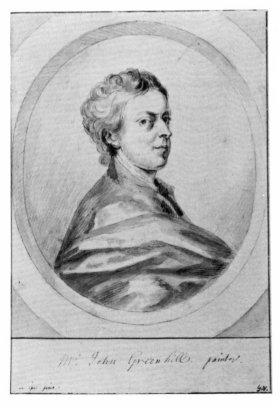

GEORGE VERTUE
H. *John Greenhill*

GEORGE VERTUE
I. *Louis Laguerre*

GEORGE VERTUE

J. *Bernard Lens*

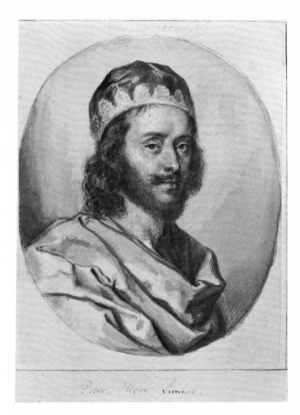

GEORGE VERTUE

K. *Peter Oliver*

GEORGE VERTUE

L. *Robert Streater*

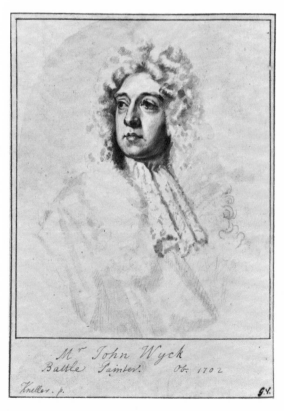

GEORGE VERTUE

M. *Jan Wyck*

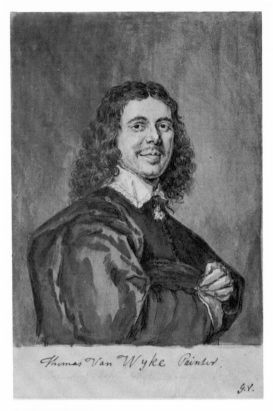

GEORGE VERTUE
N. *Thomas Van Wyck*

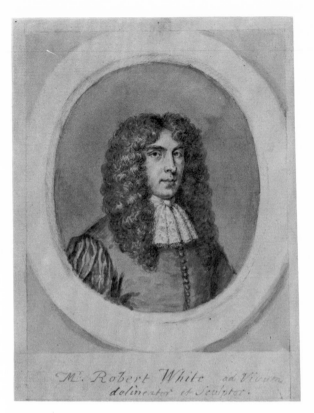

GEORGE VERTUE
O. *Robert White*

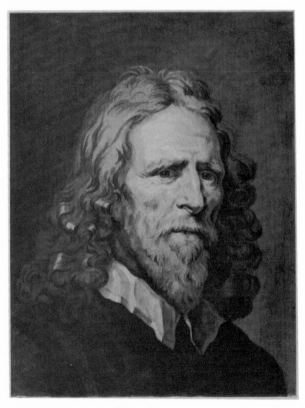

GEORGE VERTUE, attributed to
P. *Abraham Van der Dort*

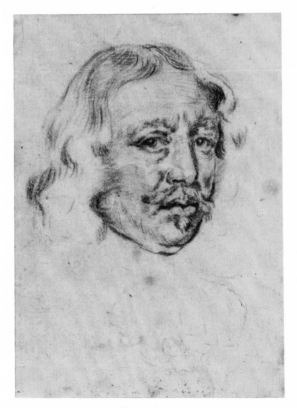

GEORGE VERTUE, attributed to
Q. *Admiral Sir Joseph Jordan*

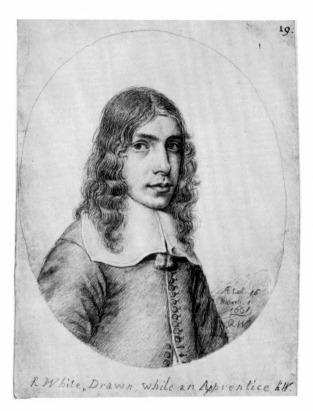

ROBERT WHITE
A. *Self-portrait*

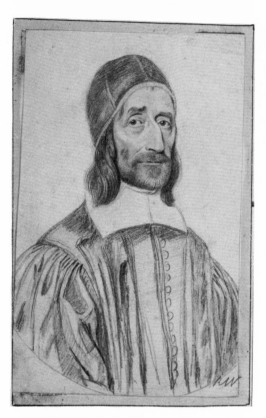

ROBERT WHITE
B. *Richard Baxter*

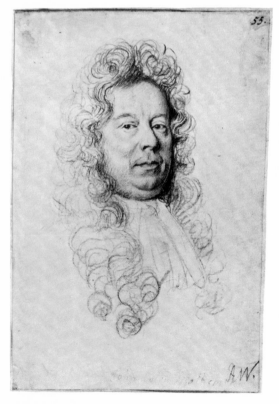

ROBERT WHITE
C. *Henry Coley*

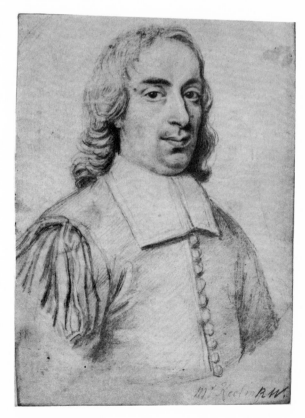

ROBERT WHITE
D. *Josiah Keeling*

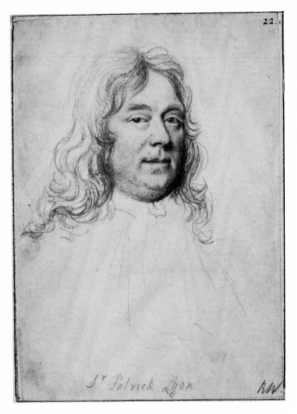

ROBERT WHITE
E. *Sir Patrick Lyon*

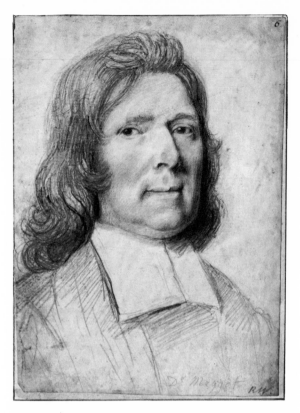

ROBERT WHITE
F. *Richard Meggot, Dean of Winchester*

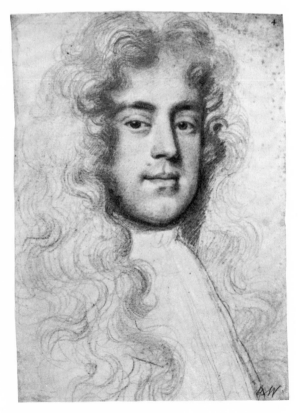

ROBERT WHITE
G. *James, Duke of Monmouth*

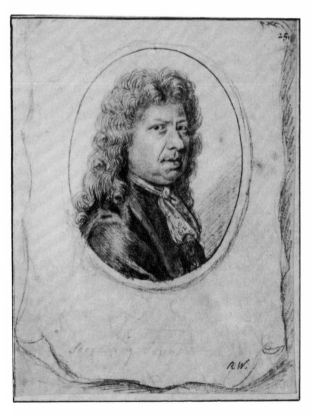

ROBERT WHITE
H. *Samuel Pepys*

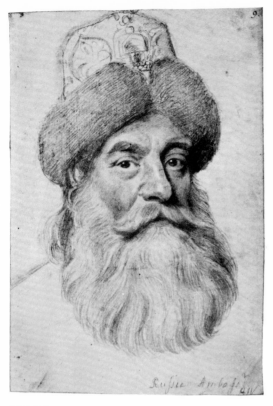

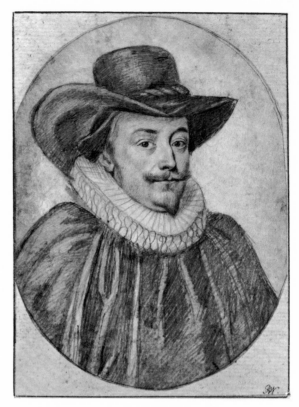

ROBERT WHITE
I. *Peter John Potemkin*

ROBERT WHITE
J. *John Williams, Archbishop of York*

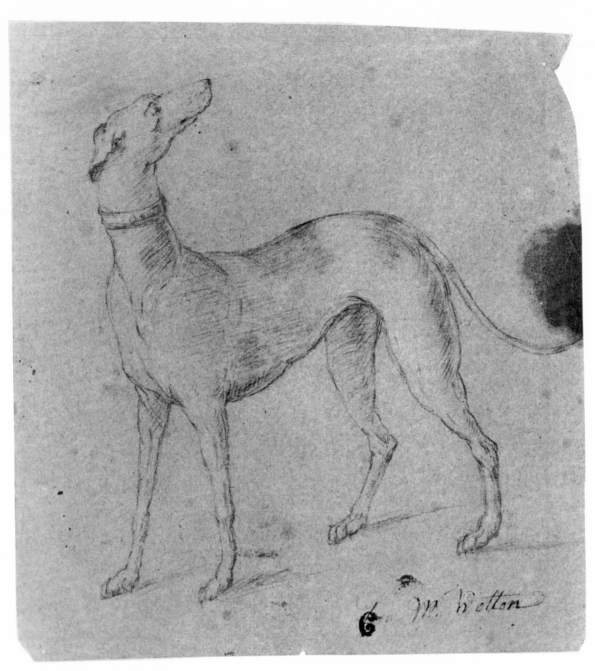

JOHN WOOTTON, attributed to
A. *A Greyhound*

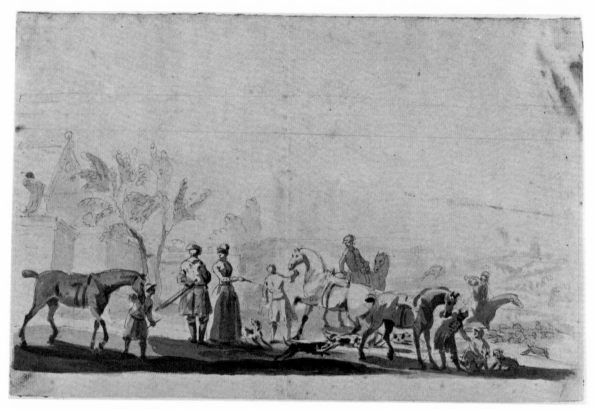

JOHN WOOTTON, attributed to
B. *Before the Chase*

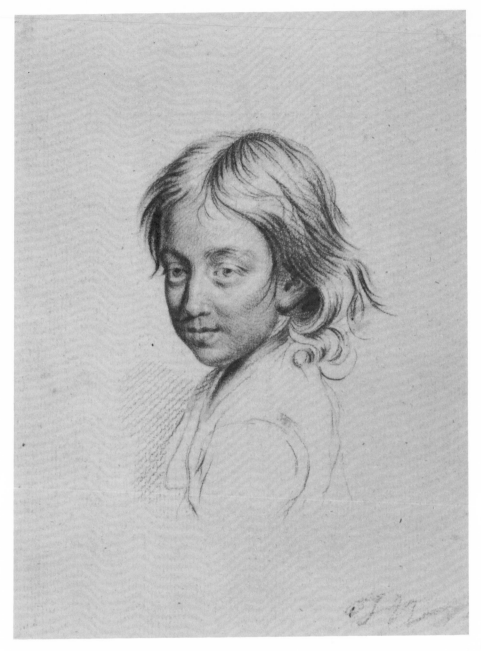

THOMAS WORLIDGE
A. *Head of a Boy*

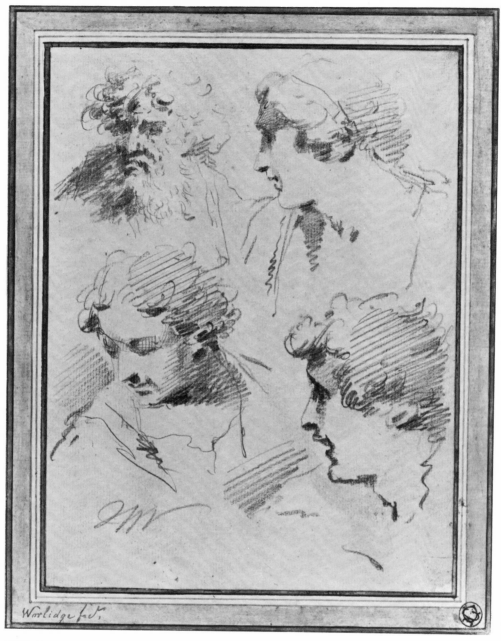

THOMAS WORLIDGE
B. *Four Studies of Heads*

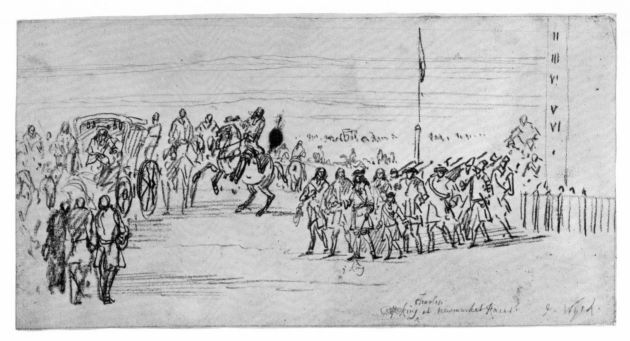

JAN WYCK
A. *Charles II at Newmarket Races*

JAN WYCK, attributed to
B. *Hare Hunting*

FRANCESCO ZUCCARELLI
A. *A Farm Girl*

FRANCESCO ZUCCARELLI, attributed to
B. *Classical Landscape*

INDEX